Art of the
Byzantine Era

ART OF THE BYZANTINE ERA

David Talbot Rice

LONDON
THAMES AND HUDSON

© THAMES AND HUDSON 1963
PRINTED IN GREAT BRITAIN BY JARROLD AND SONS LTD NORWICH

Contents

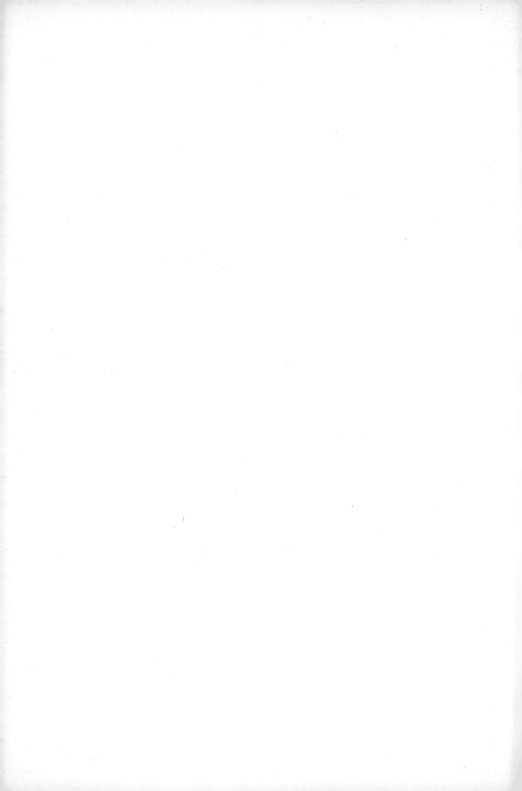

The East Christian World Before Islam

The art that will be discussed in this volume, though there are
numerous variations of style due to epoch or locality, is broadly of
a very distinct and basically uniform character. It was firstly essenti-
ally a Christian art, dedicated to the service of the Church and to
the illustration and expression of that faith, and to a greater or lesser
extent, controlled by the rulings of the Church. It was, secondly,
an art where a certain degree of abstraction prevails, and where the
rhythmical or spiritual basis of a composition was more important
than resemblance to Nature. It was nevertheless a figural art and
owed a considerable debt to the motifs and ideas that were prevalent
at an earlier date in the classical world; indeed the classical heritage
was never lost sight of, in spite of the penetration of new and distinct
ideas from the East. It was, thirdly, a sophisticated and a complex
art, where profound meaning underlay the form, and not a primitive
art, depending for its appeal principally on the attraction of colour
or intuitive qualities of design. But as it was an art which extended
over a very long period of time—the years between about 550 and
1450 are covered in this book, though the styles that are here dis-
cussed existed in embryo before and survived till much later—and
which was produced over a very extended area in space, there were
naturally wide variations not only of style, but also of character.

The finest work, the most elegant, and the most accomplished
technically, was, naturally enough, associated with the Byzantine
capital, Constantinople, which was the very hub of the civilized
world from the foundation of the city as capital around 330 till its
conquest by the Turks in 1453. But there were other great centres
too. In Rome, Milan, Ravenna, and elsewhere in the West works
of the greatest importance that were in no way provincial were
executed in the early years of Christendom, though little of quality
was produced there that belongs to the period covered by this

volume. In Alexandria, Antioch, Jerusalem, and elsewhere in the East a great deal was also being done in early times and production continued there till Syria, Palestine, and Egypt were overrun by the Moslems just before the middle of the seventh century. Though little remains on the spot, quite a large number of portable works can be assigned to these places; they mostly found their way to Cathedral Treasuries and monasteries in the West at an early date. Many smaller centres in the East were also far from insignificant, and as we proceed we will have cause to call attention to paintings and carvings in ivory which must have been produced in out-of-the-way places rather than in the great centres; they are naturally less sophisticated, but they nonetheless show the heritage of a great tradition, and sometimes, in addition, they are distinguished by the originality and freshness characteristic of a young art.

Our survey will thus be a wide sweeping one from the point of view of the area it embraces; it will also include works of a very diverse character. Something will be said of architecture, 'the mother of the arts' and the frame in which so many of the other works we speak of were set. The great mosaics and wall-paintings will receive full consideration, and so will book-illustrations and panel-paintings —icons as they are usually called. But in the East Christian world the close distinctions so often drawn in the West between 'art' and 'craft' were never really applicable, and the things on a small scale, ivory carvings, textiles, works in precious metal or enamels, even pottery, are often just as much works of art as are large-scale paintings or sculptures. The small things, too, will therefore receive attention in the text and figure frequently among the illustrations.

This does not mean, of course, that no large-scale works were produced. The great mosaics of the Byzantine world, the wall-paintings of Coptic Egypt or the Balkans, the sculptures that adorn the tympana or even the entire façades of many a church in Armenia and Georgia are all on a major scale. Indeed, the actual area of wall-space that was covered by mosaics and paintings in the East Christian world has probably never been exceeded, even in Renaissance Italy, and though much has perished, work that extends over very many square metres still survives. Some of it is, of course, primitive, some

8

of it rather crude, but much also is of very high quality and serves to convey to us, if only vaguely, something of the glory that once characterized the Church art of a whole section of the Christian world. On the evidence of what does remain a picture of what there was that is not wholly inaccurate can be reconstructed. It is hoped that the illustrations in this book will provide a basis on which to establish that reconstruction.

<p style="text-align:center">★ ★ ★</p>

It is not easy to decide at what point the story with which we are concerned should begin. The adoption of Christianity by Constantine as the official religion of the Roman Empire through the Edict of Milan in 313 marks a turning-point in ecclesiastical history, but hardly in art, for old pagan ideas and motifs were taken over lock, stock, and barrel, and there were few immediate changes in style that could be attributed to the new faith rather than to the inevitable changes which were taking place as the result of the progress of time. The transference of the capital from Rome in Latin Italy to Constantinople in the Hellenistic Greek world in 330 marks another break, which was more significant as far as art was concerned, for it brought the Court and the Church, the two main sources of patronage, into the orbit of a new and distinct culture, in part Greek and in part Eastern. The Sack of Rome by barbarian Goths in 410 is also an important date, as is the year 476, when the last of the independent Roman emperors ceased to rule in the West. But more vital for art than all these was the reign of Justinian (527–65), for then the new Byzantine Empire was set on a sure foundation and an art and architecture which were both wholly Christian and also wholly new saw their first flowering. Change had, it is true, set in before Justinian's day, for the new style was already budding when he came to the throne, and the beginning of the sixth century represents perhaps the true turning-point between the end of the old world and the beginning of the new, but it was Justinian's lavish patronage that established the new age firmly and definitely. Our story will thus begin about that time so far as generalities are concerned, but the illustrations and more detailed descriptions will in

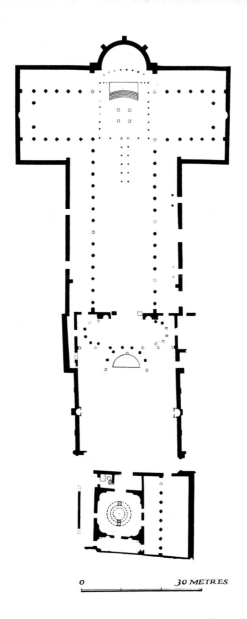

0 30 METRES

1 Plan: the Church of St Maenas, Alexandria. The church is a T-shaped basilica and had a simple wooden roof, but domes were used for small subsidiary structures, supported on both pendentives and squinches

the main be chosen from among works produced after the middle of the sixth century towards the very end of Justinian's reign rather than from its outset.

The rise of Constantinople did not at first imply any very serious decline in the importance of the other great cities of the Near East, of which Alexandria in Egypt and Antioch in Syria were the most important. The prelates of these places, indeed, disputed the supremacy of Constantinople in religious affairs and each remained the centre of a way of thought that was distinct from that of the direct line of Orthodoxy that pertained at the capital; each exercised quite an important influence on the political affairs of the Empire; in each there developed a trend in art which was different from that which characterized Constantinople. Indeed the new capital had quite a lot to learn from both these cities, for they boasted a long history and were important when the old Byzantium that was to be renamed Constantinople was no more than a minor provincial town, and they looked with some mistrust on Byzantium's rise when it was selected by Constantine for the site of his new capital. The rôle of both Antioch and Alexandria was in fact considerable; it might well have been longer lived had not the whole area comprising North Africa and the eastern fringe of the Mediterranean as far north as the mountains that separate what is today upland Turkey from the lowlands of Syria and Iraq fallen to Islam shortly before the middle of the seventh century.

We know little of the architecture of Alexandria around the time of Justinian, for no buildings of the time survive as complete structures. The churches must however have been fine; the larger ones were apparently basilicas with timber roofs, though the systems of vaulted and domical construction were known, and in the shrine of St Maenas near Alexandria (*Ill. 1*), both pendentives and squinches were used in the sixth century, though as far as we know only on a small scale. By the seventh century vaulting of quite extensive proportions had become normal, and pointed domes of large size were being used for the churches of Egypt. But the building material that became normal after the mid-sixth century, mud brick, did not lend itself to great elegance or finesse of design or

2 The size of the actual Byzantine Empire varied through the ages. Under Justinian it stretched from Italy to the borders of Mesopotamia. In the tenth century it included Asia Minor, Greece and most of the

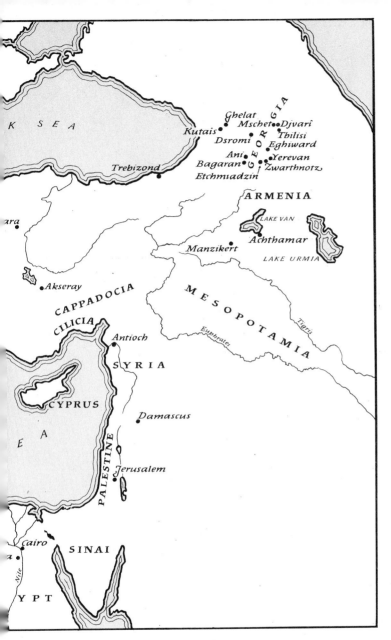

K S E A

Trebizond

Ghelat
Mschet *Djvari*
Kutais
Dsromi *Thilisi*
Eghiward
Ani *Yerevan*
Bagaran *Zwarthnotz*
Etchmiadzin

GEORGIA

ARMENIA

LAKE VAN

Achthamar

Manzikert

LAKE URMIA

ara

Akseray

CAPPADOCIA

CILICIA

MESOPOTAMIA

Tigris

Euphrates

Antioch

SYRIA

CYPRUS

Damascus

E A

PALESTINE

Jerusalem

Cairo

SINAI

Nile

Y P T

Balkans. At the end it comprised little more than Constantinople
itself and Mistra in the Peloponnese. But most of the area shown on
this map boasted an art of essentially Byzantine character

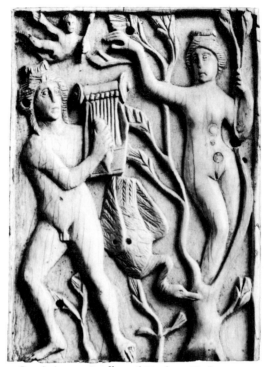

3 Coptic ivory; Apollo and Daphne. Sixth century.
The subject is wholly classical and the treatment
mainly so. It was probably carved at Alexandria
where the classical style long survived

conception, and the various structures that survive outside Alexandria
are of little interest aesthetically. The best work was done in Alex-
andria itself, and is represented by a number of stone sculptures
found on the spot and a few ivory carvings which have been
associated with the city on the evidence of style.

The ivories are the most important from the artistic point of view,
and in Alexandria itself classical themes and a certain degree of
classical elegance continued in art for quite a considerable time after
the adoption of Christianity. A plaque at Ravenna bearing Apollo
and Daphne (*Ill. 3*) serves to prove this, for the style is classical and
the theme belongs to pagan mythology. It is to be dated to the late
fifth, or early sixth century.

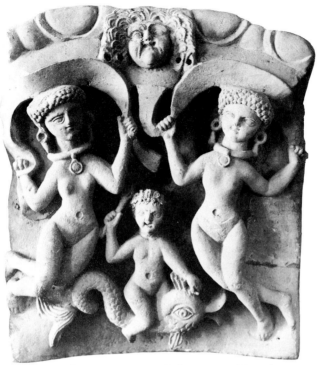

4 Carving in limestone. Coptic. Sixth century. This exuberant
style, suggestive almost of Indian art, was especially popular
in Egypt from the fifth century until the Islamic conquest
around 640

Outside Alexandria the classical elegance tended to give way to a
markedly voluptuous rendering, suggestive almost of Indian art.
It distinguished the ivories of Lower Egypt, and was present also in
the textiles, but it was perhaps nowhere as marked as in the limestone
carving which was developed almost as a national art in the region
of the Delta between the fifth and seventh century (*Ill. 4*). The fat,
luscious nudes were wholly distinct from the severe, almost stylized
figures favoured at Constantinople at the same period.

These things are unmistakable, but the Egyptian provenance is
less easy to establish in the case of ivories bearing religious themes,
for work done at Antioch and in the more cultured centres in Syria
would seem to have been very closely akin to the Alexandrine, and

5 Pyxis, sixth century. The reclining figure represents the allegory of the Nile and determines the Egyptian origin of the ivory

the authorities are still in dispute over which pieces should be assigned to which centre. There are a few examples however which can be attributed to Egypt with little doubt. The most important is a pyxis of the sixth century at Wiesbaden (*Ill.* 5), for its decoration includes such obviously Egyptian subjects as a sphinx and the allegory of Father Nile. Other pyxides, which bear subjects connected with St Maenas—there is one in the British Museum (*Ill.* 6)—are also to be regarded as Egyptian, for it was there that the Saint's principal shrine was situated and there that his cult flourished most vigorously.

6 Pyxis bearing a figure of St Maenas in a niche, his hands raised in prayer. His principal shrine was near Alexandria and it is likely that the pyxis was carved there

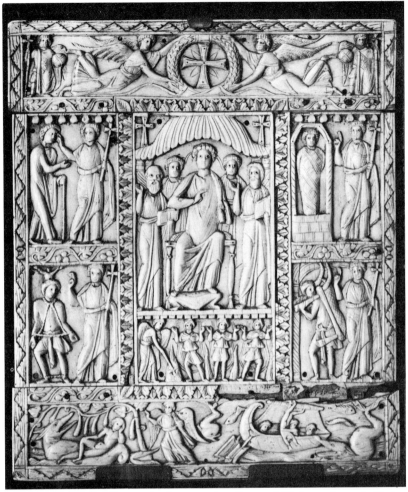

7 Multiple diptych of ivory. In the centre is a figure of Christ, enthroned; He is beardless as He often was at this date. The bearded variant only became universal later, under eastern influence

A good many other important ivories have at one time or another also been attributed to Alexandria; outstanding among them is a multiple diptych from Murano, now in the Ravenna Museum (*Ill. 7*). It is made up of five panels. On the central one Christ appears beardless, following the tradition of Early Christian art,

where He was modelled on Apollo. On either side of Him stand SS Peter and Paul, with a canopy above and the three Hebrews in the Fiery Furnace below. At the top are two Angels, confronted, with a cross between them; at the bottom are scenes from the life of Jonah. The side panels show to Christ's left the Healing of the Blind Man and of the Man Possessed with a Devil, and to His right the Raising of Lazarus and the miracle 'Take up thy bed and walk.' All the scenes are strikingly vivid; that of Jonah and the Whale (*Ill. 8*) is particularly expressive. They all represent illustrative art at its peak. One would associate such competence with a great city, such as Alexandria; the angular poses and the expressive gestures are distinct from what was being done in Constantinople.

A pair of rather similar multiple diptychs in the Bibliothèque Nationale (*Ill. 9*) are also probably to be regarded as Alexandrine, though the work is rather coarser than that on the Ravenna ivory. One leaf bears, on the central panel, a bearded Christ, enthroned between SS Peter and Paul, the other the Virgin Enthroned with the Child on her knee between two Angels; both the central compositions are surrounded by scenes from Christ's life, and at the tops are confronted Angels supporting a cross within a wreath. Like the Ravenna panel, this ivory is to be dated to the sixth century.

8 Detail of the left-hand scene of the bottom panel of the ivory shown on p. 17. The panel is devoted to the story of Jonah; here he is shown resting under the Gourd Tree, the whale beside him

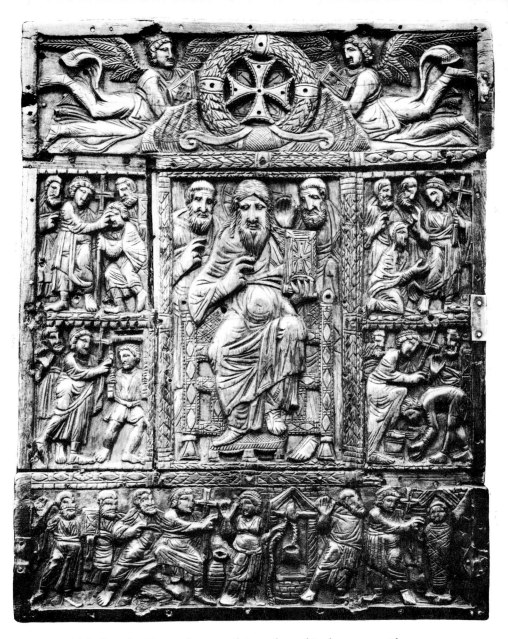

9 Multiple diptych of ivory, showing Christ enthroned in the centre, with scenes from His life around; most are miracles. Here Christ is conceived as a dignified bearded figure; the rendering may be contrasted with that on p. 17

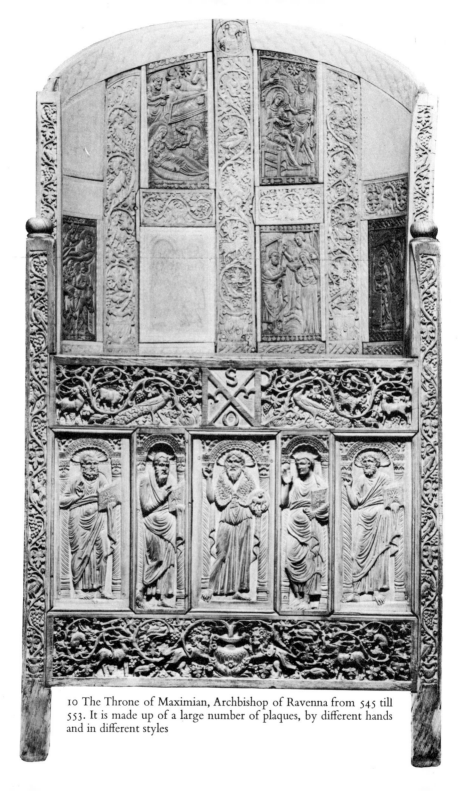

10 The Throne of Maximian, Archbishop of Ravenna from 545 till 553. It is made up of a large number of plaques, by different hands and in different styles

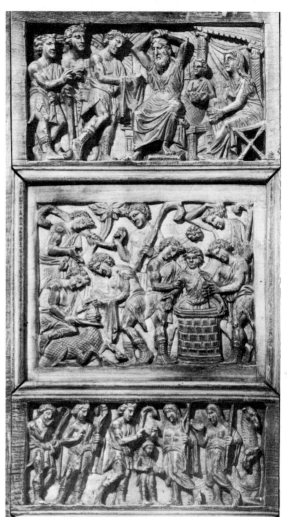

11 Three plaques from the side of Maximian's throne. They show scenes from the life of Joseph. *Above*, Jacob shows his grief at the news of the loss of his son; in the *centre* Joseph is shown in the well; *below*, Joseph is sold to the merchants. These panels have usually been assigned to an Egyptian carver

Less certain is the provenance of the famous throne of Maximian at Ravenna (*Ill. 10*), the most magnificent complex of ivory carving of all time. It was made somewhere around 550. A large number of authorities have assigned it to Alexandria; others have suggested Constantinople or even Ravenna. The case for an Alexandrine origin is best supported with regard to the scenes from the life of Joseph (*Ill. 11*) which occupy ten panels on the sides. The subject was more popular in Egypt than elsewhere, as one might expect; there are certain Egyptian features as regards the details, and the

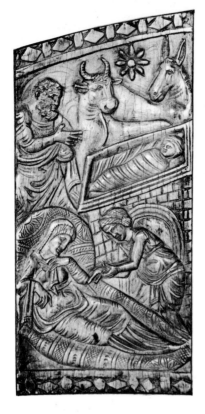

12 Detail of back of Maximian's throne. The Nativity. This is an example of work by a third hand. The front panels and the scenes from the life of Joseph were carved by two other masters

style of these panels is closely related to that of the pyxides noted above, which are certainly Egyptian. But the larger panels on the front of the throne, showing St John the Baptist and the Evangelists are, on the other hand, different in character and are distinguished by the majestic manner which there is good reason to associate with Constantinople. It is certain that artists moved about a good deal, and it is also a well-known fact that craftsmen were summoned to Constantinople by the emperors; perhaps the Joseph panels were done there by a man who had been trained in Alexandria and went to the capital armed with sketches from his native land, while the Evangelists were done by a man trained in the capital. This, in any case, seems the most likely explanation of the differences of style. The panels on the back with scenes from Our Lord's life (*Ill. 12*)—there were originally twenty-four, though some have perished—could have been done by artists trained in either centre.

The purity of the Alexandrine Hellenistic style began to degenerate in the fifth century, and when once the process had begun it went forward remarkably quickly. The elegant almost classical nudes of earlier times rapidly degenerated into plump, rather voluptuous figures, while the balanced scrolls and naturalistic floral patterns became angular and rectilinear. The process was most marked away from Alexandria and resulted around the sixth century in the establishment throughout northern Egypt of the debased style we know as Coptic, which rapidly stifled the purer and more refined Hellenistic manner. At the same time inscriptions in Coptic superseded those in Greek. The Coptic carvers were however astonishingly prolific, and small ivories, wood carvings, and rather coarse sculptures in stone or stucco were produced in surprising numbers from the sixth century onwards, and their execution continued long after the Moslem conquests of the seventh century. Some of the best work was non-figural, and decorative carvings in wood or stucco were often of real quality. Some fine stuccoes in remarkably high relief form part of the early tenth-century adornment of the so-called 'Syrian monastery' (Deir es Suryani) in the Wâdi 'n Natrûn

13 Stucco wall decoration in the Monastery of Deir es Suryani, Egypt. Stucco was a favourite medium of the Coptic craftsmen and was used for the decoration of Christian and Islamic buildings alike

(*Ill. 13*). Tombstones decorated with a cross and stylized acanthus leaves in low relief also remained very popular.

More universal than the ivories or the sculptures in other materials however were the paintings. Just as with the ivories, there were two styles, a more refined one associated with Alexandria and a cruder one dominant in the interior. No large-scale Alexandrine paintings survive, nor are there any early manuscripts, but we can gather a good deal about these from later ones, for there is reason to believe that illustrations to the first seven books of the Old Testament, the Septuagint as it is called, were produced in Alexandria even before Christian times, and they served to inspire manuscript copyists from then onwards. The artists who illustrated the Paris Psalter (Bib. Nat. Gr. 139, cf. pp. 178, 179) in the ninth century thus owed a clear debt to Alexandria, those who adorned other Old Testament manuscripts, like the Cotton Bible in the British Museum, actually worked there. Just as the scribes' duty was to copy the text as faithfully as possible, so the illuminators copied the illustrations, adhering closely to the old models, though they nonetheless saw them as it were through the spectacles of their own age. The style thus varied but the arrangement and the composition of the pictures remained in the main constant, so that the later manuscripts serve to illustrate the Alexandrine iconography; and if they give us an idea of the subject-matter and the way in which it was treated in Alexandrine painting, a number of painted panels or icons which have recently been discovered among the treasure of the Monastery of St Catherine on Mount Sinai serve to indicate the nature of the actual style and show the way in which the individual figures were dealt with. One of the most important of these icons represents St Peter (*Ill. 14*). It is painted in the encaustic technique, that is, in coloured waxes which were manipulated with a hot rod, instead of a brush, and is to be dated to the sixth century, though the style remains balanced and elegant and there is no hint of the decadence of many of the ivory carvings of the time.

Other icons in the Sinai monastery represent a transition to the coarser, more rigid style of Coptic art. Some, like one of the three Hebrews in the Fiery Furnace (*Ill. 15*), still show hints of Alexan-

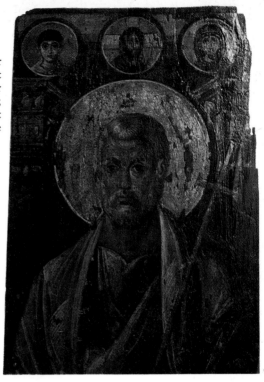

14 Sixth-century panel-painting of St Peter in the Monastery of St Catherine, Mount Sinai. The production of painted panels or icons was important from very early times; the finest collection of them is that at Sinai, which has only recently become known to any but specialists

15 Icon in the Monastery of St Catherine, Mount Sinai, sixth century. An angel beside the three Hebrews in the Fiery Furnace. This is the earliest panel of a Biblical subject that has come down to us

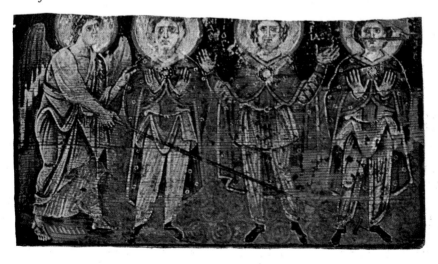

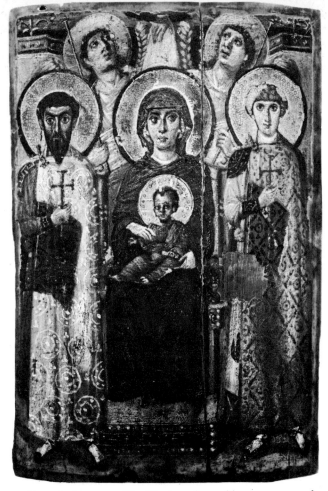

16 Icon, sixth century. The Virgin enthroned between two male saints holding crosses and wearing costumes of richly decorated silks. Behind are two angels

drine elegance; others, like one of the Virgin Enthroned with the Child on her knee, with a Saint on either side and two angels above (*Ill. 16*), illustrate the rigid frontal attitudes and hieratic poses which came to Egypt from Syria and helped to bring about the establishment of the Coptic style in painting. This was known to us before the discovery of the Sinai icons both through panels and wall-paintings. Of the former one of the most striking is in

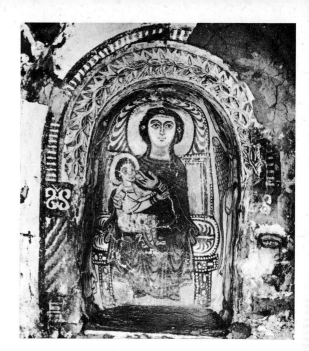

17 Wall-painting; the Virgin and Child in a niche, in the Monastery of St Jeremias at Saqqara. The Virgin is here shown in the naturalistic pose of giving suck, in contrast to the more hieratic rendering shown on the preceding plate

the Louvre (*Ill. 19*); it shows Christ and St Maenas, and like all the provincial Coptic work is distinguished by an absence of half-tones and a love of bright colours—emerald-green, red, and violet were the favourite ones. The same features are to be seen on a larger scale in the wall-paintings; those at Bagawat of the fifth, Deir Abù Hennis and Bawit of the sixth, and Saqqara (*Ill. 17*) of the sixth or seventh century, are the most important of those produced before the Islamic Conquest. But work continued, and there are interesting paintings in the monastery known as Deir es Suryani which are to be assigned to the tenth century. An unusual double composition of the Annunciation and the Nativity in the southern apse may be noted (*Ill. 18*). The story of the life of the Virgin is continued in the other semi-domes; it ends with the Dormition, or Assumption as it is more usually termed in the West, on the northern side. The last hints of Hellenistic naturalism had already disappeared by the time that the paintings at Saqqara were done, and the work of later date is usually stylized, even crude, though often not without a certain forceful vigour. It is characterized too by the development of a

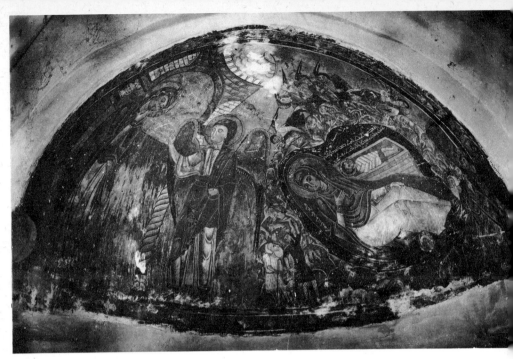

18 Wall-painting in the semi-dome of the southern apse of the cruciform church
of el Adra in the Syrian monastery, Deir es Suryani, Egypt. The Annunciation
is shown to the left, the Nativity to the right, with no separating border between
the two scenes

number of iconographic themes or ideas peculiar to Egypt, and
associated with the way of thought that prevailed in the area. The
Egyptian Christians had broken away from the Orthodox persuasion
of Constantinople after the Council of 451, as a result of disputes
as to the true nature of Christ, and Alexandria had become the centre
of a heresy known as the Monophysite. According to this, Christ
had but one nature, the divine, and the Virgin was in consequence
always designated as Hagia Maria, 'Saint Mary', for it was not
accepted that she could be 'Mother of God', or 'Theotokos', as she
was called in the Byzantine world properly speaking.

One further aspect of Egyptian art deserves mention, namely that
of textile weaving and decoration. It is to some extent thanks to the
rôle played by the dry climate of the country that Egyptian textiles
are so famous, for large numbers have been found in burying-

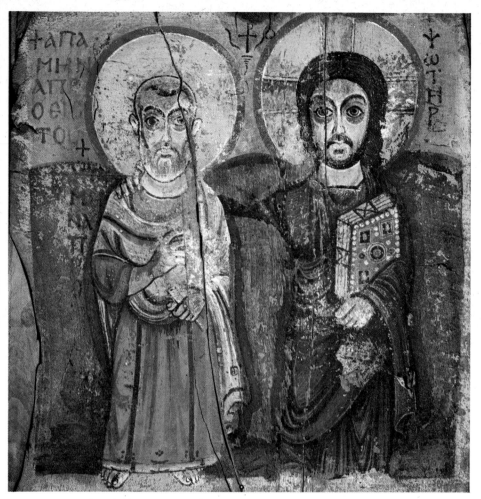

19 Icon. Christ and St Maenas. Sixth century. The icon is similar in style and technique to those previously illustrated from the Monastery of St Catherine on Mount Sinai. It is, however, readily accessible for it is preserved in the Louvre

grounds there, whereas elsewhere they have nearly always perished. But the reputation of Egypt in this art was not wholly the result of chance, for the industry was widely established and the weavers were both active and versatile, and were in a position to make habitual use of every known material and technique. Wool and linen had been known and used since very early times; cotton had

been introduced from India early in the Christian period, though in Egypt it was spun to the left, whereas in India it had been spun to the right; silk was used, but only for small-scale work until Justinian introduced its cultivation in the West; it was mostly woven at Antinoe, one of the principal centres of the Egyptian textile industry. Of the techniques the most usual was the so-called tapestry-weave, but loom-weaving was developed after the fifth century, prominence being given to a special variant called loop-weaving, where the weft was not pulled tight but left loose in a series of loops, like an uncut velvet; the same technique is sometimes used for towels today. Printed stuffs, where the pattern was made by covering parts of a plain textile with a 'resist' and then dipping it in coloured dyes, were also produced in Egypt; one in the Louvre, with the Triumph of Dionysus (*Ill. 20*), depicts a pagan theme; there is a closely similar one in the Royal Scottish Museum at Edinburgh bearing Christian themes. Embroidery also became popular at a rather later date, and was much developed after the Islamic Conquest.

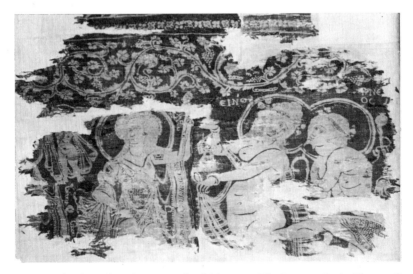

20 Resist dyed textile; The Triumph of Dionysus. The Louvre, Paris. The textile is probably to be assigned to the fifth century and illustrates the survival of classical themes and a classical style which is also to be observed in the ivories

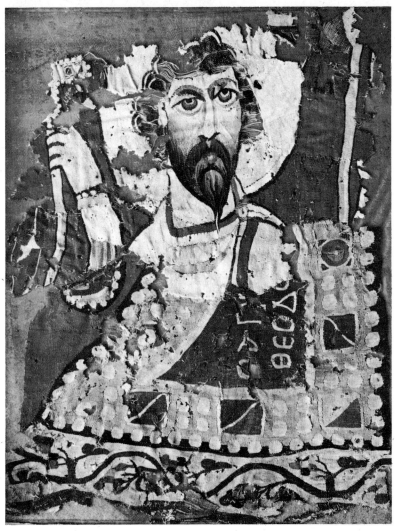

21 Woollen tapestry, representing St Theodore. The rendering is closely akin to that of the painted panels in the Sinai Monastery, and heralds the development of the full Byzantine style

The motifs of decoration of the woven textiles were at first all on a small scale and often depicted symbols of ancient Egypt, like the Ankh, or of Christianity, like the fish or the peacock. Then individual figures or subjects of the Christian story became popular, as on a fine stuff bearing St Theodore in the Rockefeller Collection (*Ill. 21*),

rendered in a style like that of some of the later Egyptian mummy portraits. Then, as time went on, a new repertory was introduced from Syria, comprising animals and birds in roundels, or confronted horsemen, all ultimately of Persian origin. Often it is very difficult to be sure where panels bearing such motifs were woven, for the same motifs were used in Syria, in the Byzantine world, and in Persia alike. A silk showing a griffin attacking a bull (*Ill. 22*), from a tomb in the Church of St Ursula at Cologne, is typical. In general, however, decorated Egyptian textiles, whether in silk or in less precious materials, were on a small scale, and were used for adorning larger stuffs which were quite plain. It does not seem likely that the large-scale figured textiles like that with the Annunciation and Nativity in roundels in the Vatican or the Samson silk in the Victoria and Albert Museum (cf. p. 75) were ever made there. But even if they were not monumental or magnificent, the Egyptian textiles made in the sixth and seventh centuries for Christian patrons were often of real artistic quality. After the Islamic Conquest the output of decorated stuffs in general and of silks in particular was reserved for Moslem patrons, and a new repertory of patterns was developed in which the *kufic* or *naksh* script played a dominating rôle; the weavers were however in many cases Christians even if their products are not to be included in the story of Christian art.

The rôle of Antioch was very similar to that of Alexandria in early times, but art there was on the whole less conservative and the Hellenistic manner died earlier, to give place to the more forceful style of Syria, which, as we have seen, also penetrated into Egypt. Indeed, the orientalizing style of Syria was a good deal more important even before the sixth century than the Hellenistic manner of Antioch itself. This orientalizing style was to the fore in some famous paintings discovered just after the First World War at Dura, on the Euphrates, which Breasted described as 'oriental forerunners of Byzantine art'. They dated from A.D. 85. By the third century oriental influences were again making themselves felt in wall-paintings in a synagogue and a church subsequently discovered at the same place, though here the subject-matter was drawn from the Old Testament, whereas in the work of A.D. 85 it was pagan. There

32

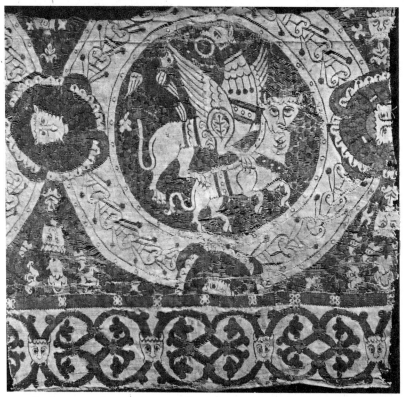

22 Silk, bearing a design of a winged griffin attacking a bull, in medallions. It was probably made in Egypt, but, like many of the surviving silks, was used in a western grave to wrap the bones of a saint or much-revered ruler or bishop

is reason to believe that the oriental style had by that time become dominant in the whole region, and the mosaic floors of Antioch—a whole series of them dating from the third to the sixth century has been unearthed—show a gradual intrusion of oriental elements which eventually became almost as important as the Hellenistic ones that were to the fore in the earliest of them. These early floors are hardly to be distinguished from those of North Africa or other parts of the world where the Hellenistic style was to the fore; the later ones are more like Persian carpets and the motifs stem from the East. Most notable in this respect is the border of rams' heads rising from

Sassanian double wings that surrounds the lovely Phoenix mosaic of about A.D. 500 now in the Louvre (*Ill. 23*), or the ribbons which fly out from behind the neck of an otherwise ferocious lion in a pavement which dates from just before the middle of the fifth century (*Ill. 24*); they recall the ribbons which were so popular in Sassanian art and which invariably adorned the mounted figures of Sassanian kings.

The distinctive character of Syrian art was not due only to the influence of the East, introduced along the great trade routes up the Euphrates or across the desert from Iraq, Persia, Central Asia, and even perhaps China. The locality itself also had a rôle to play, for Syria and Palestine had for long been the home of a way of thought

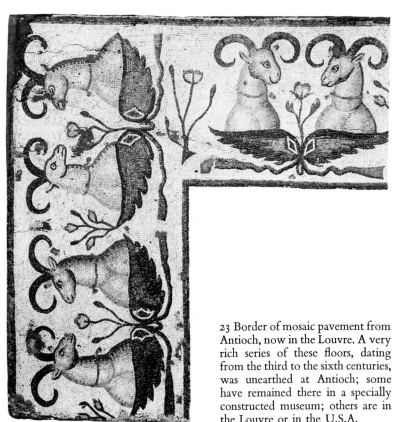

23 Border of mosaic pavement from Antioch, now in the Louvre. A very rich series of these floors, dating from the third to the sixth centuries, was unearthed at Antioch; some have remained there in a specially constructed museum; others are in the Louvre or in the U.S.A.

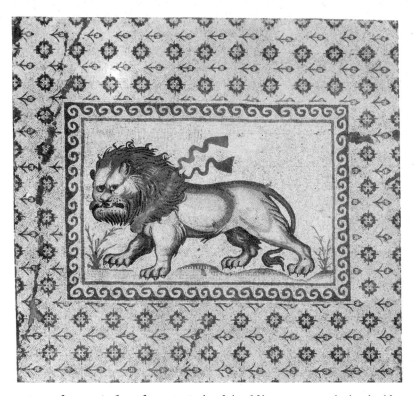

24 Part of a mosaic floor from Antioch of the fifth century. Both the double-winged motif on the previous plate and that of ribbons flowing out from the lion's neck are of Persian origin

that laid stress on the inner significance rather than the superficial aspect, and had been responsible for the development even before the Christian era of a style which may best be defined by borrowing the modern term 'expressionist'. Developments in Syria and Palestine were thus effected in two distinct ways, firstly by a stressing of the 'inner' significance of a work of art, and secondly by the intrusion of new ideas from the East, to be seen in the adoption of oriental conventions, like the full-face pose, or of Eastern motifs like the Sassanian ribbons or the confronted birds and animals with the *hom* or Tree of Life between them. Sometimes the effects were superficial and obvious, as on the Antioch floors. Sometimes they were more subtle and profound, as for example on certain ivory

25 The Ascension, from the Rabbula Gospels. The style is eastern, as are certain iconographic details, like the long robe worn by Christ in the Crucifixion scene

carvings with Christian themes, like one bearing the Adoration above and the Nativity below, in the British Museum (*Ill. 27*). There is another, closely similar, but perhaps rather later in date, in the John Rylands Library at Manchester; both were probably carved in Palestine. The frontal poses, the staring eyes, the vertical perspective, where events in the background are placed above those in the foreground, the exaggeration in size of the more important figures and the love of a rhythmic rather than a naturalistic arrangement, are all elements that belong to the orientalizing style of Syria. They become particularly apparent if these ivories are compared with a pyxis of the fifth century now at Berlin (*Ill. 28*), which is usually assigned to Antioch and which illustrates the more refined style

26 *Above*, the Crucifixion; *below*, the empty tomb and appearance of Christ after death. Illuminations from the Gospels of Rabbula, written at Zagba in eastern Syria in 586

predominant in the great cities. Hellenistic elements such as naturalism, high relief, and dignity of pose are still to the fore here, but the gestures are perhaps more dramatic, the faces more expressive than in contemporary Alexandrine work.

The style of the more Eastern, more primitive, ivories is paralleled in the illustrations of a very important manuscript, the Rabbula Gospels, which was written and illuminated at a place called Zagba in eastern Syria in 586. It is now in the Laurentian Library at Florence. The text is in Syriac, the illustrations, though the themes are those of contemporary Byzantine art, are Eastern both in style and iconography. Two principal artists are to be distinguished; the more masterly of the two was responsible for the Ascension (*Ill. 25*),

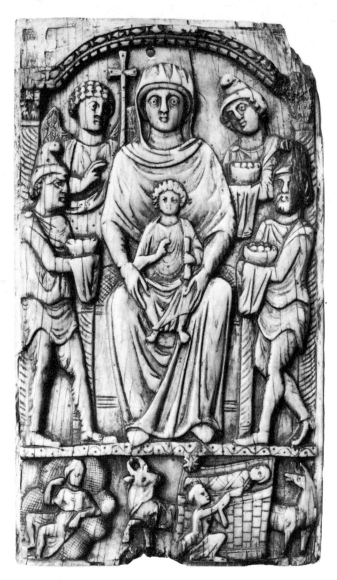

27 Ivory panel in the British Museum, sixth century. Above is the
Adoration, with an archangel holding a cross and the three Magi
in Phrygian caps. Below is the Nativity. In accordance with
eastern tradition, the more important figures are the largest

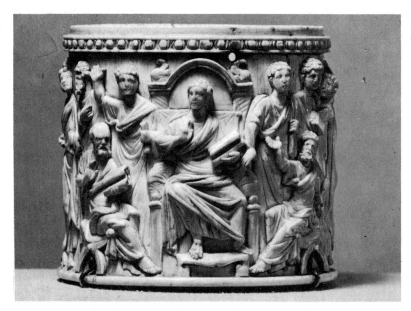

28 Ivory pyxis, in Berlin. The work is much more elegant and accomplished than is the case with the ivory on the opposite page. It must have been carved in a highly civilized centre such as Antioch

perhaps the finest scene in the book. This scene, the Giving of Tongues, the Crucifixion (*Ill. 26*), Christ Enthroned, and the Calendar tables all occupy full pages; numerous other scenes from the Gospels are shown in the margins of the Canon tables in a more summary manner. The inclusion of scenes in this way, the bright colours and the expressive movements, all attest the Eastern provenance, as do such iconographical features as the *colobium* or long robe worn by Christ in the Crucifixion scene—it is quite distinct from the short loin-cloth which was usual in the Byzantine world—or the inclusion in the same scene of the figures of Longinus and Stephaton, one with the lance and the other with the sponge on a reed, on either side of the Cross; they rarely appear in Early Byzantine renderings of the scene.

The same disposition with regard to the Crucifixion appears again on the top of a small painted reliquary from the treasure of the Cappella Sancta Sanctorum of the Lateran, now in the Vatican

29 Cover of wooden reliquary showing the Resurrection, the Ascension, the Crucifixion, the Nativity and the Baptism. The unusual order of the scenes probably has reference to the order in which the shrines associated with them were visited

(*Ill. 29*). The Crucifixion here occupies the centre, with the Maries at the Sepulchre and the Ascension above and the Nativity and the Baptism below. The reliquary must have been painted in Palestine and was probably brought back by a pilgrim; the unusual order in which the scenes are shown probably refers to the succession in which the shrines associated with them were visited by the pilgrim. The style is fairly close to that of the Rabbula Gospels and the reliquary is to be assigned to much the same date. An icon representing the Ascension (*Ill. 30*) which is preserved among the treasures of the monastery on Mount Sinai is in the same style and is also to be regarded as a Syrian work of the later sixth or early seventh century.

Of all the works of Syrian origin, however, the most numerous are the metal flasks to contain sacred oil or perhaps water from the River Jordan. A large collection is preserved in the Abbey of Monza in Italy (*Ill. 32*), where they were brought by pilgrims from the Holy Land. Like the painted reliquary in the Vatican, they were

30 Icon, the Ascension. In the Monastery of St Catherine, Mount Sinai. The icon was probably painted on Mount Sinai, but the style is closely akin to that of the illuminations of the Rabbula Gospels (*Ills. 25 and 26*)

decorated with scenes connected with localities frequented by Christ during His life on earth. The decorations are in low relief and of a rather primitive character. In the Crucifixion scene Christ wears the *colobium*, as he does on a rather unusual silver dish of the seventh century, now in the Hermitage Museum (*Ill. 31*), which is also to be assigned to Palestine or Syria, though it is rather more primitive and stylized than are the illuminations of the Rabbula Gospels. Its decoration is made up of three medallions; the Crucifixion is to the left, while to the right are the Maries at the Sepulchre, and at the top the Ascension.

The style of the Rabbula Gospels, or of some closely related manuscript, inspired a great deal of subsequent work done in the East, not only in association with Syriac texts, but also with those in Armenian. Indeed, some pages bound up at the end of a copy of the Gospels formerly preserved at Etchmiadzin and now in the library at Erevan are perhaps to be regarded as Syrian works of the sixth

41

century, while the rest of the illustrations in the manuscript, especially the Canon tables, are close in style to those of the Rabbula Gospels, though they date from 989 (cf. pp. 36, 37). Armenian manuscript illustration, which was developed so actively from the ninth century onwards, in fact owed an outstanding debt to Syria; it will be considered below, as examples are numerous and constitute a distinct school. A few Syriac manuscripts may however be mentioned here, even if some of them are a good deal later in date, for they represent the direct successors of the Rabbula manuscript. Most important is one in the Bibliothèque Nationale (Syr. 33), for part of it is to be assigned to the sixth century. It is by no means as elaborate as the Rabbula Gospels, but the individual figures in the margins are very well done; the man who painted them was working in a style a good deal closer to some classical source than that of either of the illuminators of the Rabbula manuscript.

A manuscript in the Vatican (Vat. Syr. 559) is larger and more elaborate and contains illuminations which are more oriental; it is dated in a colophon to 1219 or 1220, and at least two painters can be distinguished. At best the work is vigorous and alive, as for instance in the Marriage at Cana (*Ill. 34*), which is both spiritual and spirited. Sometimes the backgrounds are made up of an elaborate scheme; sometimes they are almost non-existent, but the colours are always rich, while the architectural frames of the Canon tables seem also to follow the Rabbula Gospels closely. Their prototype was however probably not the Rabbula manuscript, but another Syriac manuscript which is now lost, and this was also followed by some miniatures in a manuscript in the British Museum, which is dated to between 1216 and 1220 (Add. 7170). Here again several hands are to be distinguished, and some of the miniatures are closely related to more or less contemporary paintings by Moslem artists of the so-called Mesopotamian school. The scenes are all very full with a great

31 (*above*) Silver dish, of Palestinian workmanship, bearing very stylized renderings of the Ascension, the Resurrection, shown as the empty tomb, and the Crucifixion

32 (*below*) Pilgrim flask from Monza, bearing the Ascension. These flasks were made in Palestine and taken home by pilgrims, filled with holy oil or Jordan water

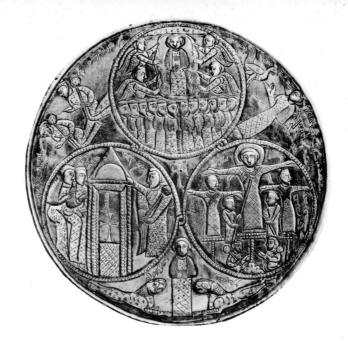

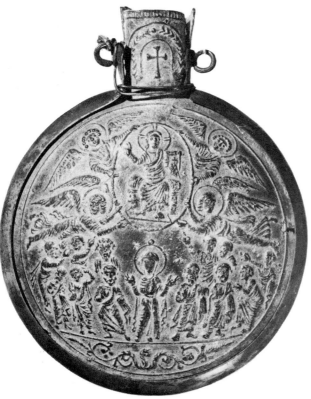

many subsidiary figures, as can be seen in the Nativity (*Ill. 33*). The Angels are like those in Islamic manuscripts of a rather later date, as are the crowns of the Magi, but the odd angular figure of the Virgin, the Child and the animals, and the scene of the Washing of the Baby in the foreground are all very expressive. The paintings of this manuscript—there are a very large number of them—may be somewhat crude, but in their way they are by no means lacking in distinction. Indeed, though nearly all the Syriac manuscripts that survive were done under Islamic domination, they constitute a by no means insignificant chapter in the story of East Christian art, and though practically nothing has survived, it would seem that wall-paintings were once important also. But the study of such things is a very specialized one, as compared to that of the art of the Byzantine capital, which constitutes one of the great styles of the medieval world, and before examining the continuation of art in Asia, we must return for a time to Constantinople and trace the developments which were taking place there while Alexandria and Antioch were still the great centres of Christian art and thought in the East.

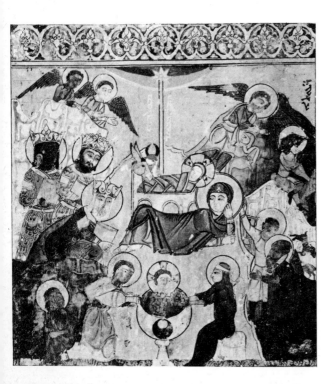

33 (*left*) The Nativity in a Syriac manuscript dated about 1216 in the British Museum

34 (*right*) Miniature showing the Marriage Feast of Cana from a Syriac manuscript dated to c. 1220 in the Vatican. Both were painted in the region of Mosul, and the style is close to contemporary Islamic painting

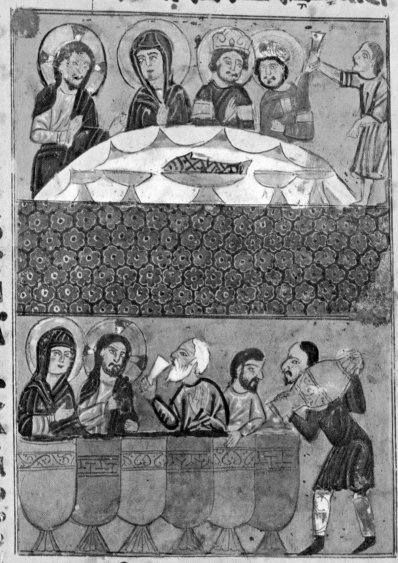

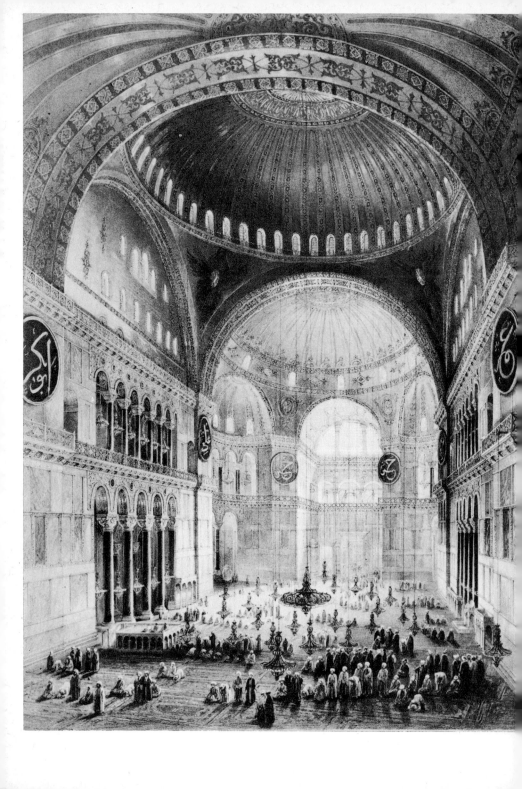

The Art of Constantinople 550–1204

Though work of real quality was produced at Antioch and Alexandria and though much that was of definite aesthetic interest stemmed from the regions of which they were the centres, there is no doubt but that Constantinople was the most important centre of art production, for it was there that Imperial patronage was exercised, there that the Court was situated, and there that the most important and influential section of the Church had its home. The city had become, under Justinian (527–65), the capital of a vast Empire stretching from Spain to Syria, and no greater or more enlightened patron of art than Justinian has ever lived. It must suffice here to mention the names of such churches as St Eirene, SS Sergius and Bacchus, the Holy Apostles, or Sancta Sophia, for which he was responsible in the capital, of S. Vitale or S. Apollinare in Classe at Ravenna, or of foundations in Jerusalem and Bethlehem in the Holy Land or of buildings at Ephesus, Mount Sinai, and many other places, to give an idea of the vastness of the rôle he played. The works themselves will be dealt with in another volume of this series; space only permits that one, Sancta Sophia, the most glorious of them all, may be illustrated here (*Ills. 35, 36*).

Though some of the territory of Justinian's great Empire, notably Northern and Central Italy, was to fall away soon after his death, the importance of the capital as a centre of art and culture was in no way impaired, and even if the emperors who followed Justinian were not always great rulers, recent research has shown that a large number of works of art of real distinction are to be assigned to the years

35 The interior of Sancta Sophia, Constantinople. The plate is taken from an engraving done for the Italian architect Fossati about 1850. It gives a better idea of the building's scale than any modern photograph

47

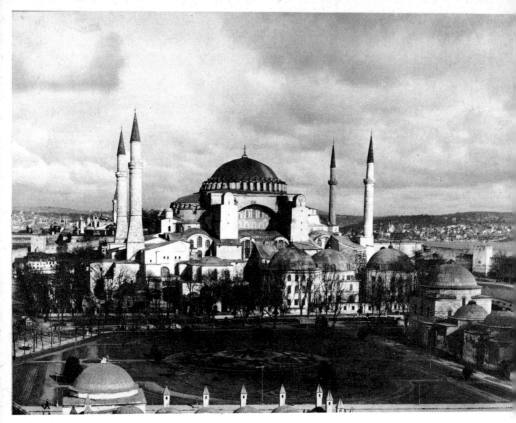

36 Justinian's Cathedral of Sancta Sophia, Constantinople. The four minarets and most of the domed buildings in the foreground are Turkish additions and somewhat obscure the building's true proportions

between 565 when Justinian died and 726, when a ban on the depiction of the saintly or divine form in art was imposed during the age that we know as the Iconoclast (726–843). Some of these works can be associated with Constantinople on the basis of direct evidence, such as inscriptions or written records. Others can be assigned to the city on the grounds of their style, for a new and wholly metropolitan manner was developed under Justinian and the products of Constantinople excelled in quality even the finest of those from Alexandria or Antioch in the same way that the paintings of the school of Paris in the later nineteenth century stood in advance

of the work of contemporary painters elsewhere. Diehl once called Constantinople the Paris of the Middle Ages, but it was really as early as around the year 500 that this ascendancy began, though it was only after the Moslem conquest of Syria and Egypt in the seventh century and the decline of Italy somewhat earlier that all potential rivals were eliminated. The West began to rise again around 800, thanks to the genius of Charlemagne, but it was not really till the eleventh century that a wholly new, original, and progressive artistic style was born there, which we know as the Romanesque.

What is so especially striking about Justinian's patronage is its universal character, for it is not only the great works—buildings, religious or secular, mosaic decorations, and so on—that bear the stamp of his munificence and taste, but also the small ones and those of all materials, ivory or metal, marble or simple limestone. The superb ivories which his artists carved seem to reflect the character of his age in the way in which the old motifs of classical art were treated; the approach is new, more imaginative, pays less attention to realism, and allows greater play to imagination. A lovely ivory of the Archangel Michael in the British Museum (*Ill. 37*) illustrates this, for the figure wears classical robes and is shown in a niche of classical character, but his feet hover above the steps, for which, being an Angel, he has no material need. At the same time the figure is grand, majestic, imperial.

Justinian's mosaicists also set up superb compositions of the greatest grandeur, wherein the figures were sometimes modelled on pagan prototypes, though the rendering and conception was again wholly new. Thus the Christ in the apse of S. Vitale at Ravenna resembles the youthful Apollo, though the Angels in the same scene are formal and severe; we can already trace here the interest in rhythmical composition that was to distinguish Byzantine art, and this idea is carried farther in the friezes of Saints who march in procession up either side of the aisle of S. Apollinare Nuovo at Ravenna (*Ill. 38*). His jewellers and metal-workers again, though often depicting themes of classical legend, had divorced the figures from their backgrounds, so that they stood isolated, silhouetted

37 Ivory—the Archangel Michael. This leaf must originally have constituted one half of a diptych, but the other leaf has perished. It is in the British Museum and is undoubtedly one of the finest pieces of minor sculpture surviving from early Christian times

38 Procession of female saints, set up about 561 as part of the mosaic decoration of the Church of S. Apollinare Nuovo at Ravenna. The Procession moves from a depiction of the city of Classis to an enthroned figure of the Virgin, and is headed by the three Magi

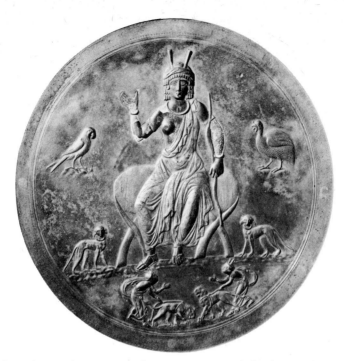

39 Silver plate in the Museum of Antiquities at Istanbul. The seated figure is a personification of India. The head dress with two horn-like protuberances is always associated with that country in early Byzantine art

against space, in a manner quite foreign to classical conceptions. This can be seen in a silver plate in the Istanbul Museum, depicting the personification of India (*Ill. 39*); they combine the grandeur and magnificence of classical art with a style that is new, interpretational, and imaginative. The same mannerism was adopted by the men who laid the mosaic floor of a court of the Great Palace at Constantinople (*Ill. 40*) which was in all probability commissioned during Justinian's reign. The figures themselves are in some cases so classical that on their evidence alone one would be tempted to assign the floor to a date almost two centuries earlier, but the disposition savours of medievalism, in the way the scenes are isolated and the manner in which each figure is silhouetted against a plain background; this impression of medievalism is borne out by a portrait-head in the border which would seem to depict some Gothic chieftain of the Dark Ages (*Ill. 41*).

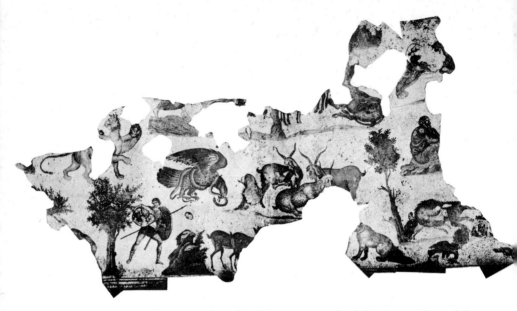

40 Portion of a mosaic floor found in a courtyard of the Great Palace of the Byzantine Emperors at Constantinople. It is probably to be dated around the middle of the sixth century

At the same time the Emperor's sculptors had conceived a system of architectural decoration that paid even less attention to the old motifs, for the cornices and capitals in Sancta Sophia or in the slightly earlier Church of SS Sergius and Bacchus have again discarded a purely naturalistic treatment in favour of an abstract one, and even if leaves form the basis of the design, it is the patterns that they make rather than their resemblance to nature that is important. This is clear if we look at the capitals and cornices of the Church of SS Sergius and Bacchus at Constantinople (*Ill. 42*) which was one of the first churches that Justinian built; though smaller than some of the others it was in many ways one of the finest.

Never for many centuries had art seen so many changes in so short a time as during the first half of the sixth century, for the innovations of the fifth century were of a minor character in contrast to those brought to fruition under Justinian. Nor were the changes only stylistic ones representing inevitable development. Rather they

41 Head, forming part of the border of the mosaic floor of the Great Palace. The head is enclosed in scroll work and is so far stylized; otherwise it is strikingly naturalistic and might be taken as the portrait of some Gothic chieftain vanquished by the Byzantine Emperor

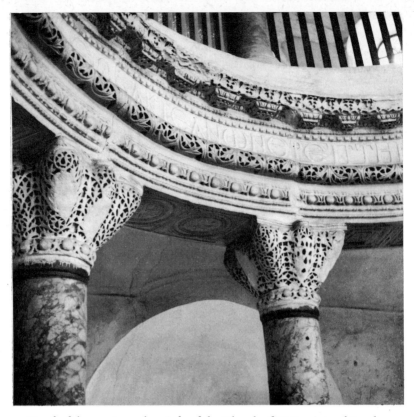

42 Detail of the cornice and capitals of the Church of SS Sergius and Bacchus at Constantinople. It was one of the first churches erected under Justinian's patronage between 527 and 536

heralded the conception of a wholly new outlook and the beginning, in religious art in any case, of a new iconographical system which was to receive the approval of the Church and continue with little change, in spite of Iconoclasm in the seventh and eighth centuries, until the end of Byzantine culture. This can be clearly seen in one of the earliest copies of the Gospels that have come down to us, the Purple Codex now preserved at Rossano. It was probably executed in western Asia Minor, or perhaps even in Constantinople itself, in the sixth century. The figures are there silhouetted against the background in the same way as in the mosaic floor of the Great Palace. The scene of the Entry into Jerusalem (*Ill. 45*), for example, shows this; it sets a model which was followed in numerous subsequent

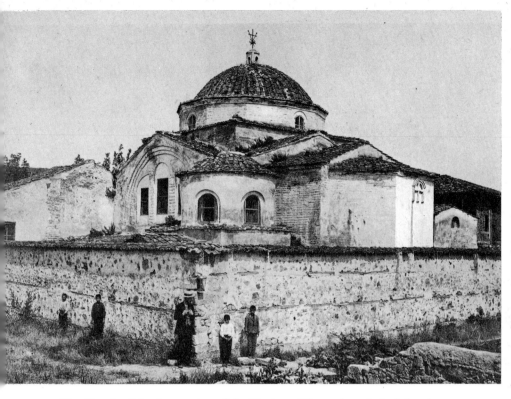

43 The Church of the Assumption of the Virgin at Nicaea, the principal church in the city which gave its name to the Nicene Creed. It was destroyed about 1922 during the Graeco-Turkish war; it had contained very fine mosaics

renderings of the theme from then onwards till the thirteenth or fourteenth century.

It is however in the great Cathedral Church of Sancta Sophia that these changes and innovations can best be appreciated. It was there that the dome was exploited to the fullest possible degree (*Ill. 44*), and there that the ideas behind the new architecture were most brilliantly developed. Experiments in the elaboration of the dome and its use as a roof for buildings of square, rectangular, or cruciform plan, had been going on for many years, both in the East and West, but it was thanks to Justinian's architects that what were really only tentative schemes were transformed into established styles, and thanks to the buildings they erected—Sancta Sophia, foremost

among them—that the domical style was thenceforth adopted well-nigh universally throughout the Byzantine world. True, nothing as vast, nothing as elaborate, nothing as inspiring as Sancta Sophia was ever attempted again, but churches like that of the Assumption of the Virgin at Nicaea of the eighth century (*Ill. 43*), now destroyed, or Daphni near Athens at the end of the eleventh, illustrate the development of the domical style and attest the immensity of the debt owed to the Justinianic prototypes.

Perhaps the greatest of the innovations that characterized Sancta Sophia was the conception of the building as an interior—in contrast with a classical temple like the Parthenon or even a basilica like the old St Peter's or Santa Maria Maggiore at Rome. The exterior is impressive, no doubt, but it is the interior that is Sancta Sophia's real glory; there worldly thoughts are lost sight of and the soul is, as it were, wafted to the skies above. As with Christian teaching, it is the inner life that is of real importance, not the outward façade, and the whole decoration of the interior of the building was conceived to support this idea. The capitals and cornices, the marble revetments and polychrome friezes survive and convey something of the former

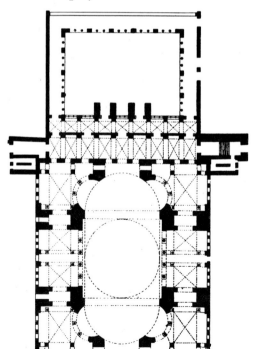

44 Plan of the Church of Sancta Sophia at Constantinople. The columned forecourt no longer exists, but the church stands, as one of the most original and superb examples of Christian architecture that have come down to us

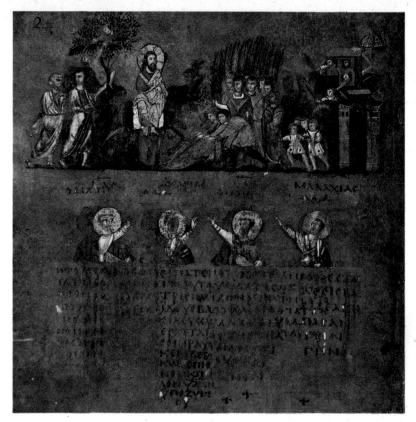

45 The entry into Jerusalem, one of the miniatures of a great gospel book of the sixth century known as the Rossano Codex. It is one of the earliest examples we have of the fully fledged Byzantine style in art

grandeur. The mosaics that are now to be seen are all of later date; the other details, silver iconostasis, silk hangings, ornaments on the altar, and so forth, have all perished, and the former glories can only be reconstituted in the imagination.

One of the most interesting features of Sancta Sophia was its plan (*Ill. 44*), or rather the way in which the plan was blended with the superstructure. Thus the idea of the old three-aisled basilica was retained on plan, but the monotonous rows of columns were varied by the inclusion of built piers and these served to support the dome above. The dome itself was supported on pendentives, but this means of transition from the square below to the circle above,

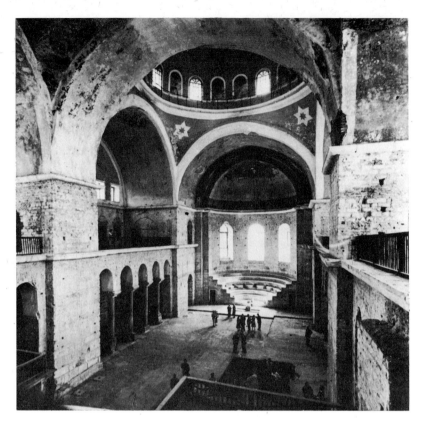

46 Plan, elevation and interior view of the Church of St Eirene at Constantinople, set up under Justinian's patronage in 532. On the ground the three-aisled basilical plan has been retained; above there are two domes in echelon. The cross in mosaic at the eastern end dates from Iconoclast times

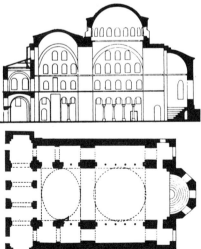

though the most satisfactory architecturally, was not universally adopted, and another form of transition, the squinch, a sort of arch built across the corner of the square, continued in use even after the twelfth century. The basis of the plan was thus dual—a longitudinal one akin to that of the basilica which had been so popular in Rome; and a centralized one in the form of a square roofed by a dome. The first was limited, expansion being possible only in one direction, that of length; the second offered numerous possibilities, in that all four sides of the square could be expanded with equal ease. It made possible the erection of churches with two, three, or even more domes on the arms of the cross, as for example in St Eirene at Constantinople (*Ill. 46*) where there was space for two domes in echelon or in Justinian's Church of the Holy Apostles, where there were five domes, one on each arm of the cross, and one at the crossing. In another of his churches, that of St John at Ephesus (*Ill. 47*), there was an additional dome on the nave, making six in all. But on the whole later developments were on a small scale and the aim was to achieve intimacy rather than grandeur. The plans tended to greater complexity as subsidiary chapels were added, and the domes tended to become small, tower-like projections, as in the Church of the Holy Apostles at Salonika of the early fourteenth century (cf. *Ills. 229, 232*).

47 Plan of Justinian's Church of St John at Ephesus. It follows the cruciform disposition first employed in the Church of the Holy Apostles at Constantinople

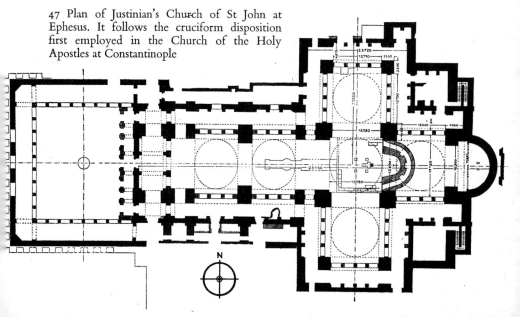

But throughout the blending of the idea of the three-aisled longitudinal church with that of the cross continued, and most of the buildings set up after the seventh century belonged to what is usually known as the inscribed-cross type; outside they appear as rectangular structures, but within the piers or pillars that support the dome produce the effect of a cross and this is usually accentuated by the carrying up to a greater height of the roofs of the central aisle and the transept, so that the form of the cross is also apparent on the roof.

There appears to have been but little building for some years after Justinian's death; resources and energies had been exhausted, and the position must have been rather like that in France at the end of the thirteenth century, when the wave of enthusiasm that had inspired the great Gothic cathedrals—Reims, Amiens, Beauvais, and the rest —was extinguished. But the years that separated Justinian's reign— the First Golden Age of Byzantine art, it has been called—from the Second Golden Age, which dawned towards the end of the ninth century, were not quite as barren as has sometimes been supposed.

Not a few pieces of sculpture, capitals, closure slabs, and so on, that are preserved in churches or have been dug up in excavations, are to be dated to the later sixth and seventh centuries. Many of them

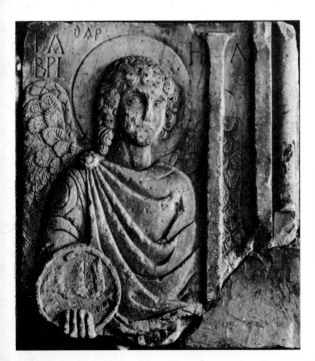

48 Marble relief of the Archangel Gabriel. It is now in the Museum at Adalia, but is of Proconnesian marble, and the accomplished nature of the carving suggests that it should be assigned to a workshop either there or at Constantinople itself

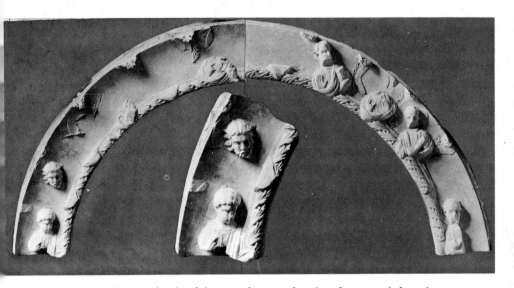

49 This arch, bearing heads of the Apostles, was found in fragments below the floor of a church usually known as St Mary Panachrantos at Constantinople. The date of the arch is not certain, but the sixth century seems likely

bear floral or geometric designs, but figures were not unusual. A very lovely slab at Adalia thus bears the Archangel Gabriel (*Ill. 48*); the work is so finished and delicate that it is tempting to assign it to Constantinople, or perhaps it was done in the Marmara Islands, where the quarries were situated. More elaborate are the fragments of an arch (*Ill. 49*) which were unearthed in 1928 in the northernmost of the two buildings which form the Church of St Mary Panachrantos in Constantinople. It bears busts of the Apostles, set radially, and probably served as a ciborium or canopy to the altar; it was apparently broken up and used to raise the floor when the church became a mosque in 1496. The church in which it was discovered was founded by a certain Constantine Lips in 908; but it took the place of an earlier one of the sixth century, and there has been some discussion as to whether the arch should be assigned to around 908 or whether it was not, more probably, a part of the sixth-century edifice. Both dates are possible, for there was a

61

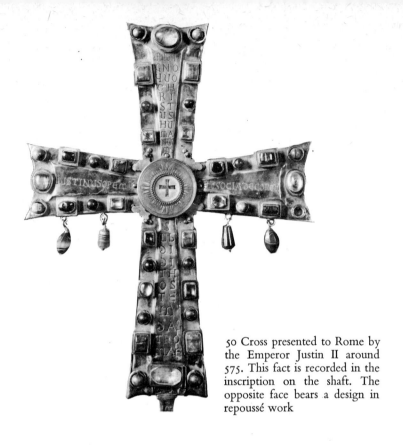

50 Cross presented to Rome by the Emperor Justin II around 575. This fact is recorded in the inscription on the shaft. The opposite face bears a design in repoussé work

vigorous revival of figural work after the end of Iconoclasm in 843; but the style in which the faces are carved, more especially the way that the eyebrows and nose are treated as a continuous line running from one side of the face to the other, is paralleled in sculptures of the sixth century and a date somewhere around 600 seems most likely.

Justinian's successor Justin II (565–78) seems to have been quite an active patron of the arts. Some of the mosaics recently uncovered by the Byzantine Institute of America in Sancta Sophia have been associated with repairs which were done at his orders, and the records tell that he sent quite a number of things as presents overseas. One was an enamelled shrine to hold a reliquary which was given to a convent in Poitiers: another was a fine silver cross with decoration in relief, which was presented to the Pope (*Ill. 50*); it still

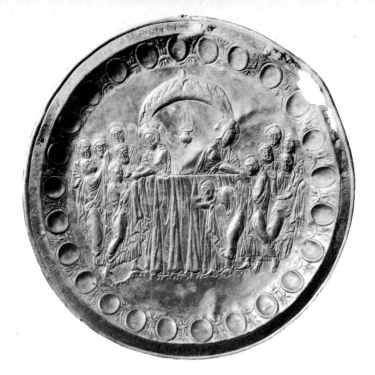

51 Silver paten bearing the Communion of the Apostles. Christ appears twice, on one side giving the bread, on the other the wine. On the reverse are stamps which fix the date of the paten between 565 and 578

survives in the Vatican though it has been a good deal restored. The parts that are to be considered original are on the coarse side, and the same is true of two silver patens representing the Communion of the Apostles (*Ill. 51*) which can be dated to this reign on the basis of the control-stamps—akin to Western hall-marks—that they bear. One is at the Archaeological Museum in Istanbul, the other in Washington. The style of their decoration suggests that the man who made them must have been trained in Syria, but the control-stamps prove that he was actually employed in the Imperial workshops of the capital at the time.

There are quite a number of other pieces of silver that can be assigned on the basis of the control-stamps to other reigns in the latter part of the sixth or the earlier seventh century. Some bear religious subjects, like a series of dishes with scenes from the life of

52 Mosaic panel showing St Demetrius and two children, in the Church of St Demetrius, Salonika. Unlike the mosaics of most churches, those of St Demetrius at Salonika are concerned entirely with representations of the Saint, more often than not with suppliants before him

David found in Cyprus (*Ill. 54*); they are now divided between the Museum in Nicosia, the British Museum, the Metropolitan Museum in New York, and the Pierpont Morgan Collection. One of the finest shows the Marriage of David. Nearly all bear the control-stamps of Heraclius (610–29). Others have formal designs of Christian character, such as crosses, while on others myths or scenes from classical literature are portrayed, such as the meeting between Meleager and Atalanta (*Ill. 55*). The whole style of these designs is antique and they indicate the conservatism of much of the art. The majority of these silver dishes have been found in Russia and are today preserved in the Hermitage Museum at Leningrad; they must have been sent to Russia either as bribes to keep the barbarian tribes from crossing the frontiers of the Byzantine Empire, or in the process of trade, in exchange for goods such as furs, or even slaves. They belong to various dates, but none would seem to be later than the middle of the seventh century. Similar silver dishes have also been found in the West, and the remarkable find at Sutton Hoo in East Anglia included vessels that were probably of Byzantine manufacture.

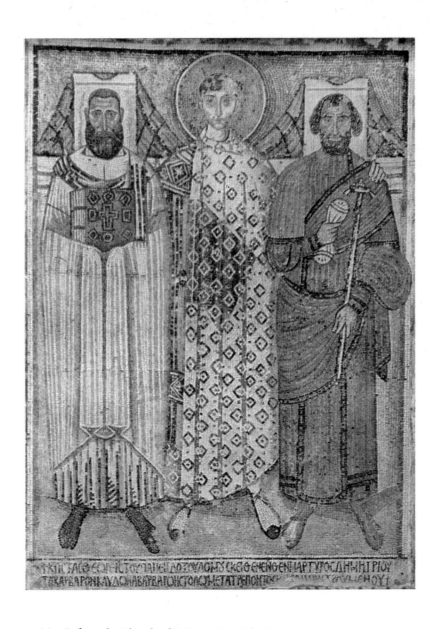

53 Mosaic from the Church of St Demetrius, Salonika depicting the Saint between Bishop John, who restored the building around 634, and Leontius, who was responsible for its original foundation

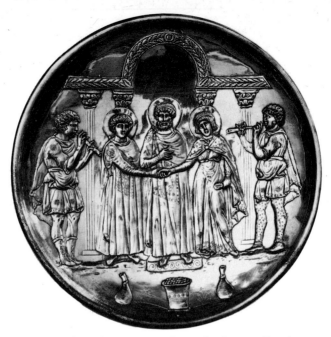

54 Silver plate; the Marriage of David. This was found, together with a number of other plates, some depicting scenes from David's life, at Kyrenia in Cyprus in 1902

The most important works on a large scale that belong to the seventh century however are the mosaics in the Church at St Demetrius in Salonika. The church was founded in the fifth century but was almost entirely rebuilt after a fire between 629 and 634, and practically all its mosaics would seem to have been set up between then and the beginnings of Iconoclasm in 726. They do not depict scenes from the Bible story, as would be normal for the decoration of a large church; indeed nearly all represent St Demetrius. On the piers on either side of the apse he was shown in association with clerics, and on the walls of the nave he appeared together with donors and suppliants. One of the finest, on the north side of the southern pier in front of the apse, shows the Saint with a cleric on one side and a layman on the other (*Ill. 53*); they are to be identified as Bishop John, who restored the building about 634, after the fire, and the man who founded the church a century earlier, a certain

55 Silver plate, bearing the scene of Meleager and Atalanta. A stamp on the reverse indicates that the plate was made between 613 and 629. It is an interesting instance of the marked conservatism of the classical style

Leontius. The mosaic must date from around 640. The inscription below records also the freeing of Salonika after the Slav attack of 612. Another panel near the apse, where the Saint stands with two children (*Ill. 52*), belongs to much the same date.

The mosaics that decorated the nave walls were mostly destroyed in the second great fire, which severely damaged the building in 1917 and only fragments now remain; they were, however, photographed before their destruction. Here secular figures stand before the Saint, or commend their children to his protection. On one panel he stands in the *orans* position with the petitioner, a woman in a long white cloak, presenting her child to him; in the background is a garden with trees in it (*Ill. 56*). The three-tiered tree like a series of umbrellas is no doubt symbolical and represents the Tree of Life; trees of similar form are common in Indian art, which suggests some ultimate Eastern connexion here. The idea of setting up panels with

56 Detail of a mosaic in the Church of St Demetrius, Salonika; a mother is presenting her son to the saint. Behind is the 'Paradise Garden', a scene derived from Roman prototypes like those at Pompeii

portraits of the donors was however a common practice at Rome, and the square haloes which back the heads of the donors in the other two panels reproduced here also belong to a Roman tradition. The inclusion of the garden here has reference to Paradise as the abode of the righteous dead. The panel is probably to be assigned to the latter part of the seventh century.

No other mosaics of the age survive in the Byzantine world, but there is circumstantial evidence indicating that the Court schools were not idle, for the texts tell us that when the first rulers of Islam were seeking to build and adorn mosques and palaces in Syria, where their earliest capital was established, they turned to the Byzantine Emperor for assistance. Much of the work in the way of building and decoration that they sponsored between 637, when they conquered Jerusalem, and 750, when their capital was transferred to Mesopotamia, was no doubt done by Syrians and owed no debt to Constantinople. But for certain other things the aid of the Byzantine Emperor was sought, and it is safe to say that the mosaics

of the Dome of the Rock at Jerusalem (691–92) and of the Great Mosque at Damascus (c. 715) owe a considerable debt to the Byzantine capital. This is especially the case with regard to the trees (*Ill. 57*), which follow a convention which had been most fully developed in the great pavement-mosaic of the Great Palace of the Emperors at Constantinople, which is in all probability to be dated to the time of Justinian and represents the high-light of secular art of the time. But the mosaicists who worked at Damascus elaborated on the original and produced a series of compositions of extraordinary imaginative power and great delight, where infinite possibilities of exploration seem to be offered in the hill towns and villages that occupy the background behind the trees. The mosaics are especially interesting, for they include no human or animal figures and so serve as a foretaste of the art that was to dominate in the Byzantine world from 726 till 843, when the depiction of the saintly or divine form was prohibited in religious art by Imperial decree.

57 Mosaic in the courtyard of the great Mosque of Damascus, set up under the patronage of the Caliph al Walid in 715, with the aid of Byzantine craftsmen

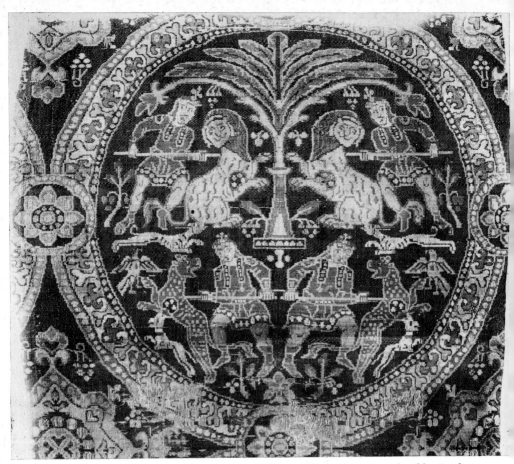

58 A silk textile with a design of medallions enclosing hunters and wild animals. It is typical of a large group of textiles of Oriental inspiration which date from the eighth century

There was a good deal of give and take between the Byzantines and the Arabs at this time, and if elements in the mosaics set up by the Omayyad caliphs came from Byzantium, many of the textiles of the time which were woven in the workshops of Constantinople owed a marked debt to the East. Animals, birds, or riders were thus shown confronted, with a tree—the Eastern *ham*—between them, as on a textile in the Vatican depicting a lion-hunt (*Ill. 58*). Ribbons, like those which bedeck the sculptures of the Sassanian monarchs in Persia—and which we have already encountered in association with

70

a lion on one of the Antioch floors (cf. p. 35)—flow out from
behind the horses or the figures mounted on them, and the rosettes
and other motifs of decoration which fill in the spaces between
the main motifs on the textiles or form the borders are often of
an oriental character. A famous textile at Lyons, showing a mounted
figure, spearing lions, arranged as confronted decorative patterns
in medallions (*Ill. 59*), is one of the best examples of the type.
It is probably to be dated to the ninth century. Its oriental character
is not surprising, for the finest textiles were of silk, and until
Justinian captured the secret of its cultivation from China around
552, all the raw material came from there by way of Persia and
the overland route through Mesopotamia. Much of it was actually
woven in Persia and first Persian and later Syrian silks remained
important even after the Imperial looms had been established in
Constantinople. Indeed, the first textile-workers very probably
came from the East, though later they constituted one of the most
tightly 'closed shops' in the Byzantine world. The nature of the
work they executed was till the end greatly affected by that intense
conservatism and astonishing continuity of tradition which has
been a characteristic of all decorative art throughout the ages.

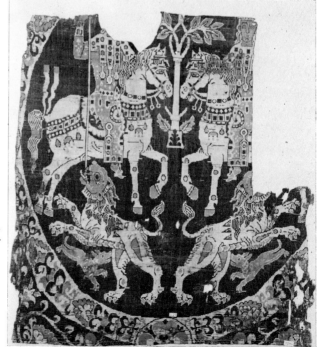

59 Silk textile. Two riders
confronted, spearing lions.
The riders wear imperial
Byzantine costume, but many
of the details, such as the rib-
bons that fly out behind, are
derived from the art of
Sassanian Persia

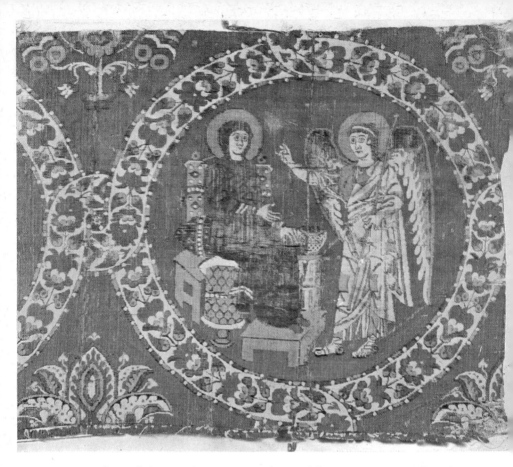

60 Silk textile bearing the Annunciation in medallions. Adjacent medallions bear the scene of the Nativity. It is probably to be dated to the eighth century

Not all the textiles were quite as oriental as those in the Vatican and at Lyons. Some depict Christian subjects which belong to the Hellenistic tradition, like that in the Vatican with the Annunciation and Nativity in medallions (*Ill. 60*), and some reproduce secular scenes like the famous silk depicting a quadriga which was found in the tomb of Charlemagne at Aachen (*Ill. 61*). Here the main design of the four-horse chariot and the subsidiary one below representing boys pouring money from sacks recall those of the consular diptychs of the first quarter of the sixth century, and one would be tempted

to assign the textile to that period were not the plant forms so closely akin to those on other textiles which are certainly to be assigned to the eighth century. Moreover it is hard to believe that an old textile would have been used for the burial of a monarch of Charlemagne's importance. At most one can say that the design was a very conservative one for the time at which it was made. The silver plates indicate the conservative trend of the Byzantines in these matters.

Other textiles of the period show a combination of orientalizing floral rosettes with scenes which stem from the classical repertory, though they have become Christianized with the course of time. One of the most outstanding is a silk now cut up and divided between various collections, which represents a male figure struggling with a lion. In its earliest classical phase it probably depicted Heracles. In the eighth-century silk illustrated here, which is in the Victoria and Albert Museum in London, the figure is no doubt to be identified as Samson, and the textile is one of a group usually known as the Samson silks (*Ill. 62*).

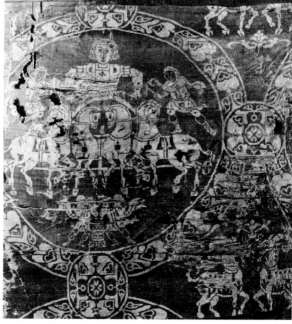

61 Silk textile bearing in medallions the design of a quadriga or four-horse chariot, shown frontally. Below are boys pouring money out of sacks. Because of the similarity of this motif to those on ivories of the fifth century, the textile was at one time assigned to an early date

The year 726 marks a turning-point in the story of Constantino-
politan art, for in that year the Emperor Leo III (717–41) proclaimed
official opposition to the representation of the divine or saintly form
in religious art. The idea was not a new one. Symbols like the fish
or the peacock had been very popular in early times, and monograms
like the chi-rho cross or the letters A and Ω had more than a
decorative or purely literal significance. In Justinian's reign a bishop
had torn down from his church a hanging on which the figure of
Christ was represented, while most of the coins until 726, even if
they bore the Emperor's portrait on the obverse, had a cross and not
the head of Christ on the reverse. Indeed the dangers of idolatry
which had run through the Old Testament almost like a leitmotif
had not been lost sight of, and the very fact that at almost the same
date that Leo issued his decree a strictly aniconic, non-representa-
tional art was being developed in the Islamic world shows how
deep-seated was the belief as to the evils of representation in the Near
East, even if the Greek and Roman love of figural art had been
dominant over it for a good many centuries.

In Constantinople the ban was no more universally welcomed
than were the ideas of the Puritans in England in the seventeenth
century, but in spite of opposition it was at once enforced in all
official art, the old representational decorations were torn down,
and aniconic ones were put in their place. One such decoration still
survives, a simple cross in mosaic in the conch of the main apse of
the Church of St Eirene at Constantinople (cf. p. 58). A similar
cross was set up in Sancta Sophia at Salonika under the patronage
of Archbishop Theophilus between 780 and 797; it was replaced by
the present mosaic of the Virgin in 886, but the arms of the cross can
still be faintly discerned beside the Virgin, as could a similar cross in
the Church of the Assumption at Nicaea before it was destroyed
about 1922.

Crosses on a smaller scale, the corners of their arms often ending
in two balls, or projections, and their stems placed between acanthus
plants which rise up to frame them on either side, were also popular
in Iconoclast times. Two of the leaves of the famous Homilies of
St Gregory Nazianzus in the Bibliothèque Nationale at Paris (Gr.

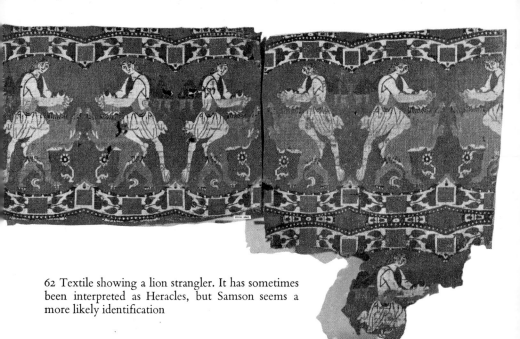

62 Textile showing a lion strangler. It has sometimes been interpreted as Heracles, but Samson seems a more likely identification

510), done for the Emperor Basil I (867–86) soon after the end of Iconoclasm, bear this motif, and it also appears frequently in sculpture. It seems to have come from the Near East, for it was very popular among the Nestorian Christians and was carried by them from Mesopotamia, where the main centre of their Church was situated, to Central Asia, India, and China. The most striking instance is on the stele of Siganfu, set up in China by a Nestorian Emperor in 981.

There were no doubt many other decorations in Constantinople like that in the apse of St Eirene, but nearly all were replaced by figural ones when the Iconoclast ban was lifted. The same was also true of the countryside, for among the famous paintings that adorn the rock-cut chapels of Cappadocia there are some where figural decorations of the eleventh century have fallen away to disclose formal, aniconic ones beneath (cf. pp. 135 ff.). But even here, in Asia Minor, when once the ban was raised, the formal designs were soon replaced by figural paintings representing not only Christ, the Virgin, and the Saints, but also scenes from their lives, drawn sometimes from the Bible and sometimes from less familiar apocryphal

texts. Only perhaps in Mesopotamia was the aniconic style retained' among Christians when once the ban was lifted in the Byzantine Empire in 843.

The style which had been imposed by law for more than a century left however an important legacy behind it, and from that time onward ornament of a formal character played a very important rôle throughout the Orthodox East, while figures and other motifs drawn from Nature became subject to a system of stylization which transformed even the most narrative or figural representations into something approaching abstract compositions. This is true, for instance, of the figures of Archangels—only one now remains—on the vault before the apse of Sancta Sophia in Constantinople, which were probably set up in 867, or of those which confronted one another across the vault in front of the apse in the Church of the Assumption of the Virgin in Nicaea (*Ill. 63*), which was destroyed in 1922. Their faces are wonderfully expressive and of great profound-

63 Mosaic of the Archangels Arche and Dynamis, in the Church of the Assumption at Nicaea. It has been variously dated but recent research has established that the figures must have been redone about 850, after the end of Iconoclasm

64 The Harbaville Triptych in the Louvre. Several similar ivories of the later tenth century survive, but this is undoubtedly the finest of them. The carving is supremely fine and delicate

ness, redolent of the spirit and meaning of the Christian faith, but the figures, set frontally with wings of equal size spread out on either side, are reminiscent of the formal confronted compositions so popular on the textiles. The same rather severe, formal arrangement characterizes many of the lovely ivories of the tenth century that constitute one of the outstanding glories of the art of the great 'Macedonian' Age in Constantinople (843–1056). The lovely Harbaville Triptych in the Louvre is perhaps the finest of them (*Ill. 64*).

65 David composing the Psalms. An illumination from the famous Paris Psalter (Bib. Nat. Gr. 139). A number of classical elements survive, such as the Muse behind David or the personification of the mountain in the foreground

But the art does not all show this tendency towards abstraction. There was, it would seem, a violent counter-wave at the end of Iconoclasm and much that was done in post-Iconoclast times represents a Renaissance in the literal sense of the term—an almost direct copying of what had gone before. The miniatures of the famous Paris Psalter in the Bibliothèque Nationale (Gr. 139), were, for instance, not only copied from an earlier manuscript—as was inevitable when the copyist's duty was to reproduce as exactly as possible the text and the appearance of the prototype—but also sought to

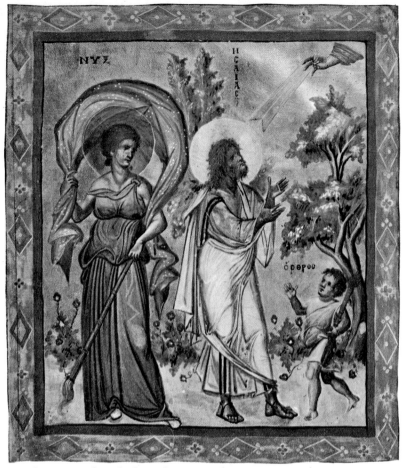

66 The Prayer of Isaiah, from the Paris Psalter. Once more there are numerous survivals from classical iconography, notably, the figure personifying Night, with a shawl over her head

depict the subject-matter in as classical a guise as possible. David as composer of the Psalms is thus almost indistinguishable from Orpheus (*Ill. 65*); classical personifications such as 'Night' (*Ill. 66*) or 'Mountain' are included to represent the phenomena of Nature; the architectural backgrounds are of a type derived from paintings like those in the Roman villas of Pompeii.

The same classical style characterizes some, but by no means all, of the miniatures in another fine manuscript of this age, the Homilies of St Gregory Nazianzus in the Bibliothèque Nationale (Gr. 510)

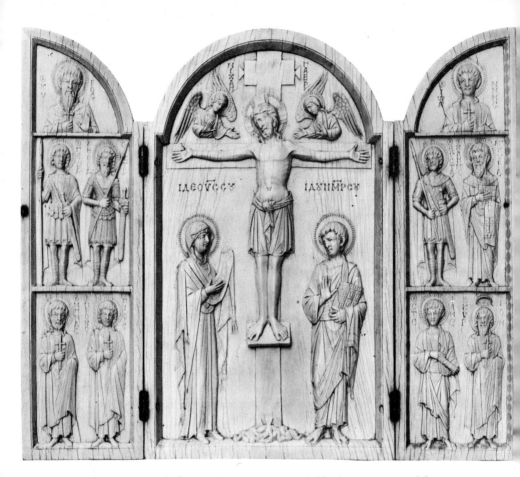

67 Ivory triptych, late tenth century. It is probable that it was carved for Princess Anna, daughter of Romanos II; she married the Emperor Vladimir of Russia in 988. This should be compared with the Harbaville Triptych (*Ill. 64*)

which we noted above because of the Iconoclast nature of the decoration of two of its pages. Ezekiel's vision (*Ill. 69*) may serve as an example, for the Prophet is accompanied by an Angel which directly follows some classical model. But many of the other pages bear illustrations of an essentially narrative character where the classical tendency towards allegory and idealization is absent. They tell the story in a factual, straightforward way and there are sometimes two or even three horizontal bands on a page, each containing

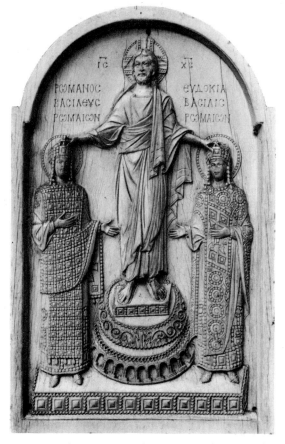

68 Ivory. The crowning of Romanos and Eudoxia by Christ. There has been some discussion as to the identity of the Emperor, for there were four of the name, but it is probably Romanos II who is represented

one or more scenes. The repertory is thus very full, and not only are the more usual events of Our Lord's life, like the Raising of Lazarus or the Entry into Jerusalem, shown (*Ill. 70*), but there are also a number of obscure subjects which are only to be found in a very few other manuscripts.

This narrative style was developed for the illustration of Gospel books and Homilies from that time onwards, but the more selective classical manner continued and seems to have been very important

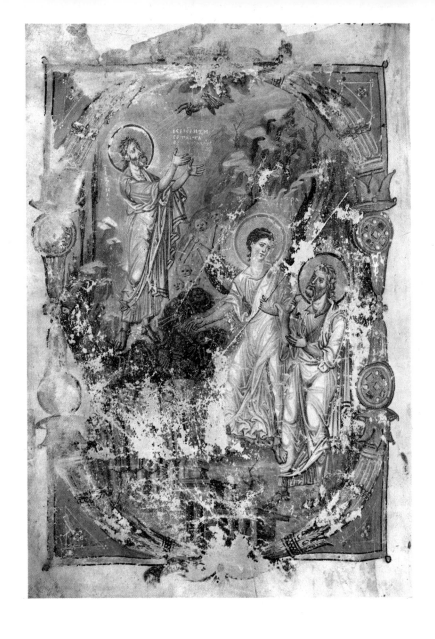

69 The Vision of Ezekiel, from the great manuscript of the Homilies of St Gregory Nazianzus, done for the Emperor Basil I (867–886). The figure of the Angel who leads Ezekiel to the mountain is especially striking

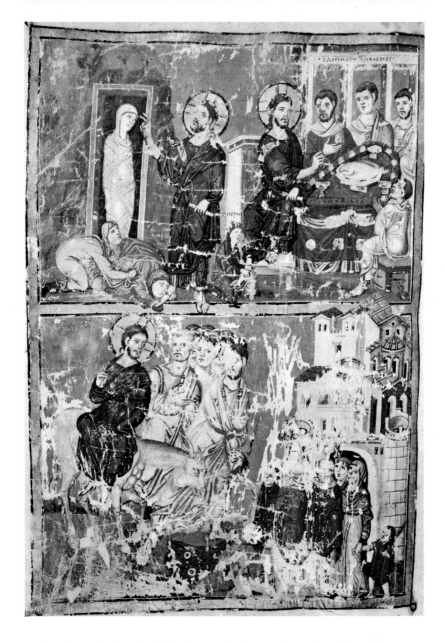

70 Page from the Homilies of St Gregory Nazianzus; above, the Raising of Lazarus, and below, the Entry into Jerusalem. This is perhaps the finest Byzantine manuscript that has come down to us, though many of the pages are in poor condition

83

71 (*left*) Ivory statuette of the Virgin and Child in the Victoria and Albert Museum. It is the only free-standing Byzantine ivory that has survived

72 (*right*) Ivory reliquary framing a fragment of the True Cross. It bears on the reverse an inscription associating it with the Emperor Nicephorus Phocas. The metal-work above the wood of the cross is a later addition

in secular art. A copy of the works of the poet Nicander in the Bibliothèque Nationale (Supp. Gr. 247) is the most important manuscript we have, but the same classical themes and a wholly classical style distinguish the carving of a series of ivory caskets of the tenth and eleventh centuries, of which the superb Veroli Casket in the Victoria and Albert Museum is the most important (*Ill. 73*). On the

73 Detail of the Veroli Casket, Victoria and Albert Museum. The scene of Europa and the bull is copied from some classical original, that of the stoning beside it, from such a manuscript as the Joshua Roll

top and sides it bears scenes from classical legend, carved in high relief. The themes are however somewhat muddled, for in one place Europa on her bull rides tranquilly into the midst of a violent scene of stoning, derived apparently from the stoning of Achan (*Ill. 74*), which is depicted in a famous manuscript known as the Joshua Roll; both probably follow an Alexandrine model.

In truth however this dichotomy of styles was fairly short-lived, and what really most distinguishes the art of this age is the development of a new transcendental and wholly spiritual approach which looks to the world beyond rather than to this. Though figures had a prominent part to play, they were arranged frontally and set in balanced ranks, and tell by their rhythmical pattern rather than because of the naturalism of their rendering. The Harbaville Triptych in the Louvre, which we have already mentioned, illustrates this clearly. There are two other triptychs very like it, one in the Vatican and the other in the Palazzo Venezia in Rome, which also depict Christ between the Virgin and the Baptist on the central leaf; and

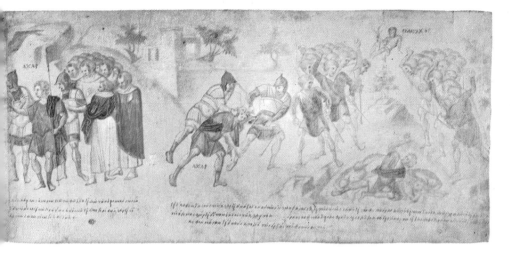

74 The Joshua Roll in the Vatican. The stoning of Achan may be compared with the scene of stoning on the Veroli Casket opposite. The illustrations of the roll are arranged in a single band, like a panorama

there is another in the British Museum, bearing the Crucifixion (*Ill. 67*). All must have been carved in the second half of the tenth century. These, and a whole series of other ivories like that in the Cabinet des Médailles at Paris, showing the Crowning of the Emperor Romanos and his Empress Eudoxia in 945 (*Ill. 68*), remain unsurpassed in the story of art. They represent the work of the Court school at its height, and excellence of technique and elegance and balance of design are its hall-marks. But the style was not uniform, and several workshops are to be distinguished on the basis of style. An ivory in the name of Nicephorus Phocas (963–69), now at Cortona (*Ill. 72*) is thus clearly different, for the faces are fatter and the work rather less elegant, and a somewhat similar manner characterizes a lovely statuette of the Virgin in the Victoria and Albert Museum (*Ill. 71*). It is the only free-standing Byzantine ivory that is known.

It was however in the sphere of church decoration that the new transcendental style reached its apex, and a number of mosaics were

set up in Constantinople in the ninth and tenth centuries, of which those in Basil I's church, the Nea, were the prototypes. None of them, alas, survives, but we know of them from the records and a few decorations have survived elsewhere which followed the same system. The conception was throughout symbolic, the church being regarded on the one hand as a sort of microcosm of the world outside, with heaven above and earth below, and on the other as the New Jerusalem, where Christ's life was lived anew from day to day just as His Passion was re-enacted in the liturgy of the Mass. Each scene was thus intended to call to mind a particular place where He had sojourned on earth, and each had its appropriate place in the church. The Nativity was associated with Bethlehem, the Baptism with Jordan, the Annunciation with Nazareth, the Raising of Lazarus with Bethany, the Miracles with Galilee, the Miraculous Draught of Fishes with Tiberias, the Washing of the Feet with Mount Tabor, the Passion with Jerusalem, and the Crucifixion with Golgotha.

The world itself was conceived as a sort of rectangular box supervised from above by the Almighty, and this conception was given expression in the illustrations of a sixth-century manuscript, a product of the Alexandrine school, known as the Cosmography of Cosmas Indicopleustes (*Ill. 75*). The copies that have survived are later; the most important of them, in the Vatican, is to be dated to the ninth century, and the illustrations were no doubt coloured to some extent by contemporary ideas in so far as their style is concerned. In Basil's church the bust of Christ Pantocrator dominated the building from the dome, just as God dominated the world in Cosmas's illustration, while marble revetments on the walls, as at Hosios Lukas, took the place of 'the earth and the waters under the earth' (*Ill. 76*). In close association with Our Lord's figure were the principal scenes from His life, and at a lower level, or perhaps in a side chapel, the Old Testament story was recorded, or that of the life of the Virgin. At the lowest level stood full-length figures of the Saints who were ready to act as intercessors or intermediaries between earth and heaven, and in the apse were the Fathers of the Church who had formulated the liturgy and who were first res-

75 The manuscript of Cosmas Indicopleustes. Diagram of the world showing the Almighty above, the world itself, as a mountain, and below it the 'waters under the earth'

ponsible for enacting it. The ideas governing this system of decoration and the way in which the scenes and figures should be arranged received the official sanction of the Church, and the painter was not permitted to deviate from it. Indeed, a series of rules were formulated and handed down by word of mouth. Eventually they were committed to paper, taking the form of what is called the Painters' Guide, a sort of handbook detailing exactly how a church should be decorated and how each scene should be painted. The earliest copy of this that is known dates from the sixteenth century.

The mosaics of this age that survive are mostly very fragmentary, both in the sense that each composition is battered and pitted and in that only portions of the whole scheme survive in each church. It is thus necessary to move from church to church to reconstruct the system devised for Basil's Nea, and to disregard strict chronology. The finest rendering of Christ Pantocrator is thus that in the dome at Daphni, near Athens (*Ill. 77*), though it dates from about 1100 and

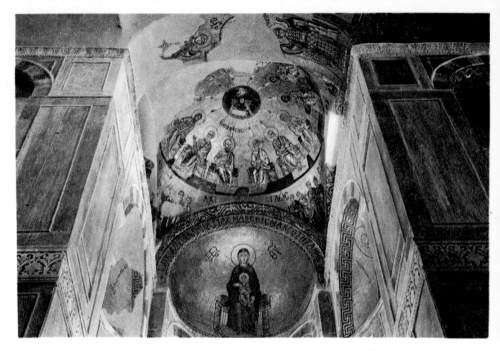

76 Mosaic decoration of the Monastery Church of Hosios Lukas, Greece. The Virgin and Child in the semi-dome of the apse, and the Pentecost scene on the secondary dome before it

is nearly a century later than most of the other mosaic decorations that survive. It is not the tender human Jesus of Western thought, but rather a strange awesome figure akin to the Old Testament Jehovah. But it is wholly spiritual in conception and immensely impressive as a picture: a forerunner of many of the works of recent times which we describe as 'expressionist'.

Next in importance after Christ, and therefore occupying the semi-dome of the apse, was the Virgin, who was sometimes shown full length, sometimes enthroned, sometimes alone, and sometimes with an Archangel on either side. An outstandingly lovely rendering was that which occupied the apse of the Church of the Assumption at Nicaea (*Ill. 78*) till its destruction in 1922. It must have dated from soon after 843, that is to say from after Iconoclasm, but it probably reproduces closely a composition set up in 787 during a brief interlude in the ban. It is interesting to compare a rendering of the same

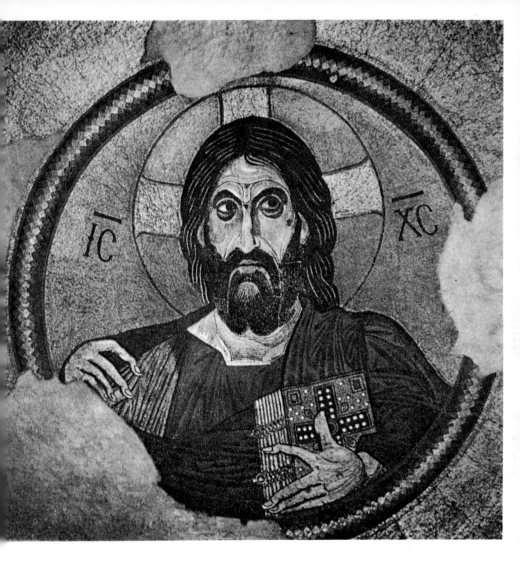

77 Mosaic in the dome, Daphni, Greece. Christ the Almighty. This strange, awesome figure belongs to the oriental conception of Christ as the stern judge—the Jehovah of the Old Testament; it is far removed from the Western conception of Him as a suffering mortal

theme some two centuries later which is to be seen at Torcello near Venice (cf. p. 180).

The principal scenes of Christ's life were, as we have seen, placed as near to His bust as possible. Four of them usually occupy the pendentives or squinches that support the dome. At Hosios Lukas, decorated shortly before 1000, they are the Annunciation, the Nativity (*Ill. 79*), the Presentation, and the Baptism; at Daphni, done about a hundred years later, the Transfiguration (*Ill. 80*) has been substituted for the Presentation; it is particularly beautiful and effective, and the mosaicist seems to have been able to include the whole space between the extremities of the conch as a part of his picture-space. Pentecost, the Giving of Tongues, a symbol of Apocalyptic power, was often placed on the roof of the choir. The mosaic survives at Hosios Lukas, although the Christ in the main dome has perished.

The interior of Hosios Lukas is colourful, brilliant, glowing, and the mosaics are very effective. But though they illustrate more clearly than any other decoration that survives the system formulated in Basil's Nea, the style of the work lacks the elegance of the Court school as we saw it in the ivories. It was a rather more primitive, more clumsy, but perhaps also a more expressive style that dominated these mosaics; it has sometimes been termed the 'monastic'. This trend towards expression, which was clearly enough marked in the mosaics of the main body of the church, was carried even farther in those of the narthex at the western end, which are by a different hand. At times these are almost crude, as in the rendering of the Crucifixion (*Ill. 82*), where the body is violently contorted, and the angular poses of Mary and John have been curiously exaggerated in order to stress the agony of the scene.

78 This mosaic formerly occupied the apse of the Church of the Assumption of the Virgin at Nicaea. It was set up soon after the end of Iconoclasm (843). The church and its decoration were destroyed in 1922

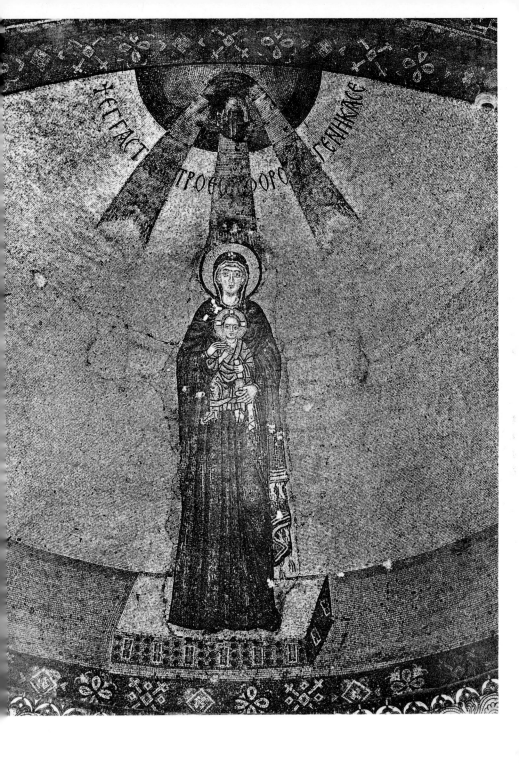

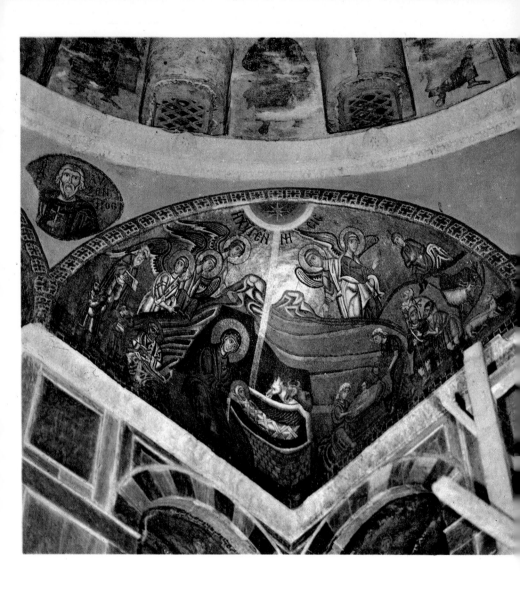

79 Mosaic of the Nativity in the squinch supporting the dome of the Monastery Church of Hosios Lukas near Delphi in Greece. It dates from around the year 1000

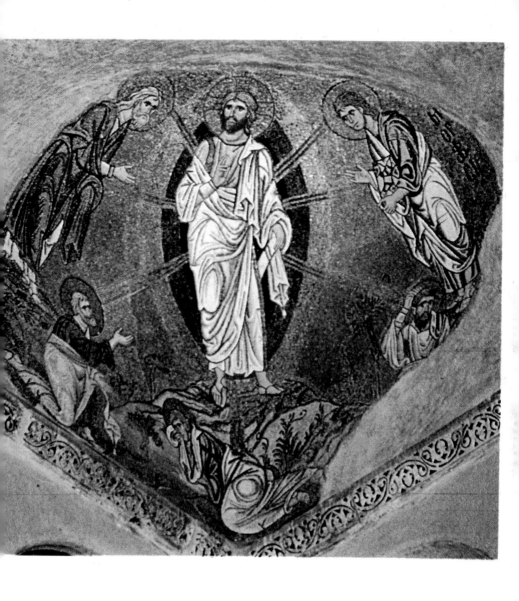

80 Mosaic. The Transfiguration, occupying the squinch supporting the dome of the Church of Daphni near Athens. The mosaic is very subtly conceived so that the figure of Christ seems to occupy the open space between the sides of the vault

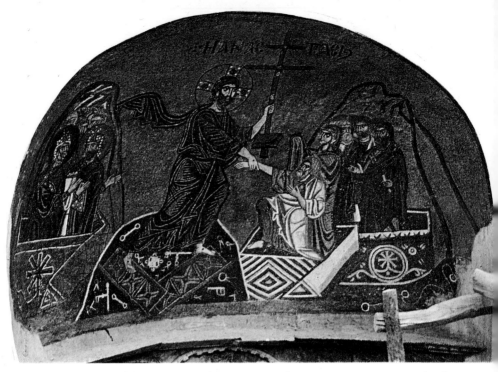

81 Mosaic of the Anastasis in the Nea Moni, Chios. In Byzantine iconography the Resurrection was always represented by this scene, where Christ breaks down the Gates of Hell and raises Adam from the dead

The same expressive style characterizes the mosaics of the Monastery of the Nea Moni on Chios (*Ill. 83*), though here the artists were more adept than the men who worked in the narthex at Hosios Lukas. The style of their work was also very much more personal, and seems to interpret individual character more effectively, as for example in the scene of the Anastasis or Christ's descent into Limbo (*Ill. 81*). The building—a very attractive one—is of rather unusual type, for the dome stands on eight squinches; the scenes that occupy them are the Annunciation, the Nativity, the Presentation, the Baptism, the Transfiguration, the Crucifixion, the Deposition, and the Anastasis: the other principal scenes of Our Lord's life, the Raising of Lazarus, the Entry into Jerusalem, the Washing of the Feet, the Agony in the Garden and the Ascension, are in the narthex.

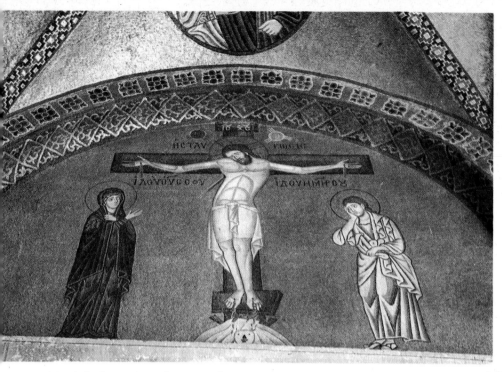

82 Mosaic in the narthex of Hosios Lukas; the Crucifixion. The proportions and other details are exaggerated to intensify the emotion of the scene

This church was built and decorated under Imperial patronage, a promise having been extracted from Constantine Monomachos by three holy men that he would come to their aid if ever he became Emperor. He came to the throne in 1042 and kept his promise; the building and decoration of the church were accomplished between then and 1054.

The mosaics of Kiev in Russia belong to very much the same date, for they were set up between 1046 and 1067. But the patrons and some of the workmen were Russian, though the master-craftsman was probably a Greek. The actual work is thus Russo-Byzantine rather than Constantinopolitan; it is more rigid, more conventional than that at Chios, and the very personal touches to be seen there are absent, so that the effect is somewhat hard and prosaic in spite of a considerable technical excellence. To much the same date again, but rather closer to the metropolitan style, is the painted decoration

83 The Church of the Nea Moni, Chios. The lovely setting is typical of a large number of later and mid Byzantine buildings

in Sancta Sophia at Ochrid, which comprises an Ascension (*Ill. 84*) on the vault of the choir, an Enthroned Virgin in the apse, a series of Old Testament and other scenes on the walls of the apse, New Testament scenes in the nave, and a vast Dormition (Assumption) of the Virgin on the western wall. This is a composition of great beauty and feeling, comprising a considerable mass of figures: the head and shoulders of Christ are especially expressive (*Ill. 85*). The work is perhaps rather more metropolitan than that at Kiev, but it still represents a local rather than a purely Constantinopolitan manner.

In contrast to these decorations which are narrative in character and religious in content are mosaics that have been uncovered in recent years in the great Church of Sancta Sophia at Constantinople. True, there is a figure of the Virgin Enthroned in the apse, with Archangels on the vault before it which we have already noted, but

98

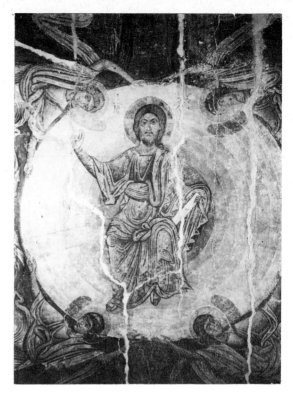

84 (*right*) Central portion of the vault of the sanctuary of the Church of Sancta Sophia at Ochrid; the Ascension. The glory behind Christ is supported by four Angels; below on either side stand groups of Apostles watching the event

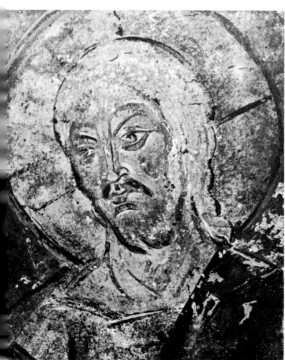

85 (*left*) Detail of Christ's head from the Dormition (Assumption) of the Virgin on the west wall of the Church of Sancta Sophia at Ochrid

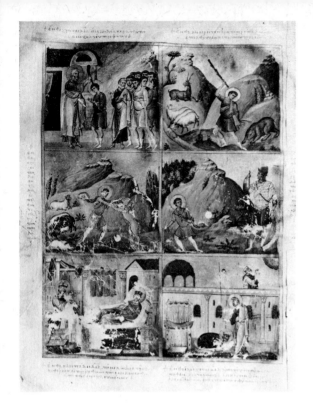

86 Six scenes from the life of David in the Psalter of Basil II. They are the Anointing of David, David protecting his flock from the attack of a bear, David and the lion, David and Goliath, David and Saul, and the Penitence of David

the other panels that survive nearly all represent emperors rather than Bible scenes. Over the door from the narthex to the church Leo VI, the Wise (886–912), is thus shown prostrated at the feet of Christ with medallions of the Virgin and an Angel above (*Ill. 87*). The Angel no doubt symbolizes the belief that the church was 'built with divine aid while Angels watched'. Over the South door is a mosaic probably set up under Basil II between 986 and 994; Constantine is shown presenting a model of the city and Justinian one of the church to the Virgin (*Ill. 88*). The same Emperor was responsible for the execution of a larger Psalter which is now in the Marcian Library at Venice, but it only contains two pages of illustrations. On one are six scenes from the life of David (*Ill. 86*); on the other is a portrait of the Emperor in military uniform (*Ill. 91*). He was known as the Slayer of Bulgars, for he waged a series of successful campaigns against that

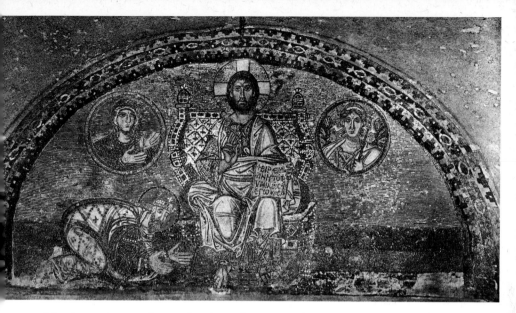

87 (*above*) Mosaic over the western door of Sancta Sophia, Constantinople; the Emperor Leo VI prostrated before Christ. In the medallions are the Virgin and an Angel

88 (*below*) Mosaic over the south door of Sancta Sophia. The Emperor Constantine presents a model of the city and Justinian one of the church to the enthroned Virgin

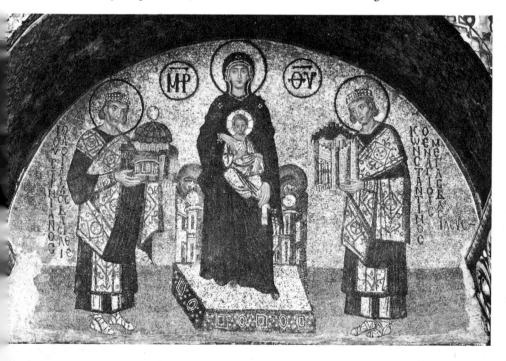

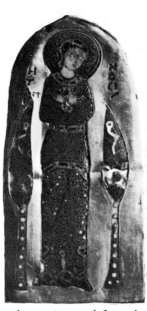

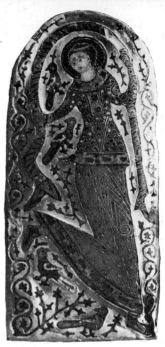

89 Plaques in cloisonné enamel from the crown of Constantine Monomachos (1042–55). Now at Budapest. The busts of saints and the figural plaques are

nation. Here the conquered Bulgars are shown prostrate before him.

There are other Imperial portraits in the South gallery. One group shows the Virgin holding the Christ Child, between the Emperor Constantine Monomachos and his empress Zoe (*Ill. 90*), and the other Christ between John II Comnenus and his empress Eirene. Constantine Monomachos (1042–55) is here depicted on one side of Christ with the Empress Zoe on the other, but there is reason to believe that only the face of the Emperor dates from the time of Monomachos: the rest of the composition is earlier, and Whittemore has shown that it must originally have depicted Zoe's first husband, Romanos III (1028–34): both face and inscription appear to have been altered to fit the new Emperor, and the alterations to the inscription are very obvious. Constantine Monomachos was Zoe's third husband and she married him when she was over sixty; whether the second husband, Michael, graced the wall for a short space in between we shall never know.

102

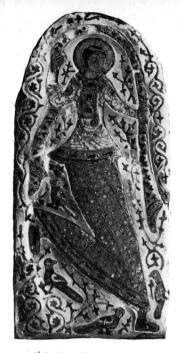
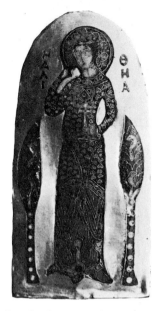

paralleled in other Byzantine work, but the dancing girls are unusual and would seem to have been influenced by Persian art

Constantine Monomachos was not a very wise ruler, but he seems to have been a zealous patron of art, for in addition to this mosaic and those at Chios discussed above, his name is associated with a series of enamels belonging to his crown, now preserved at Budapest (*Ill. 89*). They include portraits of himself, the Empress Zoe, and her sister Theodora, as well as the busts of Saints and some rather unusual figures of dancing girls. These are in a lighter vein than so much of the art of the period, and are in a rather oriental style; they serve to give an idea of what the secular art of the mid-eleventh century was like, and if the evidence of the crown is to be accepted, it may be assumed that oriental ideas had become more important than in the ninth century, when more classical tastes were to the fore.

Monomachos was the last emperor of the great Macedonian dynasty and the one hundred and eighty eight years which separated the end of his reign from the beginning of that of the founder of the dynasty, Basil I (867–86) were in many ways the most glorious of Byzantine civilization. There was much building in a wholly

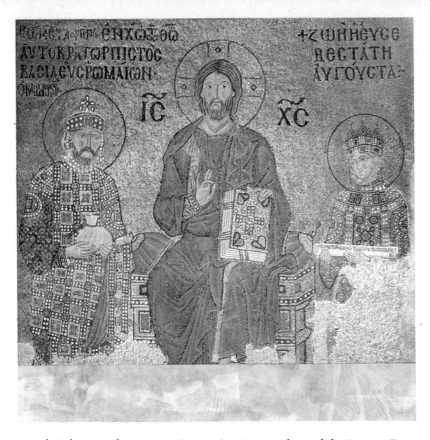

90 Christ between the Emperor Constantine Monomachos and the Empress Zoe. The mosaic was first set about 1030, but the head of Constantine was substituted for that of Zoe's first husband, Romanos, about 1042

Byzantine style. In art the classical heritage had been welded to that of the East, the influence of which had been intensified during Iconoclasm (726–843). Under the guidance of the Church, Imperial patronage had been responsible for the production of a mass of great mosaic decorations, and there were others, little less magnificent, in paint; books had been superbly decorated, and ivories of incomparable excellence had been carved. The hub of all this activity was the Great Palace of the Emperors; thence the initiative stemmed, there were situated the workshops of the craftsmen, and the texts tell us something of their working-conditions. They were organized into

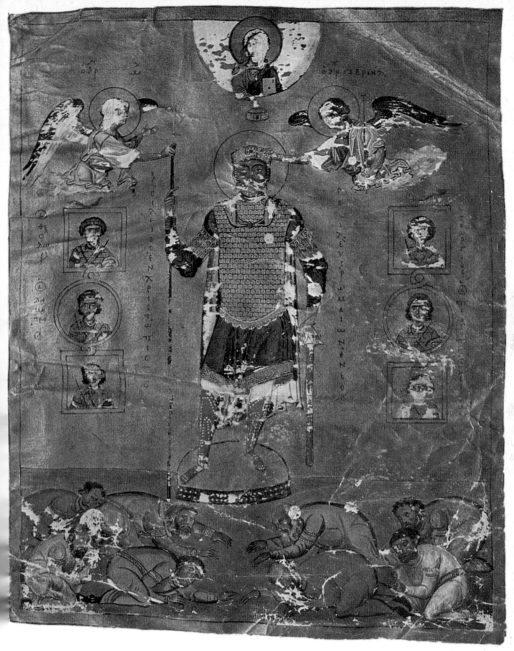

91 The Emperor Basil II on the frontispiece of his Psalter, now in the Marcian Library at Venice

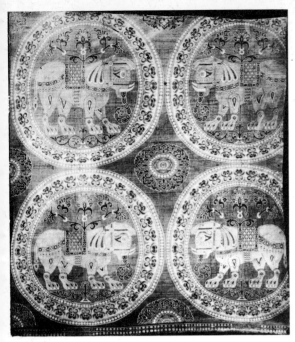

92 Silk from the grave of Charle-
magne, Aachen. It was probably
put into the grave when it was
opened by Otto III in the year 1000.
It bears an inscription stating that it
was woven in the Imperial work-
shops at Constantinople

guilds, most of which were very exclusive, and it was as hard to leave
them as to enter. Apparently one of the most important and influen-
tial was that of the textile-workers. They were housed in the
Zeuxippus, a portion of the Great Palace not far from Sancta Sophia.
It was there that the wonderful silks which were so important for
hangings, for use in the churches, for houses, and for costumes, were
woven. They were sometimes sent overseas as gifts and a few have
been preserved in the shrines of saints, monarchs, or bishops in the
West. A fine silk decorated with elephants in medallions, dating
from about 1000 (*Ill. 92*), was thus introduced into the tomb of
Charlemagne by the Emperor Otto in that year. It bears an inscrip-
tion stating that it was made when a certain Peter was Archon of the
Zeuxippus, thus indicating that it was made there, but there is no
date. There are silks of the same quality in other treasuries, like the
so-called Shroud of St Siviard at Sens, or one with eagles at Auxerre
(*Ill. 93*), which is known as the Shroud of St Germain l'Auxerrois;
it is perhaps the finest of all, for it is as much as 170 centimetres long
and the subdued gold colouring of the design on a purple ground is

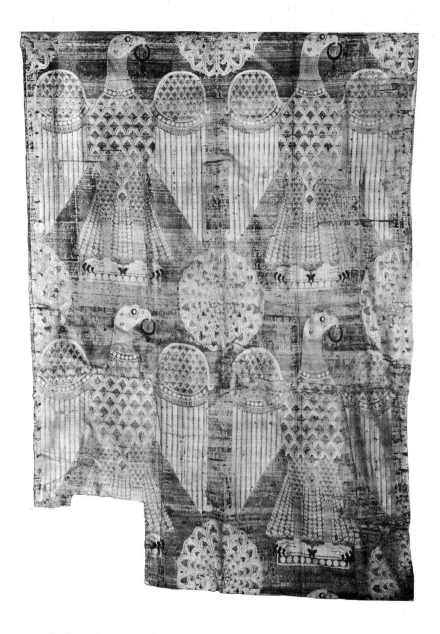

93 Silk from the grave of St Germain at Auxerre, now in the Church of St Eusebius. It is one of the finest Byzantine silks in existence

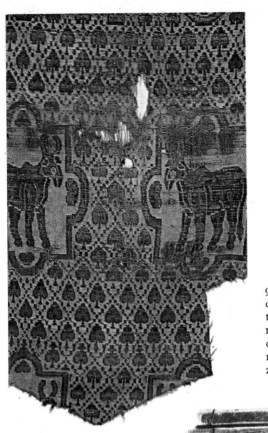

94 Silk with a bull and
diaper pattern. Repeat pat-
terns of this sort, though
not as grand as the figural
ones, were nevertheless
much in favour with By-
zantine textile weavers

95, 96 (*right, far right*) Side and end
of an ivory casket, Troyes Cathedral.
The bird on the end must have been
inspired by a Chinese textile; the
scene on the side is reminiscent of
the art of Sassanian Persia

especially effective. The motif was a very favourite one and appears on many other textiles, for example the Chasuble of St Albuin at Bressanone (Brixen); here the eagles are in black with bright yellow beaks, but their proportions are squatter and less elegant than on the Auxerre silk. But there is firm evidence for dating the silk to around 1000. These stuffs are exceptionally large; usually the fragments that survive are comparatively small, like a number preserved in the Church of St Servatus at Maastricht; a very charming one bears a design of bulls and a diaper pattern on a much smaller scale (*Ill. 94*). It too is to be assigned to the Imperial workshops.

It would seem that textiles often served as models for work in other materials. Marble slabs like those built into St Mark's at Venice or the tiny church at Athens known as the Little Metropolis thus often have the appearance of textiles, and the presence of *kufic* script on some of the slabs suggests that the textiles which were copied were sometimes Islamic. Some may even have been Far Eastern, for the ends of an ivory casket at Troyes represent birds which are clearly Chinese (*Ill. 95*). That they followed a textile model is the most likely explanation. The top and sides of the casket (*Ill. 96*) show emperors on horseback and hunting scenes which are suggestive of textiles, such as the one at Lyons (*Ill. 59*).

97 Chalice in the Treasury of St Mark's, Venice. The body is of semi-precious stone, the stem gold, and the rim bordered with plaques of cloisonné enamel. There are no less than thirty-two chalices in the St Mark's treasury, most of them brought back as loot after the sack of Constantinople in 1204

Another craft for which the workshops of the Great Palace were famous was metal-working and enamelling. Indeed one of the emperors, Constantine VII (913–59), seems even to have done work himself, for his name is associated with one of the finest of all the sumptuous treasures, a lovely reliquary for a fragment of the True Cross, now at Limburg an der Lahn in Germany (*Ill. 101*). It was preserved in the Great Palace and brought to the West as part of the loot collected at the Sack of Constantinople by the members of the Fourth Crusade in 1204. The long inscription on the reliquary not only mentions the name of the Emperor, but also of a Court official, Basil the Proedros, whose name appears on a chalice and a paten in the Treasury of St Mark's at Venice. They must have been made at much the same date. Like the Limburg reliquary they too were brought back as loot after 1204, and the same is true of the great mass of chalices, patens, Gospel-covers, and reliquaries in the same Treasury (*Ill. 97*). A few are actually dated by inscriptions, others bear the names of emperors, others again can only be dated on stylistic grounds, like the cover of a silver-gilt reliquary for a

98 (*right*) Cover for a copy of the gospels in the Monastery of the Lavra, Mount Athos. It is closely akin to a reliquary cover in the same monastery presented by the Emperor Nicephorus Phocas

99 (*below*) Gospel-cover of gold repoussé work, adorned with enamels. In the public library at Siena

fragment of the True Cross with a decoration of jewels and cloisonné enamels (*Ill. 100*). It represents the finest Constantinopolitan work of the eleventh century.

The majority of these superb sumptuous works are preserved in the Treasury of St Mark's at Venice, but there are numerous other examples elsewhere, some of which have been in the same place almost since the day they were made or brought back as loot by some Crusader, while others have changed hands more often and their history is lost. Among the former, two of the most interesting are a reliquary and a Bible-cover (*Ill. 98*) presented to the Monastery of the Lavra on Mount Athos at the time of its foundation in 970 by the Emperor Nicephorus Phocas; among the latter is a paten of onyx in the Stoclet Collection at Brussels (*Ill. 102*), with a cloisonné enamel at the centre represnting the Last Supper; its

102 Paten of onyx with enamel of the Last Supper at the centre. It is a work of the very highest excellence

decoration is comparatively simple and contrasts in this with an outstandingly fine and elaborate pair of Gospel-covers at Siena (*Ill. 99*), where enamels and precious stones are set in rich filigree mounts.

Nearly all these lovely objects date from the tenth or eleventh century, and attest the wealth and magnificence of the great Macedonian Age. Gold and silver-gilt are the usual metals, and they afford an admirable setting for the brilliant, glittering enamels and the rich stones which form a part of the adornment, or in the case of the chalices and patens, often constitute the actual body, of the vessels. The very names of the stones are in themselves colourful and romantic, and recall the descriptions of the glories described in St John's vision of the Apocalypse.

It might seem to savour of bathos to speak of pottery immediately after these rich treasures, but though the Byzantines never perhaps produced ceramics which were quite as fine as those of Persia or

China, they were, nevertheless, responsible for the development of a number of important techniques, some of which are not paralleled elsewhere, and a few of the products are really outstanding. The most interesting of the techniques was that usually termed poly-chrome, where a painted decoration was laid upon a fine white body and covered with a thin transparent glaze. Handled-cups, like modern teacups, plates, dishes, square flat tiles, and rectangular revetment-plaques, curved in section, were all produced, the designs being done in blue, green, yellow, brown, a brilliant tomato red, and sometimes even in gold or silver. Most interesting from the general point of view are the tiles, even though most of the examples that we know are fragmentary. They usually bear the busts of Christ, the Virgin, or Saints (*Ill. 103*), but one, with a por-trait of St Theodore (*Ill. 104*), is made up of a number of units. It was found at Patleina in Bulgaria, which was an important centre of manufacture, but there must have been potteries in or near Constantinople also. Most of the examples of the group date from

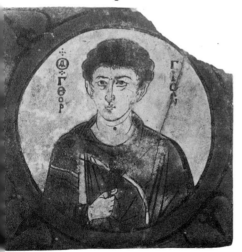
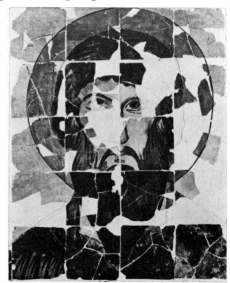

103, 104 Pottery plaques bearing saintly or religious figures constituted an impor-tant, but little known, branch of Byzantine art; the earliest examples are to be dated to the ninth, the later ones to the twelfth century

the ninth century, but the technique remained in use till the twelfth, when it was superseded by others.

The body of the vessels varies to some extent with the locality, but in most cases it is white and rather fine. Similar clays were used for another important group covered by an overall green glaze and either with no design at all or with one made by pressing the soft clay into a mould. The moulded designs sometimes represent stylized flowers or rosettes or sometimes nude figures of a rather classical character. The ware was in use all through the Macedonian Age, and was apparently exported quite extensively. Large numbers of fragments which are well-nigh identical with those from Constantinople have, in any case, been found in the Chersonese in South Russia.

With the twelfth century, however, this gave way to another type where the body was usually red and the decoration was produced in the technique known as sgraffito. This consists of dipping the whole vessel into a white slip; portions of the slip are then removed, and the vessel is then covered with a transparent glaze and fired: the glaze turns to a darker colour where it overlies the body and a lighter one over the slip. A large number of variations of this technique were in use, the designs sometimes being engraved with a thin point, while sometimes wide areas were cut away, to produce what was virtually an incised pattern. Sometimes coloured glazes were added, to bring out the design, though this practice only became usual with the fourteenth century. Very lovely results were however produced in this way, both with the engraved and the incised techniques. A bowl with two rather stylized doves (*Ill. 105*) is among the finest that have come down to us.

Though there was no very sudden change in the character of the arts with the access to power of the Ducas (1059–81) and Comnene (1081–1185) dynasties, the twelfth century in any case saw the birth of a new, more personal and more intimate style. At first however, even if the frontiers of the Empire became more restricted and its wealth reduced, sumptuous mosaic decorations were still set up according to the principles of Basil I's Nea. The most important of those that survive is in the church in Daphni near Athens, which

105 Pottery bowl with design of two doves incised and then enlivened with coloured glazes. Pottery of this type became very important in the Byzantine world from the fourteenth century onward

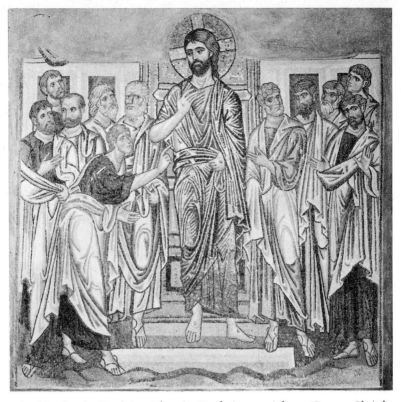

106 Mosaic, the Doubting Thomas, Daphni, near Athens, Greece. Christ's head has been in considerable part restored

dates from around 1100. We have already referred to the stupendous bust of Christ Pantocrator in the dome (p. 91), and to the compositions in the squinches. The other scenes on the walls below are perhaps less tremendous, as for instance in the delightful little scene of Joachim with the Angel who comes in answer to his prayer (*Ill. 107*); the figures are set in the countryside amongst trees and foliage, and the whole approach is picturesque and redolent of delight rather than awe. There is a rather more impressive rendering of the Doubting Thomas in the South transept (*Ill. 106*); here the gestures of the Apostles are more severe and formal, and the effect is perhaps a little cold and unemotional.

This colder manner is carried farther in a group in Sancta Sophia usually known as the John Panel (*Ill. 108*), which is characterized by a

107 Mosaic, Daphni. The Angel appearing to Joachim. The panel shows a feeling for intimacy and delicacy which was unknown to Byzantine art before about 1100

very linear style. It was set up about 1118. The figures occupy severely frontal poses and the effect is somewhat wooden, though the adjacent portrait of the Emperor Alexius Comnenus (*Ill. 109*), which dates from 1122, is rather more personal. The linear style has there affected the technique, for the tesserae of the face are set in hard

108 (*above*) Mosaic, the Emperor
John II Comnenus and his Empress
Eirene on either side of the Virgin.
It must have been set up in Sancta
Sophia about 1118

109 (*left*) The portrait of Alexius
Comnenus on an adjoining pier
dates from about 1122

parallel lines, and the high-lights are picked out with a new severity. The result, however, is very successful from the artistic point of view.

Something of the same linear manner is to be seen in a fine miniature mosaic of Christ in the Museo Nazionale in Florence (*Ill. 111*), which is probably to be dated around 1150, and it also characterizes the enamels of the age, which contrast quite markedly with those of earlier date. All are in the cloisonné technique, where thin strands of gold wire are soldered to a flat base to form little compartments, which were filled with vitrifiable pastes of various colours and then fired. In those of the twelfth century, however, the compartments are much smaller than they were at an earlier date, and the wires are set parallel to one another so that they greatly increase the linear character of the design. A beautiful little reliquary at Maastricht (*Ill. 110*), with the Virgin on one side and the Annunciation on the other, is typical.

110 Double-sided reliquary of gold and enamel; on one face is the Virgin, on the other the Annunciation. The numerous parallel gold partitions on the costume are characteristic of work of the twelfth century

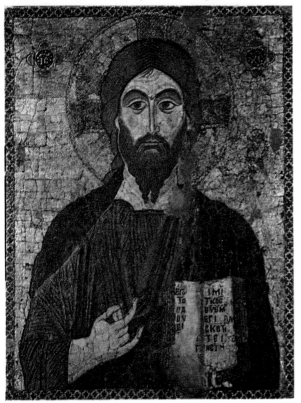

111 (*left*) Miniature mosaic of Christ in the Museo Nazionale at Florence. The work is of great delicacy and illustrates the more gentle, more humanistic conception of Christ which was coming into vogue in the twelfth century

112 (*right*) The Emperor Nicephorus Botiniates between St John Chrysostom and the Archangel Michael. The portrait of the Emperor is especially characterful

In contrast with this tendency towards a linear effect, and consequently towards greater formalism, which characterizes one aspect of eleventh-century art, a second and wholly distinct style was also developing in which a new interest in tenderness and intimacy and a new stress on humanism were beginning to appear. The first hints of this change are in the miniatures of a manuscript of the Homilies of St John Chrysostom, done for the Emperor Nicephorus Botiniates about 1078. On one page the Emperor is shown between St John and the Archangel Michael (*Ill. 112*): the figure of the Emperor is clearly a portrait and there is none of the conventional, hierarchical approach, which often dominated the portraits of an earlier date. The Saint, too, is human, if somewhat ascetic, and the Archangel gentle and kindly. Something of the same outlook is to be seen in a

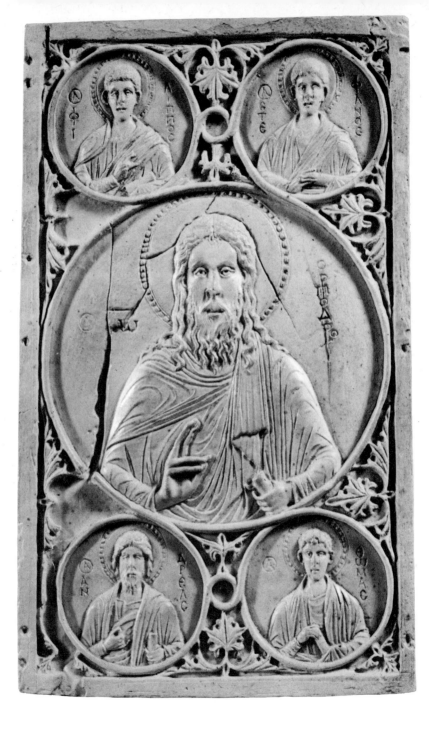

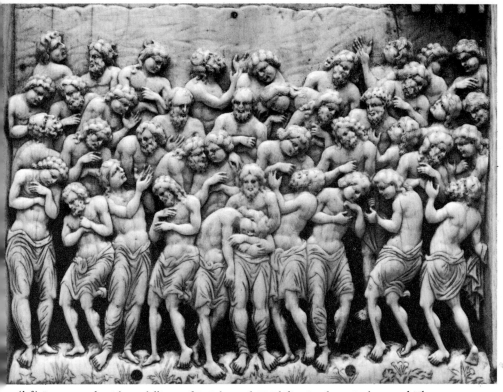

3 (*left*) Ivory panel, with medallions of St John and SS Philip, Stephen, Andrew and Thomas

4 (*above*) Detail of an ivory plaque—the Forty Martyrs. The very animated style is characteristic of the twelfth century

very lovely ivory in the Victoria and Albert Museum (*Ill. 113*), which bears St John the Baptist in a medallion, with the busts of four Apostles around. It is more delicate, one might perhaps say, more effeminate in style, than are the ivories of the tenth century. Certain other ivories show the progress of the new style, and are characterized by a more emotional approach and by more varied attitudes, as we see in a panel now at Berlin representing the Forty Martyrs (*Ill. 114*), which is probably to be dated to the twelfth century. The gradual development of this more personal, more expressive style was perhaps the most distinctive feature of the art of the twelfth century; it is an age which is rapidly taking on a new importance as fresh discoveries are made.

115 Icon; the Virgin of Vladimir. The icon was painted in Constantinople about 1125 and was subsequently transported to Russia, where it exercised a marked influence on the future development of Russian painting

116 Wall-painting—a saint.
Nerezi, Macedonia

No more striking or more lovely example of this new manner is to be found than the icon which we know as *Our Lady of Vladimir*, (*Ill. 115*), which was painted in Constantinople around 1125 and subsequently taken to Russia. Not only is the face tenderer, more intimate than was usual in earlier work, but the pose also attests the new outlook, for the Child's face is pressed against the Mother's in affection: this is a comprehension wholly foreign to earlier ages, when the two figures were associated not as mother and child, but as symbols of the faith, the Mother indicating the Child as Saviour of the World, the Child ageless and independent of His mother. It seems likely that this tendency was carried forward in such mosaics and paintings as were done in Constantinople from about 1125 onwards, but none, alas, survives. One monument does however serve to give an idea of what was being executed, namely the painted decoration of the Church of Nerezi, near Skopolje in Macedonia, for it was done for a member of the Comnene family, in all probability by artists from the capital. It dates from 1164. The paintings are of exceptional quality. The portraits of saints (*Ill. 116*) are personal and intimate, and lack much of the austerity of mid-Byzantine work; the scenes, like the Deposition from the Cross

(*Ill. 117*), show a wholly new conception in the interest that is taken in the individuals' feelings and the tragedy of the event; the way in which the emotion of tender sadness is conveyed is something of real beauty. The hieratic, monumental conception of earlier times has given place to a new approach which heralds that which was to dominate at a later date in the art of the Renaissance in Italy.

It would seem that this more intimate style was first conceived in the capital early in the twelfth century and that it at once spread all over the Byzantine world. Nerezi, however, is the only place where the paintings are characterized by the delicacy and fineness of touch distinctive of metropolitan work; elsewhere such works as survive are cruder and are to be attributed to the hands of local craftsmen. But however crude, there are numerous works which are all based on the new outlook, and which follow the ideas of Constantinople even if only indirectly. They are to be found in very widely separated areas from Staraya Ladoga in Russia to Lagoudhera in Cyprus, and from Monreale in Sicily to Kurbinovo in the Balkans. Attention will be drawn to the individual monuments in later chapters; here their relationship one to another and the debt they owe to Nerezi and through it to Constantinople may be stressed.

In addition to the development of this new style, the Comnene Age saw certain other innovations in art. First, perhaps as a result of Turkish advances into Asia Minor after the Battle of Manzikert in 1071, the Eastern trade seems to have been somewhat interrupted, and ivories tend to become less usual; instead similar low-relief carvings in semi-precious stones, more particularly steatite, became usual. There is a particularly delightful one in the Bandini Museum at Fiesole near Florence, depicting the Archangel Michael (*Ill. 118*). Part of the gilding with which it was once covered survives. No doubt ivories were also very often adorned in the same way. Another art that also came into prominence in this age, perhaps also for economic reasons, was that of icon-painting on panels. No doubt such works began to be produced immediately after the end of Iconoclasm, but virtually nothing is known from the ninth or tenth centuries. However, the rise of new merchant and landowning classes certainly widened the sphere of patronage. There are a few

117 Wall-painting—the Deposition; Nerezi, Macedonia, 1164. The paintings at Nerezi are to be attributed to a Constantinopolitan painter and illustrate the more humanistic approach which developed in the twelfth century

panels that can be assigned to the eleventh century, like one in the monastery on Mount Sinai bearing three Saints, Prokopios, Deme-trius and Nestor (*Ill. 119*), but with the twelfth century examples became more numerous, though they are now scattered throughout numerous collections. The most important are in Russia, where they were taken as imports soon after they were painted.

In 1204 the Sack of Constantinople by the troops of the Fourth Crusade put a stop to immediate artistic developments in the capital, and it was not until 1261 that the Orthodox emperors were able to return. There then began a new, and from the artistic point of view, one of the most important, chapter in the history of Byzantine art.

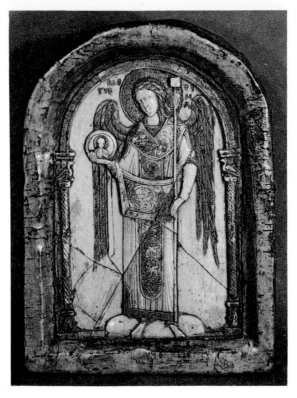

118 The Archangel Michael—green steatite, gilt. The work is of exceptional delicacy and lightness of touch

Before we examine it, however, it is necessary to move away from the capital and see what was happening outside it, for though Byzantine civilization was in many ways highly centralized, and though the patronage of the Emperor and the Court was concentrated in Constantinople, a great deal that was truly significant was done in the provinces and in neighbouring lands, first when they formed a constituent part of the Empire, and later when various of the regions had broken away and achieved independence. The arts of these regions are, in the broad sense, Byzantine arts, and in many cases constitute chapters without which the true story is incomplete, even if it is distinct from that of Byzantine art in the narrow sense of the term, that is to say the art of Constantinople.

130

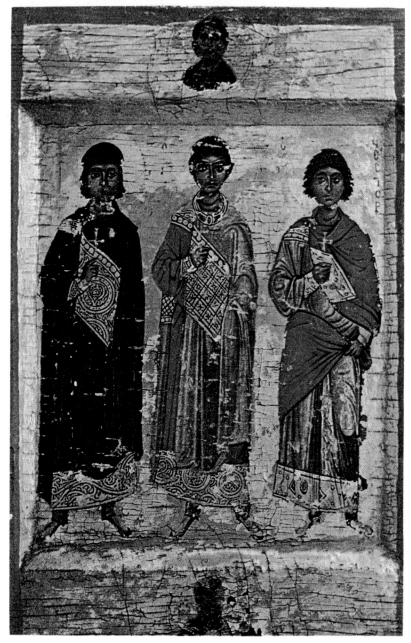

119 Icon, SS Prokopios, Demetrius and Nestor. The severe handling, characteristic of the eleventh
century, may be contrasted with the greater intimacy of the Virgin of Vladimir (*Ill. 115*)

The Eastern World from the Seventh Century

In very early times, even before the days of Justinian, Asia Minor was a very important centre of artistic development, for it was there that the Faith was first preached and there that the most numerous and active supporters of Christianity were to be found. Churches were built, paintings and sculpture were executed, mosaics were set up, and, as recent evidence indicates, silver and other materials were worked. But though it was in Asia Minor that Justinian's architects, Anthemius of Tralles and Isidore of Miletus, designed their first experimental structures, although there are numerous buildings of early date, and though it was at Ephesus that Justinian built one of his most outstanding churches, the area has little to offer us that is of great interest from the following centuries, and the literary and historical evidence suggests that from the end of Iconoclasm in 843, if not before, the great cities there had lost a good deal of their former importance. Asia Minor always remained vital because of its agriculture and its mining, and most of all, because it was the principal source of manpower in the Empire, but its culture seems to have become more and more rural in character as time went on; and as political and economic activity became more and more centred on Constantinople, the cities took on the rôle of administrative centres of rural districts rather than that of urban settlements in their own right. But the rural population was large and the countryside itself was prosperous, and even if the towns were not very important economically, nor as places where art patronage was available on an extensive scale, churches were nonetheless built and there were numerous monastic communities where art flourished, more particularly in the way of wall-painting. These communities were not usually rich enough to sponsor such expensive things as mosaics, nor were the sumptuous arts of enamelling or metal-working practised there. Of the churches of consequence, built between the sixth and

120 The Church of Changli Kilisse near Akseray to the north of Konia in Asia Minor. It must have been built shortly before the advance of the Seljuks after the battle of Manzikert in 1071

the early twelfth centuries, when much of the area was overrun by the Seljuks, one known as Changli Kilisse near the present-day Akseray (*Ill. 120*), may serve as an example. It is of the usual inscribed-cross type, with a transverse narthex at the western end, and is probably to be dated to the eleventh century. The masonry, of massive stone blocks, is typical of Asia Minor, but there are certain details in brick which suggest the influence of Constantinople.

In general, however, the built churches of Asia Minor constitute a group independent of the capital, and architectural ideas which were developed in them exercised an influence in Greece and the Balkans which was quite independent and distinct. The interiors of these churches were decorated with painting, but practically nothing survives now. We thus know little of the religious art of the

133

secular communities. With regard to the monasteries, however, the position is different, for most of these were small communities, groups of hermits rather than monasteries as we know them in the West or on Mount Athos, and they usually used caves for their churches. A considerable number of these painted cave-churches survive. A number of them, with paintings dating from the tenth and eleventh centuries, have been discovered at Latmos, near Miletus, but the greatest mass of them is to be found around Urgup in Cappadocia. Indeed, there are so many of them that their number appears almost countless. Some of the chapels are quite small, some almost as large as full-scale churches. They were carved out of the soft rock of the area by the monks, and were frequently cut to resemble actual buildings, complete with domes, apses, columns, and arches. The strange, honeycomb-like rocks of the area must once literally have swarmed with hermits and small monastic communities, each of a few monks. The monks themselves did the paintings and what they lacked in finish was compensated for by sincerity and genuine feeling, so that the work is often of real quality.

These rock-cut churches were first seriously examined by a French scholar, Père de Jerphanion, whose first expedition there was made in 1908. But this was followed up by journeys in subsequent years, and the results of the several expeditions that he made were fully published in the nineteen-twenties; though he examined numerous chapels, many more remain unexplored and await the scholars of the future. The paintings which he studied extended from Iconoclast times to the twelfth century or perhaps even later, for the Christian population still continued to exist even after the region had fallen to the Seljuk Turks as a result of their victory over the Byzantines at Manzikert in 1071. Subsequently work of even earlier date has been found. Some of the paintings bear dedicatory inscriptions and can be assigned to actual years, like Karabach Kilisse at Soglane, which dates from 1061; others can only be dated more vaguely on the basis of style.

We have already noted that work was done in Cappadocia during Iconoclast times, notably in the so-called New Church at Toqale Kilisse, which was of a wholly non-figural character; these paintings

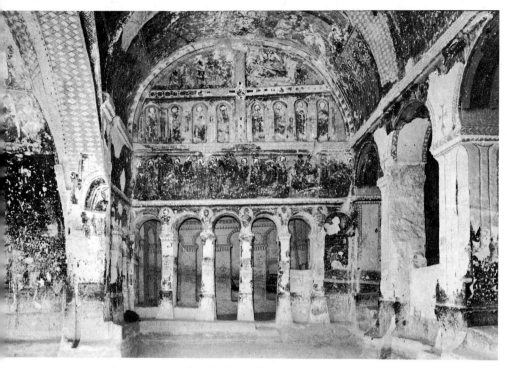

121 Interior of the rock-cut Church of Toqale Kilisse, Cappadocia. Paintings of two periods cover the walls. The upper is from the eleventh century. The plaster is falling to disclose a non-figured decoration done during Iconoclasm (726–843)

were covered over subsequently with a series of narrative scenes, but these are now peeling off, to disclose the earlier layer below (*Ill. 121*). It would seem that all the figural work in Cappadocia is to be assigned to post-Iconoclast times; the earliest of the paintings are to be dated to the tenth century, and most of them are of the eleventh or twelfth; the theory that some were done during Iconoclasm because the ban was not enforced there, which was at one time put forward, cannot be accepted.

Of the post-Iconoclast paintings, Père de Jerphanion distinguished two groups, one of which he called the archaic, and the other the more developed. Paintings of the former followed Syrian prototypes, like the Rabbula Gospels. The figures are usually rather squat, the gestures angular, the compositions crowded, and the

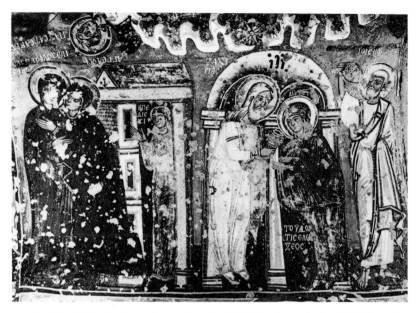

122 Wall-painting in the rock-cut Church of Kiliclar, Cappadocia. The Salutation on Proof of the Virgin

scenes are arranged in long horizontal bands like a panorama. Here and there, however, groups of figures which are extremely expressive are to be found; the scene of the Proof of the Virgin at Kiliclar (*Ill. 122*) is one of the best of them. It illustrates the old theory of the test of virginity by means of a cup of water which would turn poisonous in the event of the claim being false.

The paintings of Jerphanion's second group are more elegant and show the influence of the sophisticated art of the Macedonian Age at Constantinople. The most important examples are to be found in the church at Toqale, the largest in the area, and in the smaller chapel near by, known as Elmale Kilisse. Here the figures are tall and slender, and even if their gestures are somewhat wooden, they are possessed of a certain elegance and are arranged with great skill to fit the somewhat irregular surfaces available (*Ill. 123*). The patterns which occupy the corners not only fill the spaces admirably, but also show a real feeling for decoration.

136

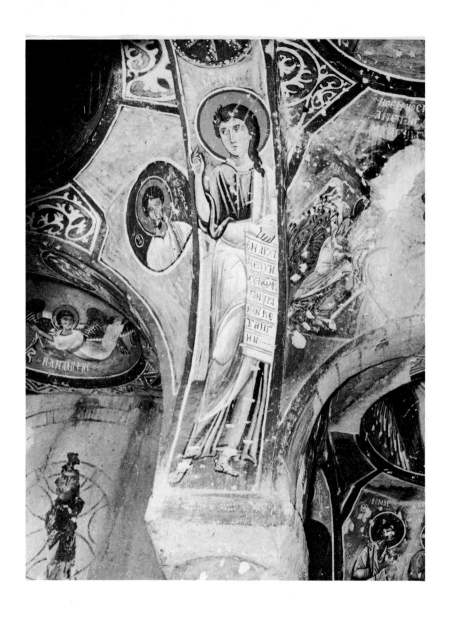

123 The rock-cut church known to the Turks as Elmale Kilisse. The figure of the Prophet Moses is admirably fitted to the space available, the soffit of a narrow arch

Other work that survives in Asia Minor is in most cases so fragmentary as to be of little artistic interest, except for paintings in the Church of Sancta Sophia at Trebizond, which are in a sophisticated, polished style, more closely related to that of Constantinople than to that of Cappadocia. They date from about the middle of the thirteenth century and will be discussed below. Work in the region of Trebizond, however, more particularly that in the Monastery of Sumela, is similar to that of Cappadocia, and the Cappadocian monastic style seems to have spread not only to that area, but also farther to the North and East, into Armenia and Georgia, where much of the painting belonged to the same Eastern family. Indeed, the monastic style of Asia Minor exercised a very wide influence, for cave paintings in Southern Italy would also seem to be related. Our knowledge of the monuments is still incomplete, and a good deal no doubt remains to be discovered, in other regions as well as in Cappadocia.

Though Asia Minor was a very vital part of the Byzantine Empire, providing minerals, corn, and an essential reserve of manpower, its religious art was after Justinian's day not really as important as that of the regions to the East, comprising the lands of Armenia and Georgia. This area was the centre of very great architectural activity, and buildings of really outstanding quality were being set up in large numbers from the seventh century onwards all over what are today the Republics of Georgia and Armenia and the eastern provinces of Turkey. At first a more or less universal style characterized the whole area; later, from about the tenth century onwards, the architecture of Armenia and of Georgia began to develop along independent lines, and by the twelfth century each country boasted an independent style of its own, though many features were shared in common, notably construction in squared stone, conical domes on tall drums, and a love of plans which were variants of the cross in square. The Byzantine world, and at a later date the West, owed a good deal to early developments in the Caucasus, but the Georgian and Armenian buildings are not Byzantine in the narrow sense of the term; they represent separate and very important families of East Christian Church architecture.

Thanks to the abundance of an admirable building material in the form of a workable but durable black tufa, a highly accomplished building technique was developed at an early date, and though timber was certainly at first used for roofing, advanced systems of vaulting and domical construction in stone soon replaced the timber almost entirely. So proficient were the Caucasian builders, indeed, that some authorities have sought to attribute the origin of the Byzantine domical style, as we see it in such buildings as St Eirene and Sancta Sophia in Constantinople, to Armenian inspiration. But though the evolution of nearly all the basic types of church can be traced in Armenia, little survives there that can be firmly dated before the end of the sixth century, and by that time considerable advances had already been made in other places, notably in Rome, in Syria, in Asia Minor, and in Byzantium itself. The earliest Armenian churches appear to have been vaulted basilicas, but it would seem that the Armenian architects had become interested earlier than those elsewhere in the elaboration of the domed square, and a whole series of variations on that plan can be traced from the seventh century onwards.

The simplest of these variations consists in the addition of niches on all or some of the sides of the square, as we see in the church at Mastara (*Ill. 124*), built about 648 under Bishop Ghuniantz. In the next elaboration buttresses which form additional chapels were

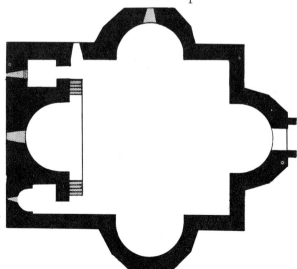

124 Plan, the Church of Mastara, Armenia. Niche-buttressed square

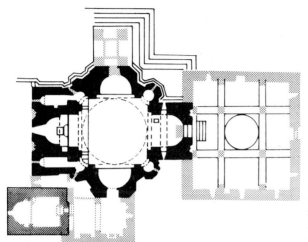

125 Plan, the Church of Achthamar. Niche-buttressed square with corner chapels. Built for King Gagik of Armenia, 915–921

added at the corners also, sometimes at all four corners, as in St Hripsime at Etchmiadzin, founded by Bishop Komitas in 618, and sometimes at the two easterly corners only, as at Achthamar, built for King Gagik by the architect Manuel between 915 and 921 (*Ill. 125*). This is one of the most remarkable churches in the Armenian style; it stands in a superb setting on an island in Lake Van (*Ill. 126*), and its exterior is adorned with a series of sculptures in quite high relief (*Ill. 127*). Below these are full-length figures depicting the founder and members of his entourage, as well as scenes from the Old Testament, ultimately of Byzantine inspiration; above is a vine scroll enclosing hunting scenes which are closely related to those current in Islamic art of a slightly earlier date; they include figures which are derived from Central Asian prototypes. The sculptures of Achthamar indeed constitute a fascinating museum of the ideas and styles prevalent in East Christian and Islamic art of the time; a large volume could well be written on their origins and influence. Today Achthamar is an isolated ruin, for there are no longer any Armenians in this part of Turkey. It was once the centre of a prosperous community. But it is to a great extent thanks to its

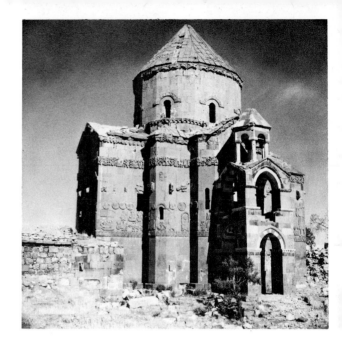

126, 127 The church on the Island of Achthamar, Lake Van, the south side (*above*) and the west end (*below*). The elaboration of the sculptural decoration of the outside is unequalled elsewhere

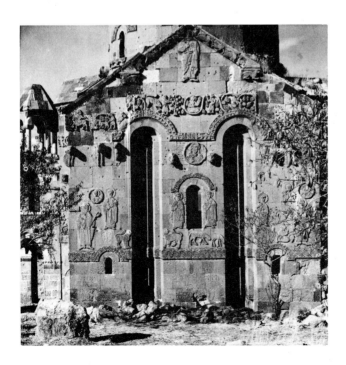

seclusion that it has survived; otherwise it might well have been used as a quarry for later buildings or road metal.

Numerous further elaborations of the square plan were practised, the most important of which was the detaching of the dome from the side walls and supporting it on piers or columns, as in the Cathedral in Bagaran of 624 (*Ill. 128*), or that at Etchmiadzin, which is the seat of the Armenian Patriarch, the Head of the independent Armenian Church. The Cathedral there was founded in 483, and vestiges of the original structure have been disclosed by recent excavations below the sanctuary. Nothing of the original work however survives above ground, for the Cathedral was entirely rebuilt in 618. It was repaired between 640 and 661 and again in 1442 and in the seventeenth century; it would seem however that but for the porch, which was added in 1658, and the treasury on the south-east which dates from 1882, the structure is in the main to be assigned to the seventh century.

128 (*right*) Plan of the Cathedral at Bagaran. Dome on piers in apse-buttressed square

129 (*below*) The city church, Ani, a three-aisled, basilical church

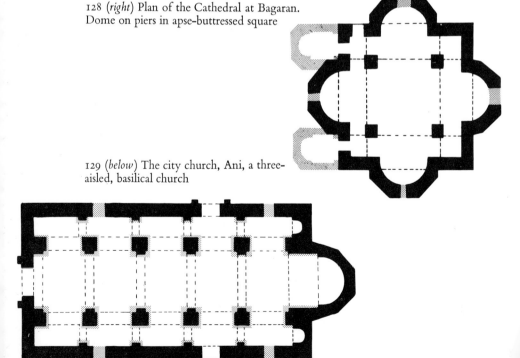

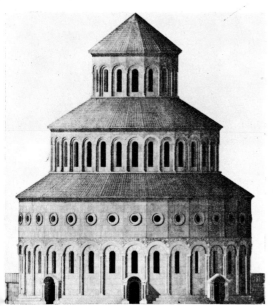

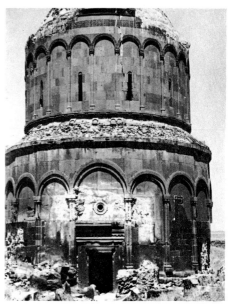

130 Reconstruction of the circular church of Zwarthnotz, Armenia. 641–61

131 The Church of the Redeemer, Ani. It owes something of a debt to Zwarthnotz

Apart from these and other variations on the theme of dome over square, the Armenian architects were responsible for developing numerous other types of plan, and elaborate forms, like the quatrefoil, hexafoil, or octofoil, were all popular. The most important example was the great quatrefoil church of three diminishing vertical stages at Zwarthnotz, built by Narses I (641–61) (*Ill. 130*). It now survives at ground level only, though enough evidence was found during excavations to permit a full reconstruction. It was copied on a rather smaller scale in the Church of St Gregory of Gagik at Ani, which dates from 1001. Of the octofoil buildings one of the best preserved is the Church of the Redeemer in Ani (*Ill. 131*).

Rectangular buildings were also numerous, three-aisled, like the city church at Ani (*Ill. 129*), of 622, three-aisled with columns, like Eghiward (seventh century), or with domes on columns in the

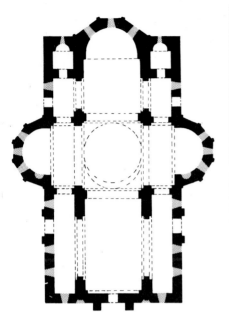

132 Plan, the Cathedral, Thalin. Longitudinal and trilobe plans combined

133 East end of the Cathedral, Ani, showing blank arcading and tall niches

Byzantine manner, as in the Cathedral at Thalin built in the same century (*Ill. 132*). Here a longitudinal and a trilobe building seem to have been combined; in the Cathedral at Ani (*Ill. 133*), begun in 989 and finished in 1001, the form is a plain rectangle outside; inside, the dome was supported on four piers and there are small chapels on either side of the large central apse. The outside is especially interesting because of the tall, deep niches which stretch from floor to roof level; they are paralleled at Kutais (c. 1003) and elsewhere. The side walls are decorated with blank arcading and in its simple dignity the Cathedral at Ani represents one of the finest buildings in Armenia; its interior could rank in grandeur with that of any great Romanesque church of France of around 1100.

Though Etchmiadzin was the home of the Patriarchate and the centre of the Faith in Armenia throughout the whole of the country's

history, it is in the ruined and deserted city of Ani that the later architecture can be most satisfactorily studied, for it was the capital from 856 till 1071, and when the country fell under the control of the Seljuk Turks as a result of the defeat of the Byzantine armies at the Battle of Manzikert, Ani still remained for a time a centre of activity. A mosque was built there in 1080, there was a castle and a palace, and there are several churches of twelfth- and thirteenth-century date, like that of St Gregory of Tigrane Honentz (*Ill. 134*) built in 1215, a single-aisled church of the inscribed-cross plan, with tall dome resting directly on the side walls. All are comparatively well preserved, for the city was gradually abandoned during the course of the fourteenth century and its site remains deserted today. It is one of the most interesting medieval towns to be found in the Near East, strangely remote and astonishingly impressive in its desertion; its domed and vaulted buildings with their arcaded exteriors herald most surprisingly developments which were to characterize Romanesque and Early Gothic architecture in the West one or more centuries later.

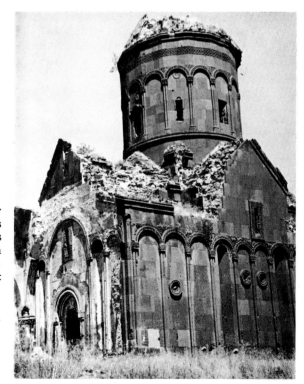

134 The Church of St Gregory of Tigrane Honentz, Ani. It is one of the finest of the numerous churches but of a later date than the majority, for by the thirteenth century Ani had lost much of its former importance

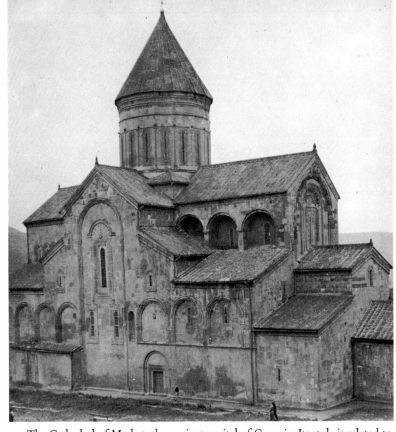

135 The Cathedral of Mschet, the ancient capital of Georgia. Its style is related to, but also distinct from, that of Armenia

The neighbouring territory of Georgia did not adopt Christianity quite as early as Armenia, nor was its Church independent in the same way, for Georgian Christians were of the Orthodox persuasion and their Faith developed in line with that of the Byzantine world. But the architecture of the area was more closely related to that of Armenia than to that of Byzantium, and there are churches in Georgia which are quite as early in date and quite as progressive as those in Armenia. Some authorities would insist that vaulting systems and the use of the dome above a square base were developed there independently of Armenian or other influence, but this is hardly likely even though domes supported on squinches are to be found there at an early date, as for instance at Dsromi, which dates

from between 626 and 634. On plan this church is closely related to St Gayane at Etchmiadzin (630–36) and to Mren Cathedral (639–40) in Armenia, and it would seem that in reality architectural developments in Georgia and Armenia constituted part of the same story; it was only with the ninth or tenth century that work began to develop along distinctive lines in the two countries.

Numerous examples, finely built in cut stone, survive from that time onwards. The tenth-century Cathedral at Mschet (*Ill. 135*), the old capital of the country, is characteristic, with its rather flat, blank arcades and its great height. The buildings are less exuberant than those of Armenia, and their effect is rather cold. They are also often distinguished by a love of very complicated plans, which included such combinations as a cross in a rectangle or in an octagon, a quatrefoil in a rotunda or a hexagon, or a combination of cross and quatrefoil. The architects seem to have thought of the churches as complicated geometric figures on the flat rather than as vertical constructions. This is for instance the case with the church at Djvarî, near Mschet (*Ill. 136*), where square corner chapels have been added to the already complicated plan of an apsed square with corner niches. It was completed under Mtavar Adarnass I (619–39).

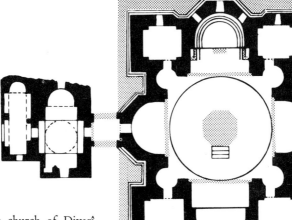

136 Plan, the church of Djvarî, near Mschet. The great complication of plan is typical

147

137 Sculpture over the west door at Djvarî. Exterior sculpture of this type was fairly common in the Caucasus, though it never occurs in the Byzantine world

The plan of St Hripsime at Etchmiadzin in Armenia is very similar. But the walls of the Georgian churches were often decorated with sculptures and there is in Georgia some interesting figural as well as a good deal of complicated ornamental work. A composition of two confronted Angels over the west door at Djvarî (*Ill. 137*) serves to illustrate the Georgian figural style. The ornamental work is based on geometric interlace of a very intricate type; such work was much used for the framings for doors or windows and illustrates the Georgian love of pattern. But these Georgian decorations are not necessarily more elaborate than those which were developed in Armenia from the tenth century onwards, where a very distinctive type of grave-stone, known as *hatchkar*, became very popular.

From the little evidence that survives it would seem that wall-paintings were not as uncommon in Armenia as was once supposed. Remains of decorations of tenth-century date survive in several churches; most important are some at Achthamar, which are presumably of the same date as the church itself (915–21). But it was as illuminators of manuscripts that the Armenians were most dis-

tinguished, so far as the pictorial arts were concerned, and though much of the work was somewhat crude in comparison with that done in the Byzantine world, it was always colourful and decorative, and showed at certain periods a vividness and appreciation of life which were quite distinctive.

The story begins with four leaves bound up in a copy of the Gospels now preserved in the magnificent manuscript library known as the Matenadaran at Erevan (Matenadaran 2374); it was formerly in the Patriarchal Library at Etchmiadzin. They bear representations of the Annunciation to Zacharias, the Annunciation to the Virgin, the Adoration of the Magi, and the Baptism, and are probably to be dated to the sixth century. The style recalls that of the mummy portraits of Egypt or of some of the earliest icons on Mount Sinai, but it is one which seems to have been fairly generally adopted in Armenia, for in a recent publication of the manuscript Miss Dournovo calls attention to the fact that a closely similar style characterizes wall-paintings of the seventh century in two small Armenian churches at Lmbat and Arudj as well as a manuscript dated to 902 now in the Mekhitarist Library of S. Lazzaro in Venice, which was commissioned by Queen Mlke of Vaspurakan (Armenia).

Apart from these four leaves at the end, the Etchmiadzin Gospels themselves date from 989. The pages bearing subject-pictures such as the Sacrifice of Abraham (*Ill. 139*) are in a much lighter, less monumental style, with brighter colours and more open backgrounds, and the same is true of the frames for the Canon tables or for some of the scenes which are in many ways the most interesting things in the book. They follow those of the Rabbula Gospels (cf. p. 37) quite closely, and it or some very similar manuscript must have been used as a model. Frames of the same kind appear in numerous other manuscripts of the eleventh century.

From that time onwards the production of illuminated manuscripts became the most important art in Armenia. Most of them were manuscripts of Gospels, and many were illustrated with a wide variety of scenes from the Bible story; almost all contain the portraits of the Four Evangelists. Two principal styles are to be distinguished at the outset, one where architecture (*Ill. 138*) or landscape

138 Miniature in the Etchmiadzin Gospels. Circular structures of this type were favourite motifs in Armenian as well as in Western painting

backgrounds play an important part and where animal and bird motifs are frequently introduced, the other where the figures stand isolated, though their faces and gestures are often expressive. This is the case, for example, with the Gospels of 1038 at Erevan (Matenadaran 6201) (*Ill. 141*); it contrasts strikingly with the rich, heavily charged pages of the Gospels of Mugni of the mid-eleventh century (Matenadaran 7736). This is indeed one of the finest manuscripts of the whole Armenian school; the colours are rich and gay, the figures expressive, the settings attractive, and there is a marked feeling for naturalism; the scene of the Presentation in the Temple (*Ill. 140*), with buildings behind and a blue sky above them, may serve as an example. It was a work produced at the command of some influential or important patron, in contrast to the Gospels of 1038, which is characteristic of a poorer, monastic school.

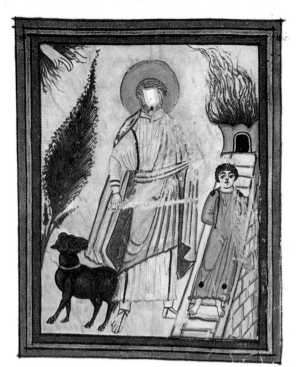

139 (*right*) The Sacrifice of Abraham, in the Etchmiadzin Gospels, Armenian work of 989. The style is primitive yet very forceful and expressive

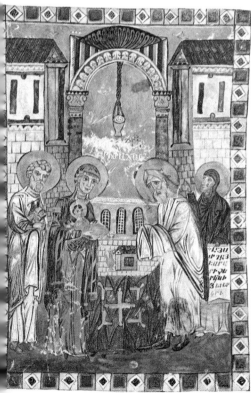

140 (*left*) The Presentation in the Temple, from an Armenian manuscript known as the Gospels of Mugni, dating from the mid-eleventh century and done in all probability for a rich and prosperous patron

After about 1100 the division between these two schools became less clearly marked. This was to some extent the result of historical events, for Ani, the centre of the Bagratid kings, fell to the Turks soon after the middle of the eleventh century and the centre of patronage moved elsewhere. Indeed, for the next century or so the best work was done not in Greater Armenia, but in Cilicia, the so-called Lesser Armenia, and it was distinguished by a marked increase of Byzantine influence. Gold backgrounds became usual, the figures were better drawn and more elegant, and the costumes were more classical and more fully modelled. Soon after this the Armenians of Cilicia also came into contact with the Crusaders, and occasional Western elements began to appear in their art though they were never very important. A great deal of work of real excellence was however done in Cilician Armenia, and some of the finest examples of later Armenian painting were produced there.

The Cilician school probably reached its apogee in the work of the painter Toros Roslin, who brought to the art a new vigour which was wholly personal. There are seven manuscripts signed by him in Jerusalem, dated between 1256 and 1268, and others at Erevan and elsewhere have also been attributed to him. He was at his best in work on a small scale, especially when he did scenes in the text, for his figures have the expressive brilliance of works like the famous Vienna Genesis of the sixth century; those in a manuscript at Erevan called the Gospels of the Six Painters (Matenadaran 7651) are especially delightful (*Ill. 142*). His full-page illustrations are characterized by decorative borders, very full backgrounds, and exaggerated angular poses, while his palette is lively and fresh.

Though Cilician Armenia was the most active centre during the twelfth century, work in Greater Armenia continued, and a number of distinct schools grew up there such as those of Etchmiadzin, Van, and Mush. In all great stress was laid on rhythm and there was great interest in expressive illustration, which resulted at times in an almost ominous character. There was no gold, no grandeur, yet the scenes were rendered so that all could follow the story without difficulty. There was little sophistication, yet there was greater universality, and the art was something available to all.

Few of the later manuscripts are of the same quality as those done up to the twelfth century. Sometimes the old 'silhouette' style, where the backgrounds were omitted, was revived; sometimes the work showed the clear influence of Byzantine prototypes, both in style and iconography. Sometimes Canon tables or margins were profusely decorated in the manner of the Etchmiadzin Gospels; sometimes the heavy features characteristic of Syrian art in the 'Egyptian' style were revived. But nearly all the later miniatures were naïve and somewhat clumsy, depending mainly on decorative effect for their appeal. The best work took the form of marginal adornments, and the animal and bird motifs used in this way were often very delightful. This 'animal style' often showed close links with Persia, and by the fifteenth century many Armenian illuminators were clearly being inspired by Persian masters. Conversely some of the manuscripts decorated in Iran for Islamic patrons owed quite a debt to Armenia.

The story of painting in Georgia differs from that of Armenia much more than does that of architecture. Georgian manuscripts are far less numerous than Armenian ones, and the majority are wholly Byzantine in style; wall-paintings, on the other hand, played a very important rôle in Georgia and there are also vestiges of several extensive mosaic decorations; those at Dsromi, of the seventh century, and at Ghelat, of the later eleventh, are the most important. The Ghelat mosaics were actually done between 1125 and 1130. In the apse is the Virgin, full length, between the Archangels Michael (*Ill. 143*) and Gabriel. In both a predominance of red and purplish tones and a love of rather linear patterns distinguishes the work from that of the Byzantine area more narrowly speaking. At Ghelat the mosaics are set in a rather distinctive way, the cubes being placed in lines which follow those of the muscles below the skin, and so produce what is virtually a piece of linear pattern on the faces.

Of the paintings the earliest are some of the eighth century at David-Garedja, but most of the work there is of the tenth (*Ill. 144*). The colours, like those of the mosaics, are quite distinctive, green, brown, ochre, and white prevailing in the costumes, while the faces

153

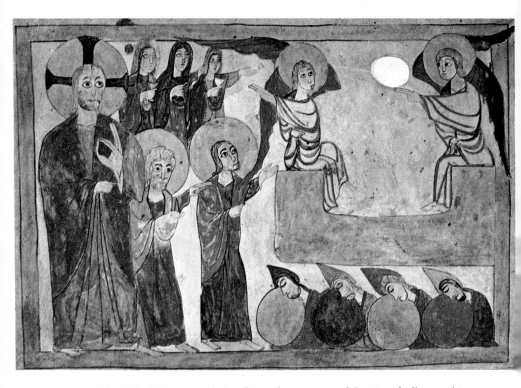

141 The Holy Women at the Sepulchre, from a copy of the Gospels illustrated in Armenia in 1038. The rather primitive style may be contrasted with the more polished work of the Gospels of Mugni (*Ill. 140*)

are now dark brown or even black, though this is to be to some extent attributed to changes that the pigments have undergone since they were applied. Green undercoats were thus normal and their colour has deepened while that of the overlying flesh tints has faded. At David-Garedja the figures are severe and linear; at Ateni in the tenth century, they are rather fuller and more modelled and suggest Byzantine prototypes, but the colouring, with muddy grey, brownish-red, and ochre predominating, is wholly Georgian. There are other paintings of the tenth century at Ghelat, and some of the eleventh at Ihari, akin to those of David-Garedja.

142 Individual scenes from a book known as the Gospels of the Six Painters at Erevan. The feeling for bright colour distinguishes it from much of the work of the same period

Though mosaics and wall-paintings were thus important in Georgia—indeed they were probably more numerous than the examples that survive would suggest—the primary place in the arts must be accorded to the metal-work and the enamels. A surprisingly large number of examples in both materials were produced, and the making of repoussé metal-work icons, crosses, frames for icons, or covers for books was virtually a national art. Literally hundreds of examples survive, many of which have now been assembled in the Museum in Tbilisi. The earliest are to be dated to the ninth century, the later ones to the eighteenth. Often they were adorned with

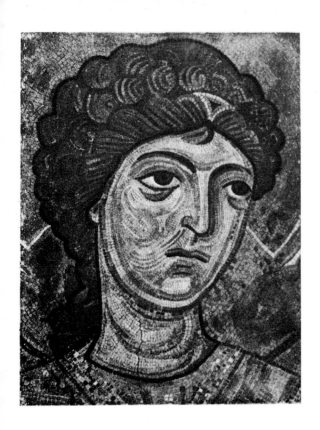

143 (*left*) Mosaic at Ghelat, Georgia

144 (*below*) Wall-painting, at David-Garedja, Georgia. These two works, though in different media, serve to illustrate the rather harsh style of Georgian art in contrast to the Byzantine, as well as its greater sophistication in contrast with the Armenian

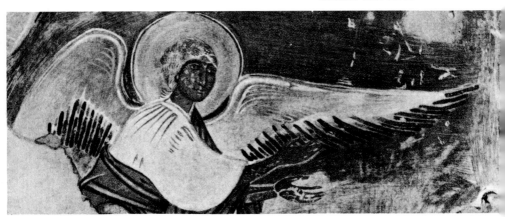

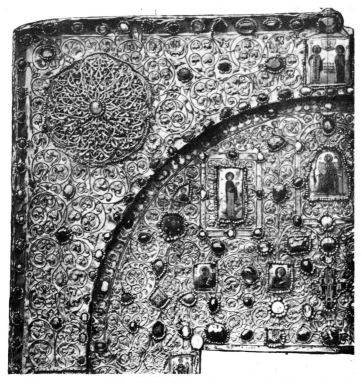

145 Upper quarter of the Khakhuli Icon. It consists of richly embossed metal, with enamels and precious stones attached. Some of the enamels are Georgian, some Byzantine

enamels, some of which were Byzantine and some Georgian; it would seem that their manufacture began there in the eleventh century and reached its fullest production in the twelfth. The Georgian work is to be distinguished from the Byzantine by rather higher cloisons, less delicate colours and, in the twelfth century, by a great profusion of cloisons, which produced a very linear effect. In figural work the multiplicity of cloisons tends to be rather disagreeable, but it does not mar the ornamental work so much, and it was in the ornamental sphere that the best Georgian work was produced. A considerable number of Georgian and Byzantine enamels appear together on what is the most famous piece of Georgian metal-work, the Khakhuli Icon, now in the Tbilisi Museum (*Ill. 145*). It consists of

a metal panel, as much as 1·40 metres high, with the main design in repoussé. To this are attached a number of enamels of dates varying between the ninth and the twelfth century. Those showing the Crucifixion, Constantine and Helen, and the portraits of Michael Ducas and his Empress (1071–78) are Byzantine; nearly all the others are Georgian.

Another art—or perhaps one should call it a craft—which was widely practised in Georgia was that of wood-carving, and some fine doors and similar panels, originally for cupboards and so forth, survive in not a few of the churches. Glazed pottery was made there too; it is interesting as affording a link between the ceramic arts of Persia and the Byzantine world; indeed Persian elements played an important rôle in many of the arts of Georgia, and secular manuscripts of the fifteenth century and later seem to have been illustrated in a wholly Persian style, as opposed to the essentially Byzantine style of the earlier religious ones. But manuscript illumination was never a national art as it was in Armenia, nor, conversely, was metalwork ever important in Armenia. Probably in no other instance are the differences between two peoples living so near to one another under such similar conditions as clearly expressed as in these arts.

In the early centuries Sicily was a part of the Byzantine Empire, but with the advance of Islam much of the island fell under Moslem domination as early as 662, and its control remained disputed until the arrival of the Normans in 1072, when a new and stable Kingdom was founded and the Moslems were finally expelled. Little, if anything, survives from the years of Byzantine overlordship; it is to that of Norman domination that the most important Byzantine monuments in Sicily are to be assigned, for nearly all the Norman rulers were active patrons of art, and nearly all sought for craftsmen in the Byzantine world and sponsored works which were more Byzantine than they were Western. The churches they built, though they usually adopted the longitudinal three-aisled plans of the West and were without the traditional Byzantine domes, were mostly very Byzantine in detail. They constitute a group which may best be described by the term 'orientalizing'. The east end of the Cathedral at Cefalù (*Ill. 146*) is, for example, typical. It is adorned with blank arcading of a wholly Byzantine character and one would be less surprised to find it in Constantinople than, say, in Southern France. The mosaics that decorate the interiors were even more purely Byzantine, and were as often as not the work of Greek craftsmen who had been brought to Sicily from Constantinople to work for the Norman patrons. The minor arts, especially the textiles, that were produced for them were either inspired from the same source or showed the effects exercised by proximity to the Islamic world; the ceiling of the Palatine Chapel at Palermo, for instance, might equally well have served for a palace in Cairo or North Africa.

The earliest of the mosaic decorations, and in many ways the finest also, are those in the apse and presbytery of the Cathedral at Cefalù. The church was begun by the most important of the Norman kings, Roger, in 1131, but the presbytery was not finished till 1148. The

mosaics were started soon after, beginning with the apse, continuing with the vault, and ending with the vertical side walls of the presbytery; last of all to be set were the Prophets and Patriarchs at the tops of the walls. These, and probably the rest of the mosaics on the side walls, are to be regarded as the work of Sicilian pupils who had been taught by the Greeks who did the walls of the apse and the conch. The apse was probably finished before King Roger's death in 1154. Work must then have stopped for a time, but it was resumed perhaps before 1160 on the presbytery walls, then on the vault and finally, about 1170, at the point of junction between vault and walls.

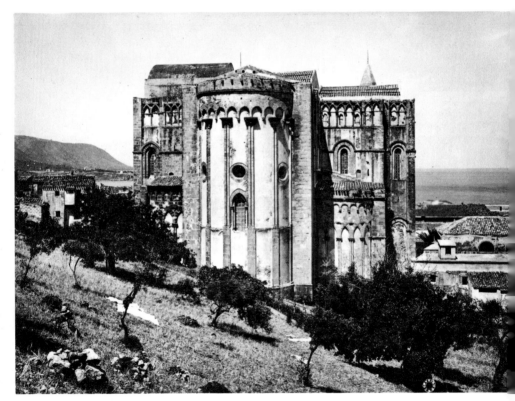

146 The east end of the Cathedral at Cefalù. It is a Romanesque structure in a very eastern style

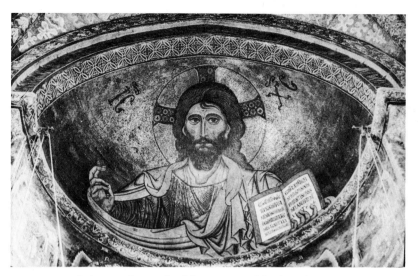

147 Mosaic of Christ in the conch of the apse at Cefalù, done for a Western patron by Byzantine craftsmen

The most important feature is the large bust of Christ Pantocrator in the conch of the apse (*Ill. 147*)—a figure, which in a truly Byzantine building would normally have occupied the central dome. Christ holds a Bible, open at the text 'I am the Light of the World'; in keeping with the dual character of the civilization of Sicily at the time one leaf bears the text in Latin, while on the other it is in Greek, though all the work must have been done by Greek craftsmen. The face is full of majesty, but less awesome and strange and at the same time less spiritual than that at Daphni in Greece (cf. *Ill. 77*). It was followed closely by the mosaicists who worked some forty years later at Monreale, but the rendering there is harder and less sympathetic and subtle than that at Cefalù.

On the vertical walls of the apse the mosaics are arranged in three rows or registers, the Virgin in the *orans* position between Archangels above, six Apostles in the middle, and six more below. Other Saints are shown on the North and South walls of the presbytery, four below and four above on each side; above again are medallions

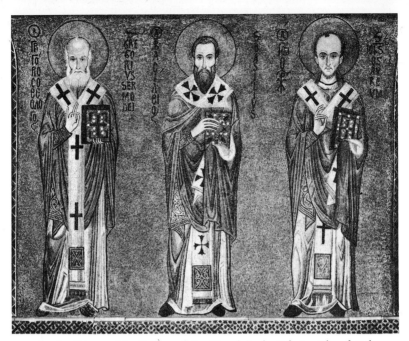

148 Mosaic of three of the Fathers of the Church in the Palatine Chapel, Palermo. Greek and Sicilian craftsmen both worked on the mosaics; this is Greek work

containing busts of Prophets, and on the vault, which is quadripartite, there are Angels in the corners and Cherubim and Seraphim in the main area. They are decorative rather than emotional, but effective nonetheless, even if to a lesser degree than the very beautiful and powerful figure of Christ.

The Palatine Chapel at Palermo was also begun soon after 1130, but the mosaics that decorate it are not only more extensive than those at Cefalù, but their setting also extended over a longer space in time, and represented the work of several distinct schools. First to be finished were the mosaics of the dome and its supports, dated by an inscription to 1143. Like the earliest mosaics at Cefalù they are to be attributed to Greek craftsmen; the technique is excellent, the gradations of tone and colour are subtle, the draperies flowing, and the figures elegant; a rendering of three of the Fathers of the Church, St Gregory, St Basil, and St John Chrysostom (*Ill. 148*), serves to indicate their character and to show the very refined nature of the work. As soon as the mosaics of the dome were completed, work

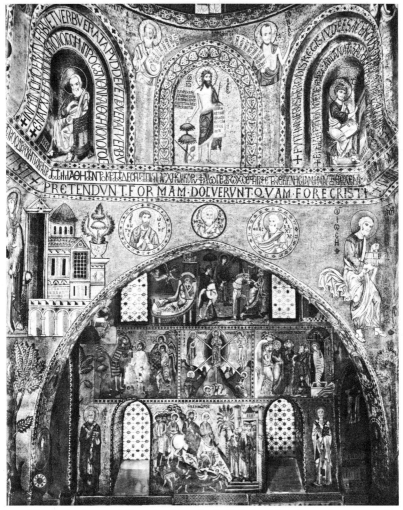

149 Mosaics in the area below the dome in the Palatine Chapel at Palermo. On the wall face below are five of the main 'Feasts of the Church'

seems to have begun on the walls of the central square below, probably by the same craftsmen; it was finished about 1148. The transepts were decorated when the central square was finished, but before that or the walls were completed there must have been a change of plan, for it is clear from the way that the Baptism and the Nativity join (*Ill. 149*) that the former scene was an afterthought, resulting perhaps from changes due to the death of King Roger in

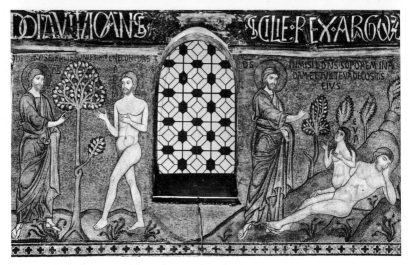

150 Mosaic in the nave of the Palatine Chapel. Christ with Adam and the Creation of Woman. The work in the nave is by Sicilian craftsmen taught by Greek masters

1154. The other scenes—the Transfiguration, the Raising of Lazarus, and the Entry into Jerusalem—are akin to the Baptism in that they have the character of framed icons, and must have formed a part of the same reformed scheme. They are placed directly opposite the Royal Box which was reconstructed by King William I (1154–66) early in his reign, and are no doubt to be dated to the same time.

The mosaics of the nave are in a distinct, much clumsier style. Those in the upper tier are probably the earliest, and were set soon after 1158; they show a series of scenes from the Old Testament. Those in the aisles, with scenes from the lives of St Peter and St Paul, were probably put up next and date from the sixties or even the early seventies. In all these the inscriptions are in Latin, Western traits are marked, and the work is certainly to be attributed to Sicilian and not to Greek craftsmen. The various scenes all illustrate the stories vividly enough, as for instance the Creation of Man and Woman (*Ill. 150*) and the Paradise scenes, and there are delightful and expressive renderings from the lives of St Peter and St Paul; but the spiritual profundity of the earlier work is lacking, and we would seem to be in the presence here of a style which represented a transition from the transcendental interpretational manner of Byzantine art to a new, vigorous, but wholly illustrative style of a more Western character.

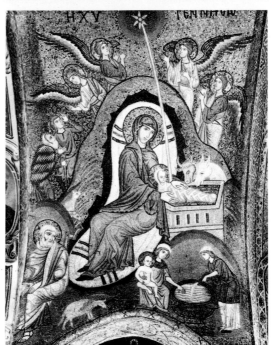

151 Mosaic—the Nativity. Church of the Martorana, Palermo, 1143–51. The work in this church is particularly delicate and is to be attributed to Greek craftsmen

The mosaics of the one remaining church in Palermo, the Martorana, all date from between 1143, the date of the church's endowment, and 1151, the year of its completion. They would however appear to follow rather than to antedate the first work at Cefalù. The decoration was done at the demand of a Court official and not for a monarch, and the character of the patron seems to be reflected in the mosaics for they have an intimacy and a simplicity absent from the other monuments on the island, though the master must have been trained in the same school as the Greeks who worked on the other decorations. The church is a centralized domed structure of Byzantine plan, and a series of scenes from the New Testament survive today in the dome and on the walls and vaults below it; the whole area to the east, the presbytery or *bema*, to use the Greek term, has been re-done with a moulded-plaster decoration in the rococo style, which is hardly a happy juxtaposition, for the mosaics, though more intimate than many mid-Byzantine works, are nonetheless still in an austere, transcendental style, which does not blend with the more material manner of the plaster-work. The Nativity (*Ill. 151*) on the vault to the west of the central square is

thus well nigh an abstract composition, from which the more narrative aspects of the subject which are so often present—the Annunciation of the Good Tidings to the Shepherds, the Arrival of the Magi, and so on—have been omitted. Some of the other scenes, however, like the Presentation in the Temple, show a very intimate and expressive conception, in which the more humanistic outlook which characterizes so much twelfth-century Byzantine art is clearly to be seen. The hierarchic outlook of the tenth century is nevertheless still very marked in two panels in the narthex which depict respectively the Crowning of Roger II (*Ill. 152*) and the Dedication of the Church to the Virgin by its founder, the High Admiral George of Antioch. The crowning follows closely the scheme of mid-Byzantine coronation themes, as for example on the Romanos Ivory (cf. p. 87); the King's figure is nearly as large as Christ's, for he takes on, through the crowning, the rôle of Christ's vice-regent on earth. But in the dedication scene the High Admiral appears almost as a worm before the divine figure of the Virgin. This was certainly intentional, to stress on the one hand the importance of the Sovereign and on the other the immensity of the gap that separated the divine from the human figure, the spiritual from the material world.

On a far more extensive scale is the decoration of the Cathedral of Monreale a few miles to the south of Palermo. Unlike the Palatine Chapel and the Martorana, it is a huge Cathedral and every square inch of the wall-surface is adorned with mosaics or decorative marble-work. The mosaics were set up under the patronage of William II and represent the last of the great Sicilian decorations; they were probably all completed by 1190. The cycle of scenes there is one of the fullest that survives in the whole Byzantine world, not only in mosaic, but also in paint. Where the scenes repeat those of the Palatine Chapel, they follow the same iconographical model, but there are considerable stylistic differences, and they are in no way copies of the earlier works. Indeed, Kitzinger, in a recent study, sees little that is purely Sicilian in them and suggests that several teams of workmen must have been brought from the Byzantine world to do the work at Monreale, men who were familiar with the most

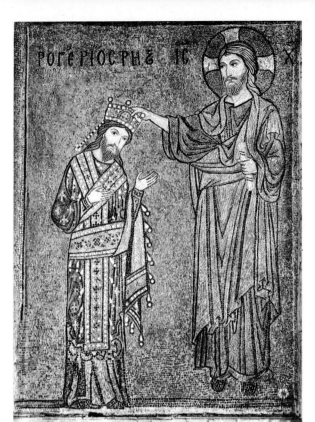

152 Mosaic—the Crowning of Roger II by Christ, in the narthex of the Church of the Martorana, Palermo. It may be contrasted with the much clumsier rendering at Monreale (*Ill. 155*)

up-to-date developments of the penultimate decade of the twelfth century. Their work is distinguished by a love of wind-blown draperies, by very dynamic movements, and by a greater intensity of feeling than is to be seen at Palermo, though there is less elegance and beauty. The more static, more conservative work in the Palatine Chapel contrasts very markedly. Kitzinger finds the closest parallels to this approach in a whole series of wall-paintings done between about 1180 and 1200 in places as far apart as Staraya Ladoga (1180) in North Russia and Lagoudhera in Cyprus (1192); the most extreme examples of the style are afforded by the wall-paintings at Kurbinovo and Kastoria in Macedonia (cf. pp. 193, 195). The first developments of this more expressive style no doubt took place in Constantinople; in the absence of monuments in the Byzantine capital the paintings of Nerezi in Yugoslavia must serve as an illustration of their character (cf. *Ills. 174, 175*, p. 127). But the great

extremes of expression, movement, and the tendency towards angularity and elongation which we see at Kurbinovo and elsewhere are to be regarded as provincial variants of the style, and the Monreale mosaics savour only slightly less of provincialism than do the paintings of Kurbinovo; it is impossible to agree with Kitzinger when he regards the Monreale mosaics as almost wholly the work of Constantinopolitan craftsmen. The wall-paintings at Nerezi bear the hall-mark of the metropolis; all the other work in the style, including the Monreale mosaics, lacks the distinguishing touch of elegance which had from the earliest times been typical of all that was done in Constantinople. Yet all these decorations owed a great deal to the capital, and the nature of the debt is illustrated by the basic similarity of some of the Kurbinovo paintings to Nerezi, though Kurbinovo is essentially a provincial, Nerezi a metropolitan, monument.

In spite of their dynamic character, their great extent, and their undoubted power of expression, the Monreale mosaics are in many ways disappointing. The colours are frigid and unattractive in comparison with other Byzantine mosaic decorations, the setting of the cubes somehow lacks subtlety and the scintillating colours and effective high-lights which make many mosaics so delightful, so moving, and so impressive are absent. The mosaics of Monreale are, no doubt, immensely important and of great significance to the iconographical specialist, but aesthetically they cannot compare with the other Sicilian works, especially those at Cefalù.

As at Cefalù there is a great figure of Christ Almighty in the apse. This image is set there in both places as neither building has a dome, the normal place for the theme. It is interesting to compare the rendering at Monreale with the closely similar one at Cefalù; the face is harder and less sympathetic, the folds of the costume are at the same time more agitated yet more mechanical, and the pose is more

153 Detail of mosaic showing the healing of the paralytic, the lame and the blind (*Ill. 154*) in the Cathedral of Monreale, Sicily

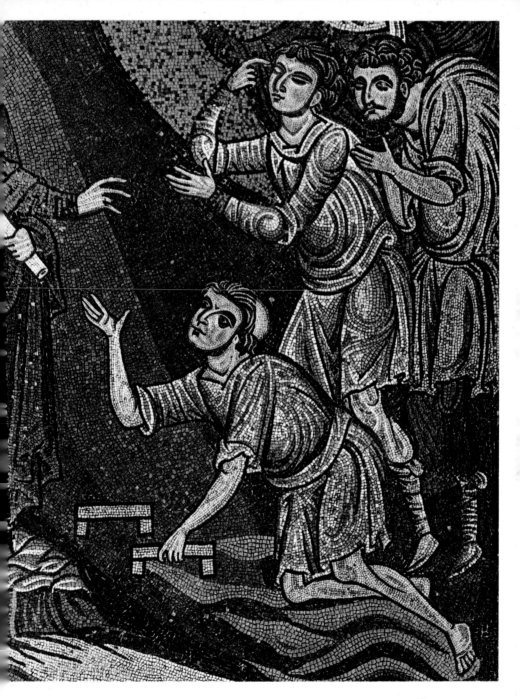

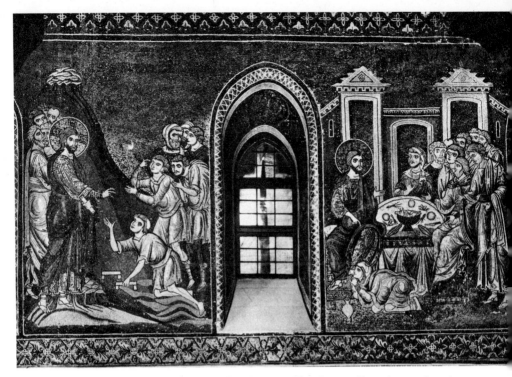

154 Wall mosaics at Monreale, showing Christ's miracles. The work is here
probably to be assigned to Sicilian craftsmen

angular and more exaggerated. Similar differences are also apparent
if the scenes of a more narrative character are compared with those
in the Palatine Chapel. In the Healing of the Lame and Blind (*Ills.
153, 154*) for example the suppliants are expressive at Monreale, but
Christ's followers are crowded into too narrow a space behind Him
and the composition is consequently unpleasing; in the Palatine
Chapel the allocation of space to the various figures shows a far
better feeling for composition. The scene of the Founder's Coronation
by Christ (*Ill. 155*) again is hard and mechanical, and the composi-
tion is spoilt by ungainly inscriptions and the awkward arrangement
of the Angels; as a picture it compares most unfavourably with the
similar scene in the Martorana. These contrasts might be multiplied
and they serve to show the essentially provincial character of the
Monreale mosaics. But there are nevertheless some very attractive

155 The crowning of the Emperor William II by Christ at Monreale. William was responsible for the church and its decoration; he wished it to surpass in glory all the buildings of Sicily

156 Decorative mosaic in a room of the Royal Palace at Palermo. It is of a very oriental character, recalling Persian textiles

details, like that where Isaac as an old man sends out Esau to hunt for game (Gen. xxvii. 3) (*Ills. 157, 159*); here a marked feeling for the decorative nature of mosaics is most subtly allied to a vivid interest in the narrative itself.

One further monument in Sicily remains, though it is of an entirely different character, namely the mosaic decoration of the so-called Norman *stanze* in the Palace at Palermo (*Ill. 156*). The mosaics have been much repaired, but even so they represent the only secular decoration that is at all complete that has come down to us from the Byzantine world. They depict stylized beasts, formal trees, and hunting scenes, very like those which formed the motifs of oriental textiles, and the whole scheme savours of Persia. The mosaics that decorated several chambers of the Great Palace of the

157 Detail of the mosaic of Isaac and Esau, Monreale (*Ill. 159*). The gay colours and dynamic composition show the Monreale work at its best

158 Miniature mosaic of the Crucifixion. The tiny cubes are set in wax on a wooden core. The background here is silver; more often the cubes are gold

Emperors at Constantinople must have been very similar, for they too were in the Persian style; one of the chambers was called the Persian House. There are vestiges of similar decorations in two other palaces at Palermo, the Ziza and the Torre Pisana, but they would seem to have been more purely ornamental. Stylistic considerations suggest that the mosaics in the Norman *stanze* were executed between 1160 and 1170.

Apart from this mass of mosaics set up under the patronage of the Norman kings, Palermo was the centre of extensive artistic activity in other directions. Miniature mosaics were done, and it has been suggested that a very lovely little panel bearing the Crucifixion, now at Berlin (*Ill. 158*), was executed there; the style is however so very close to that typical of Constantinople that this seems unlikely; or, if it was made in Sicily, it must have been done by one of the

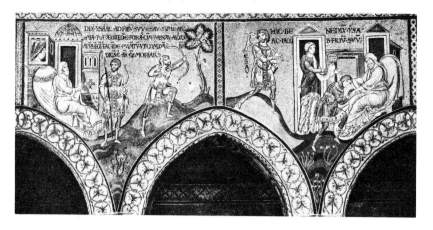

159 Old Testament scenes in the nave of the Cathedral at Monreale. The compositions tend to be overcrowded and the work shows to best advantage in detail

Greek workmen who were brought there from the Byzantine capital. It must date from the third quarter of the twelfth century. Panels were also painted, and it is tempting to attribute to Sicily two very similar ones now in America (*Ill. 161*). Again the style is close to that of the capital, but there is a certain precision and dryness about these paintings which is apparent if they are contrasted with the only certain Byzantine panel of the twelfth century, the icon, *Our Lady of Vladimir*, which suggests that they should perhaps be assigned to Sicily.

Sicily was also an important centre of ivory-carving under the Norman kings, but the work was secular and more Islamic than Byzantine in character, and can hardly be included in a survey which is devoted to the Christian art of the Near East. The textiles which were woven there, however, were of an essentially Byzantine type, and it is not always easy to be certain which of those that have come down to us are to be assigned to Sicily, and which to some centre in the eastern part of the Byzantine world. This is perhaps not surprising, for the texts tell us that weavers were brought to Palermo by the Normans from Corinth and Thebes, both important centres of the Byzantine textile industry. The largest and most important of the silks that have with reasonable certainty been assigned to Palermo is one at Sens, 1·39 metres long and 1·04 metres wide, bearing eagles

160 Silk with confronted birds. Sicily became an important centre of textile weaving under the Norman rulers and it is often hard to tell the products of the Sicilian looms from those of other centres in the Near East

confronted and winged lions back to back in medallions; it is known as the Shroud of St Potentien. There is a similar silk in Berlin (*Ill. 160*), but the birds are less 'baroque' and the whole treatment is more formal. The designs repeat motifs from the old oriental repertory long familiar in the Byzantine world, but the border is in Islamic script: the ceiling of the Palatine Chapel has, as we have seen, distinctly Egyptian traits, and Arab influence was of great importance in Sicily before the Normans arrived. Here we see it being exercised in the decoration of a textile. The most glorious of all the Sicilian textiles however is the great Coronation mantle of the Norman kings, now at Vienna, bearing formal trees and camels confronted. It is in a wholly oriental style similar to that of the mosaics of the Norman *stanze* in the Palazzo Reale at Palermo, but the addition of a long inscription in Arabic makes it a work of Islamic rather than Byzantine art, and it is impossible to do more than call attention to it here.

161 Panel-painting—Enthroned Virgin and Child. The painting is probably to be attributed to a Sicilian master working in the Byzantine manner.

The same close links with the Byzantine world that distinguish Norman Sicily were also at the basis of Venetian art in the twelfth century, but the Arab elements were absent and Latin influence played a more influential rôle—or rather one should perhaps say that the Venetians seized on those features in Byzantine art which were most susceptible to latinization, whereas the Sicilians preferred those of a more oriental trend.

Mosaics survive in the region of Venice in three places; on the Island of Torcello, on Murano, and in the Basilica of St Mark in Venice itself. Those in St Mark's are mostly of fairly late date and many of them are in a Renaissance rather than a Byzantine style, but a few, notably those in the apse, date from between 1110 and 1120, while there are quite large areas of decoration which are to be assigned to the last quarter of the century in other parts of the building. They comprise the scene of Pentecost (the Giving of Tongues) in the western dome, together with the Angels in the supporting pendentives, scenes from the life of St John in the northern dome, and four scenes from Christ's life: the Temptation by the Devil, the Entry into Jerusalem, the Washing of the Feet, and the Last Supper (*Ill. 162*), on the southern vault of the central dome. They are all in a narrative rather than a transcendental style, and have left behind many of the Byzantine conventions; nor are the stylistic elements that characterized the twelfth-century revival in the provinces—the dynamic attitudes, the elongated figures, or the wind-blown draperies—present. In the Washing of the Feet, for example, the Apostles are arranged in two rigid rows, those in front seated, with their right legs curled up, those behind peeping through between each of those in front; the whole conception is dry and rigid. In the Last Supper the conception is similarly static, though there are inconographic innovations. Ten of the Apostles are seated in a row behind a long rectangular table, with Christ at one end, St John bending over towards Him; the twelfth Apostle is at the opposite end. The Eastern semicircular table which persisted in the scene in truly Byzantine work from the sixth century till an even later date than the mosaics in St Mark's has given place to a table of purely Latin type; the inscriptions are in Latin and the whole

162 Mosaic in St Mark's at Venice, the Last Supper. The mosaics in the church are of various dates; that showing the Last Supper is probably of the last quarter of the twelfth century

scene is indeed conceived as much in a Western as in a Byzantine manner.

A Latin, one might almost call it a Romanesque, style is even more marked in the next group of mosaics in St Mark's which belong to the end of the twelfth century. The figures are stiff and angular, the compositions are crowded, and the mosaics, though colourful, lack nearly all the imaginative qualities of the best Byzantine work. As time went on the change towards a more rigid, essentially illustrative, style that we see here became more and more marked, and the work lost much of its aesthetic quality. But even so, the colours remained effective and the rather dim tones, with a great predominance of white, which characterized the Monreale mosaics, were never adopted at Venice. Rather, it may be said that a new Romanesque art was in the process of being born while the old Byzantine art was on the way out.

There are hints that the same process was taking place at Torcello, but it was not as marked as in St Mark's, primarily because the

179

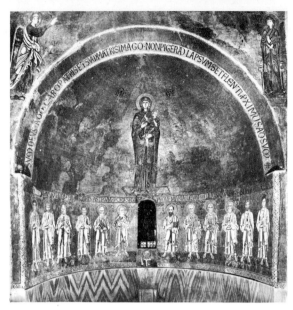

163 The apse mosaic of Torcello. The Apostles below are to be dated to the earlier eleventh century. The Virgin above probably replaced a figure of Christ, and was set about 1190

mosaics there are of rather earlier date. The Cathedral was rebuilt in 1008, and the mosaics on the vertical walls of the apse were probably set up very soon after the building was dedicated; they depict the Apostles (*Ill. 163*). The composition was inevitably rather rigid, but the arrangement is formal and rather abstract, and is something quite distinct from that which characterizes the later twelfth-century work in St Mark's. The Virgin in the conch above is later in date than the Apostles; the figure was probably set up about 1190, and perhaps replaced one of Christ, for the inscription above would seem to refer to Him rather than to the Virgin. But the Virgin's figure is of outstanding beauty, tall, elegant, and of fine proportions, recalling the best work of the Constantinopolitan school, and combines all the dignity of earlier mosaics like those at Nicaea (cf. p. 92), and all the loveliness of the later, like those in Kariye Camii.

The great Last Judgment on the western wall at Torcello (*Ill. 164*) lacks the spirituality of the Virgin in the apse, but it illustrates the theme vividly and expressively and it is possible that the hardness of detail is to be attributed to the fact that the mosaic was very severely restored in the nineteenth century. Whole areas were renewed, as a number of fragments of the original mosaic now

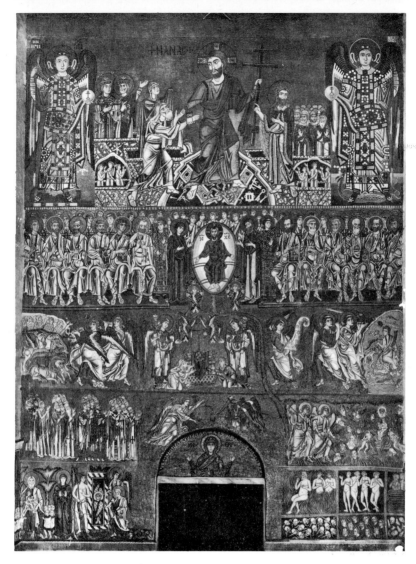

164 Mosaic on the west wall of the Cathedral at Torcello representing the Last Judgment. It dates from the twelfth century, but has been much restored

preserved in a little museum to the west of the church serve to prove. It is one of the fullest renderings that have come down to us of a scene which was extremely popular in Romanesque art. It must date from the first half of the twelfth century.

165 Mosaic in the apse of the church on the island of Murano. The style is lighter and more delicate than at Torcello and the work is probably to be assigned to the early fourteenth century

The apse of the church on the neighbouring island of Murano is adorned with an even taller and more elongated figure of the Virgin (*Ill. 165*) than that at Torcello. It is of great quality, but perhaps lacks something of the firmness and dignity of the earlier example for it is obviously a work of the Palaeologue Revival; the mosaics of Kariye Camii at Constantinople and the miniature mosaic of the Annunciation in the Victoria and Albert Museum, may be compared (cf. pp. 225, 236 ff.) and serve to support a date around 1310 for the Murano Virgin. It and the mosaic in the apse at Torcello are to be attributed to Greek craftsmen from Constantinople; all the other work, with the possible exception of the Apostles in the apse at Torcello, must have been done by Venetians, who rapidly became extremely accomplished. It was not so much for technical reasons that their work did not reach the aesthetic standard of the Byzantine, but rather because the Venetian outlook was distinct, and was ill-suited to the mystic transcendentalism that made the best Byzantine art so beautiful and so outstanding.

As in Sicily, work on a small scale was also done in Venice, and a group of ivories which were previously regarded as Byzantine have recently been attributed to Venetian craftsmen. One of the most striking examples of the group is in the Victoria and Albert Museum (*Ill. 166*). The panel is divided into three registers and shows the Annunciation and the Nativity above, the Transfiguration and the Raising of Lazarus in the centre, and the Maries at the Sepulchre and Christ with the Maries in the Garden below. If it is indeed Venetian, it serves to indicate how good was the work which was done there; but the Venetian provenance is by no means certain, though the ivory is no doubt to be assigned to the twelfth or even the early thirteenth century and not to the tenth or eleventh, like so many of the finest Byzantine examples.

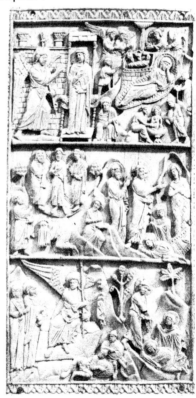

166 Ivory showing the Annunciation and Nativity, the Transfiguration and the Raising of Lazarus, and the Resurrection and appearances of Christ after death. It belongs to a group which has been assigned to Venice though some authorities would still consider it to be Byzantine

167 Marble relief—confronted peacocks. There is much sculpture of this type built into the walls of St Mark's at Venice

There was nevertheless a great deal of contact between Venice and Byzantium in the twelfth century; Byzantine objects and Byzantine workmen must have found their way to Venice in quite large numbers, and Venetian craftsmen had certainly been trained in the copying of Byzantine techniques and had adopted a more or less Byzantine style as early as the eleventh century. The Basilica of St Mark's itself, which is of that date, is virtually a Byzantine building, and a large proportion of the sculptures that decorated it were of Byzantine origin. But it was really as a result of the immense influx of Byzantine works of art brought after 1204 as loot accumulated by the Fourth Crusade that the imitation of Byzantine objects began on a really wide scale, and it was then that Venice became really active as a centre for the production of works in metal and enamel, and even stone, in a basically Byzantine style, so that it is sometimes hard to tell the Venetian copies from the Byzantine originals. Thus a number of slabs with decorations in low relief like one bearing two peacocks confronted are built into St Mark's (*Ill. 167*), and some of them are Byzantine imports while others were carved in Venice. Two rather attractive reliefs in stone at Caorle near Venice may also be noted in this connexion; they depict St Agathonikos (*Ill. 168*)

184

168 Stone sculpture at Caorle near Venice. It is probably a local copy of an imported Byzantine ivory and is to be dated to the twelfth century

and St Theodore. Their names are in Greek letters beside the heads and the iconography is wholly Byzantine, though the style is distinct from that of similar reliefs at Constantinople or in Greece, and they are probably to be regarded as the works of local sculptors in the Byzantine manner.

Even more important than the byzantinizing sculptures were the works in metal. The skill of the Venetian craftsmen was very considerable. In the thirteenth century many of the superb Byzantine works brought to the Treasury of St Mark's after 1204 were damaged by fire and had to be repaired. The work was very skilfully done, but the restorations are rather hard and unfeeling in contrast with Byzantine work of the eleventh or early twelfth century, and may be taken as indicating the character of the Venetian as opposed to

that of the true Byzantine craftsmanship. One of the numerous gospel-covers in the Treasury (*Ill. 169*) serves to illustrate this. The enamel in the centre is a Byzantine one of the eleventh century, the metal border represents a Venetian addition done after the fire of the thirteenth century. On other book-covers in St Mark's purely Western architectural motifs are used in a Byzantine way, or Western elements of costume or features, such as the tonsures or the croziers carried by bishops, are wholly Western. Not a few of the enamels that compose the famous Pala d'Oro in St Mark's are also Venetian, while others are wholly Byzantine. Indeed, Venetian art and culture as a whole were deeply saturated in the Byzantine spirit, and even till a much later date the Byzantine elements survived and can be discerned in Venetian painting in the work of such men as Jacopo Bellini. A whole group of panels, mostly Madonnas, which date from the fifteenth century onwards and which were painted in Venice or the neighbourhood represent the final outcome of the Byzantine influence.

169 Silver gilt and enamel gospel-cover, the Treasury of St Mark's, Venice. The central panel is Byzantine and dates from the eleventh century, the border is Venetian work, probably done after a fire in the thirteenth century

The Slavonic Art of the Balkans

The Balkan lands constitute a distinct geographical area of the Byzantine world, but the art of the area was by no means uniform in style for the population was of very varied character, and when once Byzantine control became weakened, independent Kingdoms were established which stemmed from very different sources. Thus the Bulgars came to the area from somewhere to the East of the Black Sea and had already developed a culture derived to some extent from Sassanian Persia at the time that they settled in the West, whereas the Serbians were more wholly Slav, while the Macedonians remained throughout something of a mixture, and Greek, Slav, and local characteristics all blended with one another in the establishment of their make-up. Again the progress of events in the different areas varied chronologically, and whereas the Bulgarians had an art and a culture of distinctive character as early as the seventh century, Serbia only began to emerge as a cultural entity at the end of the twelfth. Thus, in any study of art the Balkans can hardly be treated as a whole, but fall rather into a series of independent groups or compartments. The earliest of them to develop was that constituted by the First Bulgarian Empire.

It was founded in 679 and lasted till 1018, when the area was once more brought back into the Byzantine Empire. Its art and culture at first owed a considerable debt to Persia, but Byzantine influence penetrated rapidly, and by the eighth century architecture and architectural sculpture were thoroughly byzantinized, as the buildings, capitals, and cornices excavated at Aboba Pliska, the first capital, and Patleina, near Plovdiv, serve to prove. But no paintings of this age survive, and it is among the minor arts that the most important products are to be found. The metal-work as represented by the Treasure of Nagy Szent Miklos, is more Persian than Byzantine; the pottery was of a very distinctive character, oriental in

style, but of a type also found in Constantinople, Greece, and elsewhere in the Byzantine world. It is usually known as polychrome ware. The majority of the Bulgarian examples come from Patleina, where a kiln was excavated in addition to numerous fragments of vessels, revetment-plaques and tiles. The most important of them was an icon of St Theodore, made up of twenty independent square plaques, or tiles, which has already been discussed (cf. p. 115). There is nothing intrinsically Bulgarian about it.

Unfortunately little else survives from these early days, and it was not really until the foundation of the Second Bulgarian Empire in 1185 that religious art began to develop, with a new capital, Tirnovo, as the main centre. It is there that the earliest buildings of the Second Bulgarian Empire (1185–1396) are to be found. All are of brick, skilfully used for its decorative qualities, and all were decorated inside with paintings. It was there that the first national school of painting developed in the thirteenth century, though most of the works that can be assigned to it belong to the fourteenth. The paintings are characterized by rather heavy draperies, and there is a definite search for plasticity both in the faces and in the compositions, where movement is from front to rear rather than sideways. The colours were applied in large splodges with a wide brush, and with a very sure hand. The best-preserved work is in the Church of SS Peter and Paul, and dates from the second half of the fourteenth century.

The most important of the paintings that survive, however, are not at Tirnovo, but in the small church at Boiana near Sofia and date from 1259. The influence of Constantinople was still very much to the fore, even though the inscriptions that accompany the scenes are in the Slavonic script. The hieratic approach of early days has been forsaken, a new interest in personal emotions is apparent, the landscapes show a real understanding of Nature, and it is clear that the progress towards humanism that we noted in such Constantinopolitan works as the icon, *Our Lady of Vladimir*, was here being continued; the renderings of Christ both as a Child disputing with the Doctors in the Temple (*Ill. 171*) or as the Pantocrator (*Ill. 172*) prove this. The faces are carefully modelled in half-tones, round

170 Wall-painting at Boiana of the donor, the Sebastocrator Kaloian and his queen Dessislava. They are clothed in rich costumes, perhaps the products of Byzantine looms and the painting is to be assigned to an artist who had been in close touch with Constantinople

surfaces have been sought, and high-lights are not used in the way that they were at Mileševo and Sopoćani in Serbia (cf. pp. 197 ff.). The elegance that we saw at Nerezi is absent, nor are the colours as bright or as attractive in themselves, yet there is an intimacy and feeling for personality here which is surpassed nowhere else. This personal touch is to the fore in the scenes which depict the more worldly events of Our Lord's life; the essentially spiritual ones are shown in a rather more abstract manner, which is in closer accord with developments that were taking place in Serbia at the time, and which were to reach full fruition in the fourteenth and fifteenth centuries at Mistra. The scene of the Transfiguration, for example, is a very lovely piece of formal composition, and the formal basis is brilliantly enhanced by the nature of the colouring. White, pale blue, and yellow are the dominant shades, and give a strange, etherial character to this scene, wholly in keeping with its subject, and contrasting admirably with the more sombre tones of, say, the scene of Jesus with the Doctors in the Temple.

In spite of the innovations, the scenes from Christ's life are arranged in accordance with the traditional disposition as it was developed at Constantinople in Basil I's Church of the Nea, so that we see at Boiana the blending of a number of traditions and influences. First there is that of the conservative Byzantine style, to be seen in the arrangement and to some extent also in the poses. Then there is that of the progressive, humanist style which was first developed at Nerezi, and finally there are the elements which belong properly to Bulgaria—a deeper colouring and a certain degree of realism which is distinct from the elegant manner of Nerezi. Nor is there present that love of decorative detail which was to dominate in Constantinople in the fourteenth century, for example, in the mosaics and wall-paintings of Kariye Camii.

In addition to the events from Christ's life there are eighteen scenes from the story of St Nicholas, and some outstandingly fine figures of Saints—St Theodore Tyro (*Ill. 174*) is one of the best of them. There are also some interesting portraits of the Founders in the narthex, notably the Sebastocrator Kaloian, holding a model of the church, and his consort, Dessislava (*Ill. 170*). The drawing is sure,

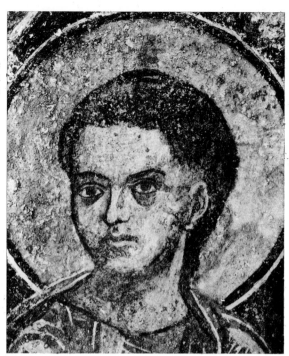

171 Christ's head from the scene of Christ among the Doctors in the Temple. Boiana, Bulgaria, 1259

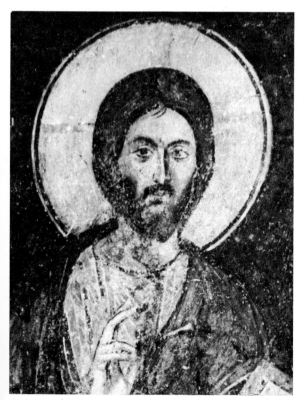

172 Christ blessing. Wall-painting at Boiana, Bulgaria. Though distinct from the rendering of the more youthful Christ in *Ill. 171* the figure is none the less personal and sympathetic

191

173 Wall-painting at Kurbinovo, Macedonia, 1191. The work shows the influence of Nerezi, but is less elegant and sophisticated

the colouring effective, and the portraiture would appear to be true to life. In this, as in other portraits of the age in Yugoslavia and else-where a technique is used distinctive from that of the religious scenes, for the faces are more fully modelled and the high-lights are less stressed than in the scenes of deeply spiritual character; obviously a clear distinction was drawn in the artist's mind between living per-sonages of the material world and the divine or saintly figures of the spiritual one.

Of the later work in Bulgaria, that is, dating from the last part of the thirteenth and the fourteenth century, there are good examples at Mesembria (Nisibor) as well as Tirnovo, but finest of all is a Procession of Prophets in the Church of St George at Sofia. The work shows a masterly rhythmic swing and constitutes from the

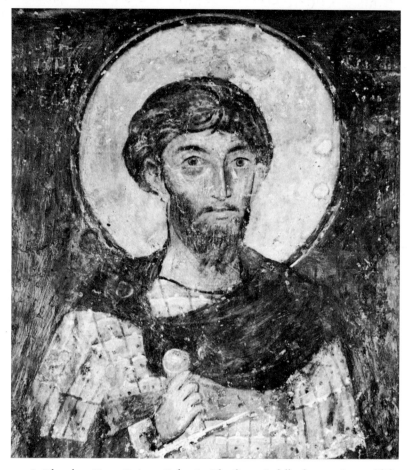

174 St Theodore Tyro. Boiana, Bulgaria. The figure is full of expression and life, and is typical of the very high quality of the Boiana paintings

artistic point of view one of the most impressive examples of four-teenth-century Bulgarian art to be found. Most of the other paintings in Bulgaria belong to a more primitive tradition which had its origins in the East rather than in Constantinople. Painting was on the whole conservative and looked back to early models, though sometimes it was expressive and the architectural backgrounds often showed a great feeling for decoration. This was, for example, the case at Zemen where the paintings date from 1160.

Very little on a small scale survives from the days of the Second

Bulgarian Empire, and to judge from the succeeding period, when the territory formed part of the Turkish Empire, the most important work was probably in the way of wood-carving. A few icons may have been painted, but they do not seem to have been nearly as numerous as in other parts of the Byzantine world. Manuscripts though rare were, however, distinctive. The most famous, the Curzon Manuscript in the British Museum, which dates from the fourteenth century, is in a naïve, wholly primitive style, but others are more sophisticated, notably one of the sixteenth century in the Sofia Museum. It contains portraits of the Evangelists in a linear style, which is both original and effective. The old Byzantine disposition is followed, but the miniatures cannot be termed Byzantine works in the narrow sense, and Western elements have been assimilated to a considerable degree in addition to purely local ones.

<p style="text-align:center">★ ★ ★</p>

The story of painting in what is today Yugoslavia—for Macedonia and Serbia cannot really be separated so far as their arts are concerned —begins shortly before the year 1200, as the country was almost till then under Byzantine control, and the wall-paintings of Sancta Sophia at Ochrid and at Nerezi, which we have already mentioned (cf. pp. 127, 129), are really to be counted as Byzantine monuments on Macedonian soil; there is nothing essentially Slav about them. But from just around the turn of the century paintings which were more truly local in character began to be produced, though at first there was little differentiation between those in the Greek and those in the Slav areas of Macedonia. Thus some at Kastoria in the Greek area are well-nigh identical with those at Kurbinovo in the Slav area (*Ill. 173*). The paintings there were executed in 1191. The debt they owe to Nerezi is obvious, especially with regard to the individual figures and the arrangement of the scenes. But there is at Kurbinovo a new stylization, a new love of strange, angular lines that is wholly distinctive, and it affects not only the actual forms of the bodies, which are often severely contorted, but also the details of the costumes, which are twisted as if blown by a violent wind, and the delineation of the faces, where the linear rendering of the muscles is severely

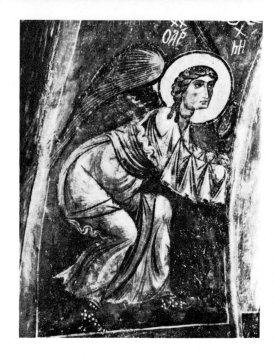

175 At Kastoria, in Greek Macedonia, a surprisingly large number of paintings survive. Some, like this Angel, are so closely related to those at Kurbinovo that they might be attributed to the same hand

exaggerated. Some of the Kastoria paintings are closely similar and might even be by the same hand (*Ill. 175*). It is a strange, exaggerated style, but it left an important heritage behind it, and Kurbinovo is to be described as the first truly Macedonian monument. The painters, Michael and Eutychios, who worked in central Macedonia and southern Serbia about a century later, represent an evolved and perhaps more sophisticated phase of the same school.

Paintings which were perhaps rather less original but at the same time of a much less extreme and more sophisticated character were being produced at the same time in Serbia; the earliest examples are to be found in the Church of the Mother of God at Studenica, done about 1220. The greater sophistication is obvious, and there is also a more marked interest in naturalism and human emotion. The former is clearly to the fore in the Centurion's head in the background of the Crucifixion; the latter is apparent in the rendering of the Crucifixion itself (*Ills. 176, 177*). Though the iconography of the scene is Byzantine, the style shows certain links with Italy, and the expression of Christ, with eyes closed and with head on one side, recalls the work of the Pisan school. Both here and at Mileševo it

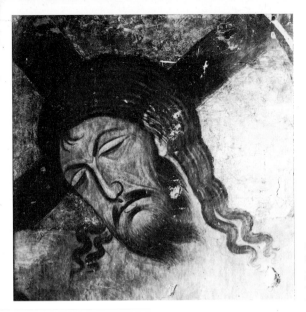

176, 177 The scene of the Cruci-
fixion at Studenica, Yugoslavia. The
iconography is Byzantine, but the
details, like the head of Christ, show
links with the work of such paintings
as Giunta Pisano in Italy

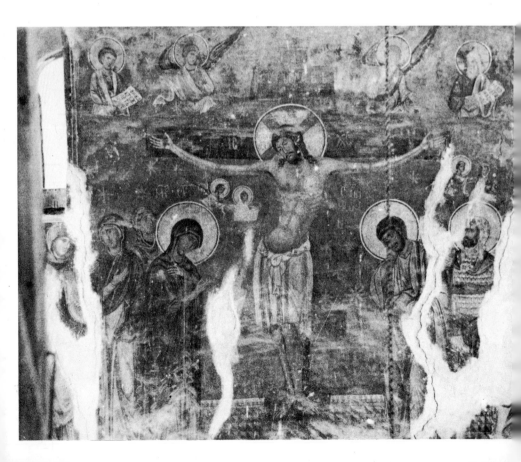

would seem that Western influence had a part to play. Fundamentally however the style is Byzantine, and all these paintings constitute a branch, albeit an individual one, of the great Byzantine school.

If the Studenica paintings are grand and impressive, a lighter, more intimate touch distinguishes those at Mileševo, the next great monument of Serbian painting in respect of date. They were done between 1230 and 1237, under the patronage of King Vladislav, whose portrait appears in the exo-narthex (*Ill. 178*). Three painters, George, Demetrius, and Theodore, seem to have worked there, but it is not possible to distinguish what each of them did. Much of the work is however of very great beauty and the styles are very varied. The head of the Virgin in the Annunciation (*Ill. 181*) is thus possessed of a tenderness and shyness worthy of the best Sienese painting, while that of the Angel who is seated beside the empty tomb in the

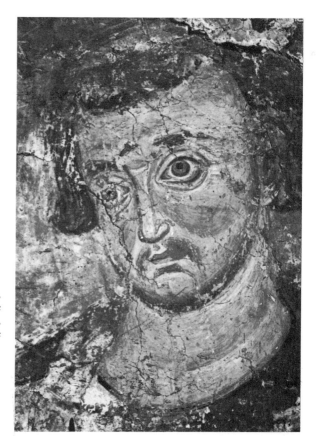

178 Portrait of King Vladislav, donor of the wall-painting in the Monastery Church of Mileševo, in Serbia. The work was done between 1230 and 1237

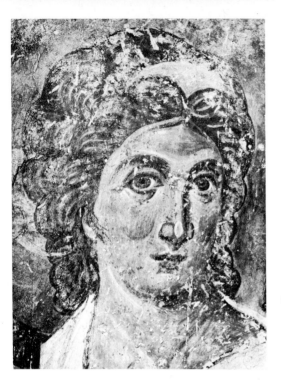

179 Detail of the Angel's head from the scene of the Resurrection at Mileševo. The face is almost classical in its refined elegance

180 Mileševo. The Maries shown the empty tomb by the Angel. The sleeping soldiers below are rendered with an almost brutish realism

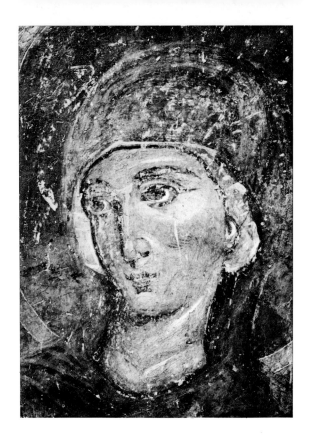

181 Detail of the Virgin's head from the scene of the Annunciation at Mileševo. The expression of tender delicacy is outstanding

Resurrection scene (*Ills. 179, 180*) suggests a Hellenistic model, like that which must have served the painter of the frescoes in Santa Maria Antiqua in Rome some four and a half centuries earlier. The scene itself departs from the traditional arrangement, with a circular tholos-shaped tomb, and the expressive Angel and the group of soldiers sleeping below almost anticipate the realism of a Van Eyck.

A rather more conservative style, combined with rather sombre colouring, characterizes the earliest of the paintings at Peć, for long the seat of the Serbian Patriarchate. There are three churches there, one beside the other, all of them attractive domed buildings in the Byzantine style (*Ill. 182*), but the paintings that adorn them date from different periods; only those in the central church, dedicated to the Holy Apostles, concern us here. They were done about 1235.

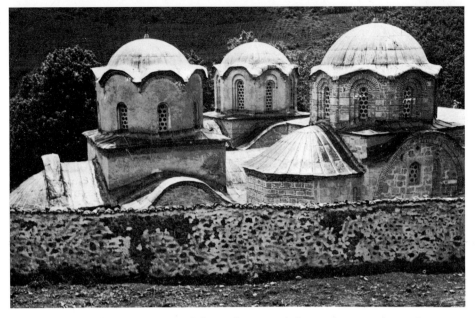

182 Peć, one-time seat of the Serbian Patriarchate. There are three adjoining churches, their paintings of varying dates

The Deesis appears in the apse in a fine, dignified, and wholly conservative manner. The paintings at Morača, done in 1252, were apparently in a similar style, but practically nothing of the original decoration survives.

The finest of all the paintings of this age, however, are those in the Church of the Trinity at Sopoćani, done for Uroš I about 1265. Once more portraits of the Founders appear; they are characterful and expressive, notably so in a scene concerned with the Death of Queen Anne, where Uroš appears as a mourner (*Ill. 183*). But it is the rhythmical movement of the composition and the sculpturesque modelling of the costumes that is most distinctive, and the way in which the sweeping curves of the figures balance and contrast with one another in such a scene as the Dormition of the Virgin is profoundly effective (*Ill. 184*). The individual figures are impressive, too, for example that of the Apostle Paul. Most lovely of all, however, are some of the scenes of the appearances of Christ after

183 Head of King Uroš, in whose memory the wall-paintings of Sopoćani were done

184 Part of the scene of the Dormition (Assumption) of the Virgin at Sopoćani. It is remarkable for the large number of figures and the elaboration of the architectural background

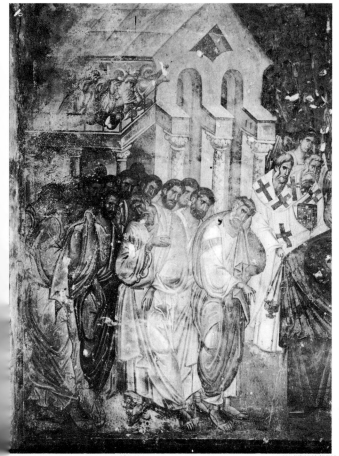

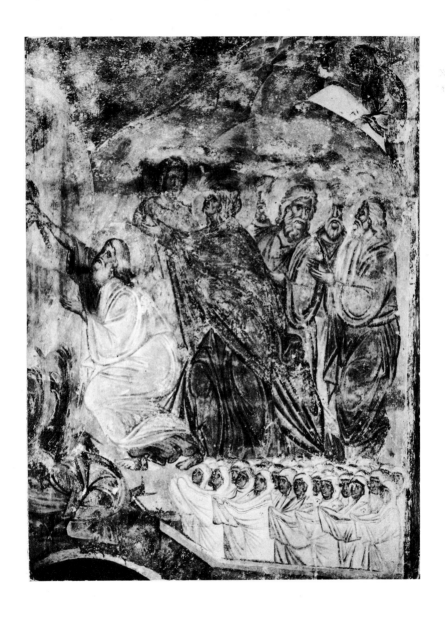

185 Part of the scene of the Anastasis at Sopoćani. Christ's hand is just visible as
He grasps that of Adam. Compare *Ill. 81*

186 Detail of the Nativity scene at Sopoćani—the two Shepherds. They are shown with a new feeling for realism and an interest in personality

death. The Anastasis or Descent into Limbo (*Ill. 185*) is a profoundly spiritual composition, in which the emotions of awe and love are most subtly expressed. In places the backgrounds are gilt and painted with criss-cross lines to suggest mosaics, but in general the colours are naturalistic. The palette is varied, and colour is used very effectively both to bring out the modelling and to add to the expression, as is the case with the two Shepherds who appear as part of the Nativity scene (*Ill. 186*).

With the turn of the century the Slav element rapidly became more important; inscriptions in that language replaced those in Greek, men who were Slavs did most of the work, and painters not only turned towards the more forceful, more angular manner which had characterized Macedonian painting as we saw it at Kurbinovo and Kastoria, but also began to develop a more truly national style.

203

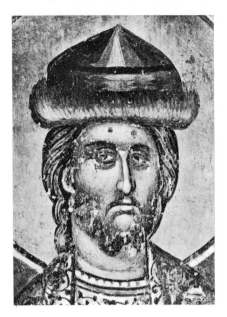

187, 188 Paintings at Staro Nagori-
čino. The Mocking of Christ and a
detail of the head of St Jacob of
Persia. The work is vivid, but the
colouring is closer to monochrome
than is usual in Yugoslavia

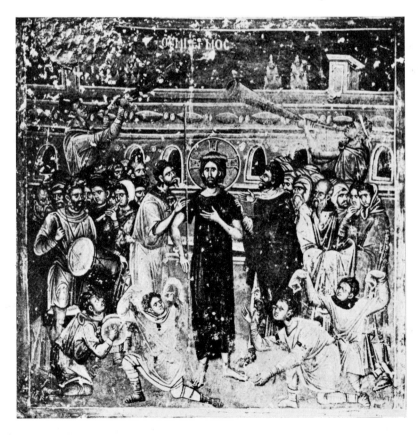

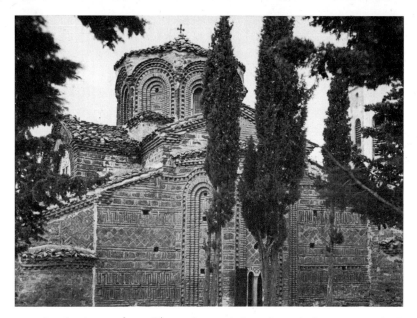

189 Church of St Mary Peribleptos, later rededicated to St Clement, at Ochrid. It is a typical brick building of the later thirteenth century

This tendency is apparent in the work of three masters whom we know by name, Astrapas, Michael, and Eutychios, who worked for King Milutin in a whole series of churches between about 1295 and 1310. Astrapas would appear to have been the oldest of the three and to have followed a more conservative manner; Eutychios was more extreme and his work may be cited as the most characteristic of the new school. He would seem to have been responsible himself for nearly all of the extensive decoration of Staro Nagoričino, done around 1317. The paintings there comprise a very complete cycle of scenes, and the scenes themselves are very full and detailed. There are numerous subsidiary figures and a great deal of dramatic action, as for instance in the Mocking of Christ (*Ill. 188*). The colours however are rather sombre and even though the scenes are full of interest and drama, there is a tendency towards coarseness; the best work is in the detail of the figures, like the portrait of St Jacob of Persia (*Ill. 187*).

Eutychios and Michael worked together in the Church of St Mary Peribleptos, later known as St Clement's, at Ochrid (*Ill. 189*). It is a

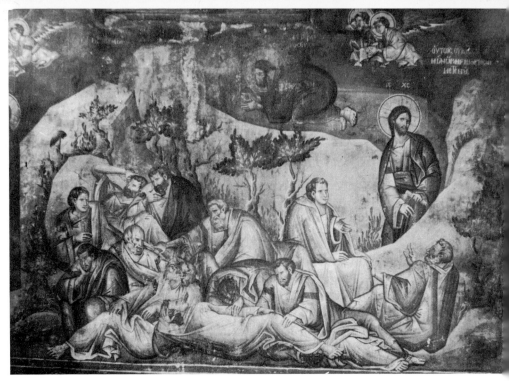

190 Wall-painting. The Agony in the Garden, Church of St Mary Peribleptos. The work is signed by the two painters Michael and Eutychios

delightful building of brick which was founded by King Milutin in 1295, and the bricks are laid to produce a very decorative effect on the exterior. The whole interior is covered with paintings and the colours are much brighter than at Staro Nagoričino; indeed, since their recent cleaning they seem somewhat garish, but the figures are expressive and the whole decoration is forceful, even if the compositions are somewhat over-crowded. One of the most effective of them is the Agony in the Garden (*Ill. 190*), where Jesus is shown praying above and chiding the sleeping Apostles below. The landscape is beautiful in itself, and the group of the Apostles is very finely composed. But perhaps the most interesting feature of the paintings lies in the fact that the painters' names are inscribed for the first time on the paintings, that of Eutychios on the belt of St Prokopios and that of Michael on the sword of St Demetrius; the

191 Painting of the Crucifixion in the narthex of the Church of the Mother of God Ljeviška at Prizren, signed by the painter Astrapas

Saints themselves are on the westermost of the four piers that support the dome. From this time onwards signatures become fairly normal.

Of all this signed work, however, the best from the artistic point of view is that in a church known as the Bogorodica Ljeviška at Prizren. Work in the exo-narthex was done by Astrapas between 1307 and 1309. It consists of a very full and detailed rendering of the Last Judgment, with the Almighty at the centre of the vault, and a mass of figures below. Green undercoats were used very extensively, and have perhaps now come to the surface from below the flesh tints more than was the case originally; the faces of the Saints and other figures are thus dominated by a green hue. But they are extremely expressive, and often of great beauty in spite of the rather strange colouring. A rendering of the Crucifixion (*Ill. 191*) is particularly expressive and may serve as an example of Astrapas's style.

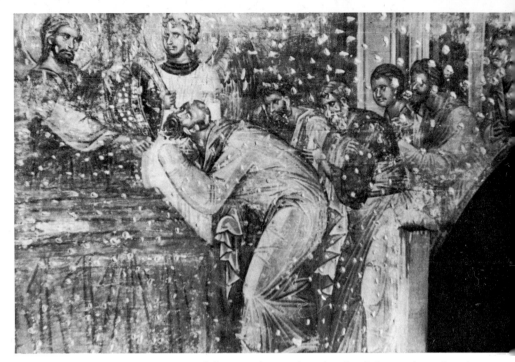

192 The Communion of the Apostles, in the Church of the Mother of God Ljeviška, at Prizren. The church was turned into a mosque by the Turks and the paintings were plastered over

The paintings in the church itself are devoted to scenes of Christ's life and Passion, and though they were severely chipped to facilitate the adherence of a layer of plaster when the church was turned into a mosque by the Turks, the beauty of their design can still be appreciated. The various scenes are also fitted with great skill into the available wall-space, as for example in the way. in which the Communion of the Apostles (*Ill. 192*) allows for the curve of the arch. Our Lord gives the bread on one side of the aisle and the wine, out of an enormous chalice, on the other.

Michael and Eutychios were also responsible for the decorations at Arilje (1296), St Nikitas near Skopolje (1310), and Žiča (c. 1300), and there is some very lovely early fourteenth-century work in the exo-narthex and in the Church of St Demetrius at Pec, which is similar, notably the scene of the Birth of the Virgin (*Ill. 193*), which

is particularly lovely for its colour and where many of the figures show a realism which suggests that the painter was making use of living models from the neighbourhood. It is however really in the large monastery churches like King Milutin's church at Studenica (1314), Gracanica (c. 1321) or Decani (from 1327) that the most extensive and important decorations done after about 1310 are to be found. All comprise a mass of scenes; at Decani, for example, there are no less than forty-six scenes from Genesis, forty-three of the Passion cycle, twenty-six of the Last Judgment, and a Calendar with a separate scene for each day of the year. The church is a veritable mine of information for the student of iconography, but the work is not all of very great quality and the general effect is somewhat

193 Detail of hand maiden in the scene of the Birth of the Virgin, Church of St Demetrius, Peć

194 The Church of St John the Baptist, Gračanica, c. 1321. Like many churches in the Slav lands, height has become a preoccupation of the architects

overwhelming. Even so, individual figures, like a head and shoulders of St John the Baptist (*Ill. 195*) in the semi-dome at the end of the northern aisle at Gracanica, are fine and the compositions are often extremely impressive, as for example the Raising of Lazarus at Gracanica, where Christ is shown approaching above and in the act of performing the miracle below. The church itself is also worthy of note for it represents the ultimate evolution of the Byzantine cross-in-square type with central dome (*Ill. 194*). There is an additional dome on each of the corner chapels, but not on the arms of the cross, as in the true five-domed group derived from Justinian's Church of the Holy Apostles. Immensely tall churches of this type were not developed by the Greeks, though the Slavs preferred them and very similar results were arrived at by architects in Russia working quite independently of those in Serbia.

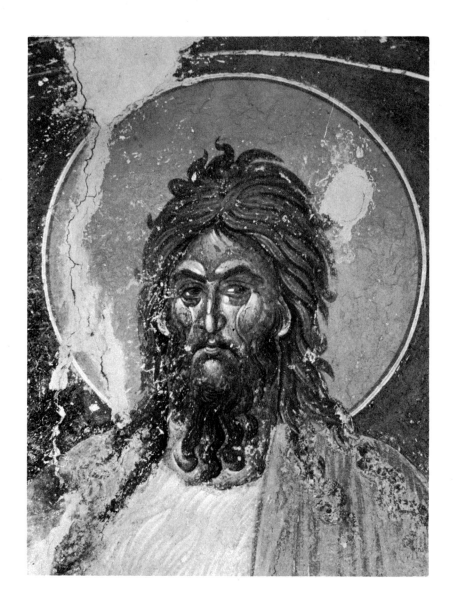

195 Painting of the Baptist in the conch of the apse of the northern side aisle, Gračanica. It dates from the same period as the church, that is, about 1321

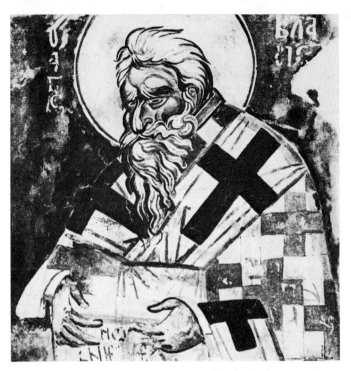

196 Wall-painting, Markov Manastir, St Blaise. The element of near-caricature is something rare in the Byzantine world

The paintings in these large monasteries, even though most of them are unsigned, were done by painters of King Milutin's school, and the expressive movements and rather deep colours attest the Macedonian heritage. But there are a few decorations of the age in a different tradition, notably those at Lesnovo and Markov Manastir. The church at Lesnovo dates from 1341; the paintings were completed about 1349. They depict a full cycle of Old and New Testament scenes. At Markov Manastir, where the work dates from the late fourteenth century, the interest in expression of the early Macedonian style had turned almost to caricature in some of the figures, for example the rendering of St Blaise (*Ill. 196*). One feels that the artist had some especially sly old monk in mind when he drew it, and he clearly was not afraid of exaggerations in order to obtain the effect he wanted; the Gothic sculptors of Britain were

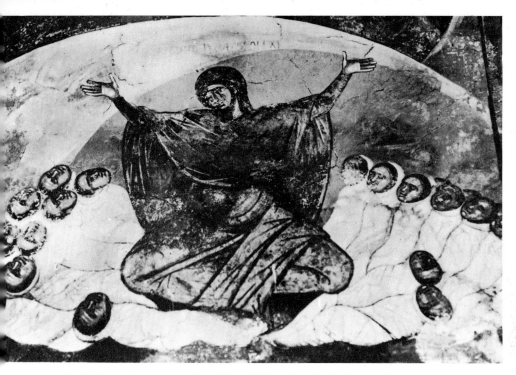

197 Rachel lamenting over the loss of her children. Detail of a fourteenth-century painting at Markov Manastir

doing just the same thing at the same date in their carvings on corbels or capitals. But the figure of Rachel lamenting for her children (*Ill. 197*), which is included as a detail in the scene of the Massacre of the Innocents, though in the same rather primitive style, is both profound and pathetic.

The last phase of Serbian art was a distinctive one. As the Turks gradually penetrated inland from the region of Salonika the Serbs were forced northwards till, towards the end of the century, they achieved stability for a time along the Morava Valley. There a number of churches and monasteries were founded, and for their decoration there was developed a new style of painting, intimate, delicate, tender, perhaps effeminate, yet very lovely. There seems to have been a conscious effort to escape from the terrors and troubles of the age into a sort of exquisite nirvana. Five outstanding decorations

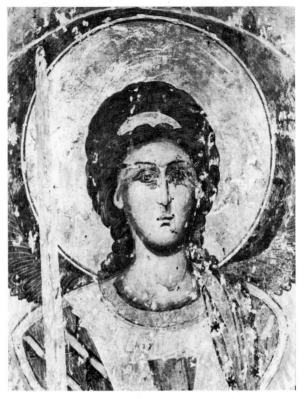

198 Wall-painting, the Archangel Michael, in the Monastery of Manasija. The refined delicate style which characterizes this painting dominated the Morava area around 1400

survive, those at Ravanica (1377), Ljubostinja (end of the fourteenth century), Kalenic (early fifteenth century), Rudenica (1403–10), and Manasija—also called Resava—(1407–18). The churches are tall and quite large and the scenes are all on a large scale; architectural backgrounds play a very important part in their compositions. The colouring is in the main naturalistic—the green undercoat so prominent at Prizren for example is absent—and the shades are subtle and gentle; in this they contrast notably with the garishness of St Clement at Ochrid. The compositions are elegant and decorative, with extensive architectural backgrounds; the figures are tall and elongated and the faces refined, like that of the Archangel Michael at Manasija (*Ill. 198*).

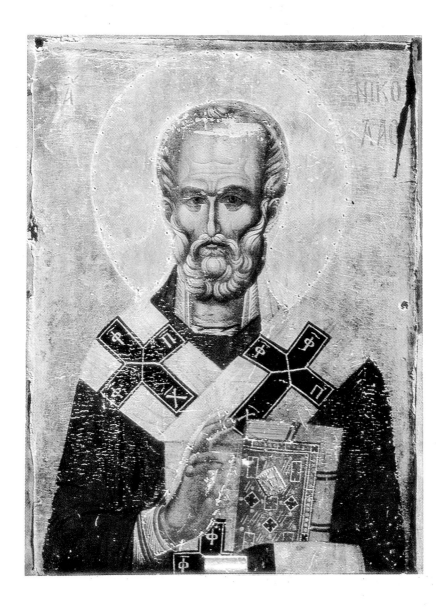

199 Icon, St Nicholas, in the Monastery of Chilandari, Mount Athos. The icon is a double-sided one; on the other side is the Virgin Tricheirusa

It is curious that this delicate style should have come into being in Serbia at this time, when one considers that the Serbian kings were fighting for their very existence. But art is not always a true mirror of its time, and the art of the nation which went under fighting like a lion had all the characteristics of a lamb. It has been called decadent, the art of this last phase, and if to be gentle in an age of violence denotes decadence, then the designation is correct. But it was a very Christian art, and gentleness is a Christian virtue. In this, it reflects a very essential aspect of medieval Serbia—and through that, of the Byzantine world. Gentleness was not, perhaps, a universal facet of all Byzantine art, but it characterized all the great works of the last phase, Nerezi, Kariye Camii, and Mistra, so that the art of the Morava Valley does not stand alone. It brings our story of wall-painting in Serbia to a close on a note of beauty, elegance, and delight, and it is to be regarded as not one of the least of the Byzantine contributions to the story of the world's art.

<p align="center">★ ★ ★</p>

The earliest icons in the South Slav world were nearly all imports from Byzantium, but by the thirteenth century production had begun in Serbia and Macedonia, and the Nemanja family were active patrons, not only of wall-painters, but also of icon-painters and those who produced other works on a small scale. Icons seem to have been exported to the West, and one of SS Peter and Paul in the Vatican is a Serbian product. Singularly few such things survive however. Of those that are still to be found in the Orthodox world one of the finest is of Christ Pantocrator at Chilandari (*Ill. 200*), the Serbian monastery on Mount Athos; it is to be dated around 1260. The rendering is still rather austere and belongs to the monumental Byzantine tradition, though the colouring and technique attest its Slav origin. With the next century a more intimate and delicate style was developed, and Slavonic lettering began to replace Greek, as on a mid-fourteenth-century icon of the Archangel Gabriel at Dečani (*Ill. 201*). The modelling is done in brown and olive-green, and the high-lights are in greenish ochre. This sort of modelling, with high-lights but little stressed, is one of the features that serves to

200 Detail of an icon of Christ, in the Monastery of Chilandari on Mount Athos. Chilandari is a Serbian foundation and the icon is to be counted an early Serbian work and dated to 1260

201 Icon, the Archangel Gabriel in the Monastery of Dečani, Yugoslavia. It was probably painted by a Serbian artist before about 1350

distinguish Serbian from Greek work. The icon was done for the iconostasis at Dečani on the orders of the Emperor Dushan about 1350. To much the same date belongs an icon of St Nicholas at Chilandari (*Ill. 199*). Here the lettering is in Greek characters and the work is less characteristically Serbian; perhaps it was painted on Athos, where contacts with Greek thought and Greek art were closer.

Of the works on a smaller scale the most important is a reliquary in the form of a diptych now preserved at Quenca in Spain. On one leaf is the Virgin and Child, on the other Christ. Both figures are surrounded by richly bejewelled and adorned metal mounts, and these in turn are framed by portraits of Saints similarly mounted. There are four at the bottom and top of each panel and three at each side, their names beside their heads in Greek characters. The two leaves are joined by a hinge and shut face to face. The reliquary bears the name of the Despot Thoma Preljubović, and dates from between 1367 and 1384. It is however impossible to say where it was made.

218

The Revival under the Palaeologue Emperors

The last phase of Byzantine art, that of the Palaeologue Revival, was a very vital and very distinctive one. It occupied the last forty years of the thirteenth, the whole of the fourteenth and the first half of the fifteenth centuries, and at Constantinople in any case it was separated from the main trunk of Byzantine civilization by three-quarters of a century of Latin rule, from 1204 till 1261. The Fourth Crusade, lured on by prospects of loot and spurred by the jealousies of Venice, had turned its efforts to the conquest of Constantinople rather than to the less gainful task of assisting the Latins already established in Syria and Palestine. But the Greeks were not completely routed; members of the Imperial family set themselves up as petty rulers, one at distant Trebizond not far from the Caucasus, one in Epirus, on the mainland of Greece to the south and west of Salonika, and one at Nicaea, the modern Isnic, on the Asiatic mainland only some sixty miles as the crow flies from Constantinople itself. The Empire of Trebizond lasted longest, for the Comnene line which was established there was to survive in independence till finally conquered by the Turks in 1461, but the emperors there made no attempt to regain Constantinople. That of Epirus, though at one moment Constantinople seemed within grasp, was short-lived and need hardly concern us; that at Nicaea became progressively more and more firmly established, till in 1261 Michael VIII Palaeologus was able to re-install himself as Emperor in the old Byzantine capital of Constantinople. Though the size of the Empire was much reduced and the economic situation was far from satisfactory, the old life of the Orthodox emperors centering round a luxurious Court, supported by nobles and intellectuals, and working in close association with the Patriarch and the Church, began once again, and in art there dawned a new and very progressive age which brought fresh and resounding glory to the Byzantine tradition.

There has been much discussion as to the intrinsic quality, the character, and the origins of the art of this age. Sixty years ago the little that was said of Byzantine art as a whole was only to denigrate it, and this last phase was wholly disregarded and despised. Then, with the turn of the century, the quality first of early and then of mid-Byzantine art came to be recognized. But even as recently as 1926 Peirce and Tyler, in their otherwise excellent little book, *Byzantine Art*, were still ignorant enough to write 'the manner grows dry and hard before the twelfth century is half over, and although a few new ideas are seen stirring in the thirteenth and fourteenth centuries, the story of Byzantine art really ends with the sack of Constantinople by the Franks in 1204'. But their views were already out of date. The French scholar Gabriel Millet had by 1914 drawn attention to the importance of this last phase in a number of scholarly publications, and soon after the First World War the quality of much of the late work had already begun to be appreciated by a wider public, even though it is perhaps only within the last ten or fifteen years that it has become possible for most people to estimate this art justly, thanks to the production of fine books with coloured illustrations or really good photographs.

But Peirce and Tyler were not only at fault in their failure to appreciate the quality of the later art; they also estimated its character quite wrongly, when they said that it grew dry and hard. In fact, the very opposite was the case, and what distinguishes it above anything else is its new vividness, its new humanism, and its new feeling for gaiety and decoration. The figures are more personal, more individual, the scenes are brighter and fuller, and there is a new concern with detail, which is in itself wholly delightful. We have already seen the birth of the more humanist style in the twelfth century, in such works as the icon, *Our Lady of Vladimir* (c. 1125) or the wall-paintings at Nerezi (1164); we have followed its continuation and development in Serbia and Bulgaria during the thirteenth century, when Constantinople was under Latin domination. We must now turn for a moment to two other monuments before we can trace the full flowering of this last style in the capital, after the return of the Orthodox emperors in 1261.

202 Christ, the central figure of the Deesis panel in Sancta Sophia, Constantinople. The panel has been variously dated to the twelfth century and to around 1380; the earlier date is more probable

The first of these is the superb mosaic panel portraying the Deesis (*Ill. 202*), or Intercession of the Virgin and St John before Christ, in the southern gallery of Sancta Sophia at Constantinople. It is certainly in the new style which is to be associated with the Palaeologue Revival, and is not dissimilar from some of the work at Kariye Camii. Whittemore, however, who was responsible for uncovering it from below the plaster which had been applied by the

221

Turks, assigned it to the early years of the twelfth century, stating that the lettering of the inscriptions was of a type not found later, and comparing the style with that of the icon, *Our Lady of Vladimir*; he held that if the icon, already so clearly in the new manner could have been painted about 1125, there was no reason why a wall-mosaic should not have been set up at the same time. Others, Professor Otto Demus foremost among them, have on the other hand compared the style to that of a somewhat similar panel in Kariye Camii, which is firmly dated to just before 1310 (cf. p. 225), and have assigned the Sancta Sophia mosaic to the later years of the thirteenth century. Others again, notably Professor Lazarev, would favour a date during the twelfth century, and preferably not later than that of the mosaic of Christ at Cefalù in Sicily (c. 1150). From what has already been said here it is clear that the existence of what we term the Revival style before 1200 can be definitely accepted, so that a date shortly before 1200 seems on the whole the most likely for the Deesis panel.

On this assumption it would also seem that the Palaeologue Revival style must have seen a good deal of development during the years in which the emperors were in exile between 1204 and 1261. Unfortunately however nothing survives at Nicaea, the centre where the line of emperors who were eventually to return to Constantinople had their temporary capital; but some extremely fine wall-paintings, which are probably to be dated to around 1260, have recently been uncovered in the Church of Sancta Sophia at Trebizond, at the eastern end of the Black Sea. They were whitewashed over when the church became a mosque, and were severely chipped to facilitate the adherence of a layer of plaster at a subsequent restoration of the mosque. The work of cleaning them has recently been completed on behalf of the Russell Trust. They are highly sophisticated, and reflect clearly the changes which were taking place at this time. The colours are fresh and varied, the scenes dynamic, and the individual figures vivid and expressive. In some of the scenes, for example, the Feeding of the Five Thousand in the narthex, there are large numbers of subsidiary figures; all are spirited and would seem to have been inspired by living models; a group of

people waiting to be fed by the Apostles who are carrying round the bread is especially remarkable—they are types who might be encountered in the streets of Trebizond today (*Ill. 204*). Nowhere in Byzantine art has a more expressive or effective rendering of any scene been produced than in that of the Casting Out of the Devil from the Daughter of the Woman of Canaan (Matt. xv. 22) (*Ill. 203*). The devil is clearly of the type that is to be driven out only with difficulty, and the anxiety of the mother is almost as great as the apprehension of the daughter who is being cured. It is a very expressive painting. Indeed, all the work in Sancta Sophia at Trebizond is remarkable, and is distinguished by a vividness and a feeling for characterization that is unparalleled in Byzantine art of an earlier date.

As noted above, however, it is in the little Church of Kariye Camii at Constantinople itself that the work of the Palaeologue Revival is to be seen to best advantage. The church is a veritable jewel. It consists of a square sanctuary or naos, where there survive panels of the Virgin and of Christ on either side of the apse and, over the western door, a small but very beautiful rendering of the Dormition (Assumption) of the Virgin. To the west of the naos are two separate transverse aisles or exo-narthices, as they are called in the Orthodox world, with the bust of Christ over the door. The vaults and domes of the roof and the upper portions of the walls are entirely covered with scenes in mosaic, illustrating the life of the Virgin and the early life of Christ. Later scenes from Christ's life and those of His Passion were presumably in the sanctuary. The decoration was done under the patronage of Theodore Metochites (*Ill. 205*), who appears over the western door from the inner narthex to the sanctuary, presenting a model of the church to Christ. He is clothed in the rich silk costume and enormous hat of a Court official, for he served for a time as one of the first ministers of the Crown. Soon after the mosaics were executed, however, he was disgraced and he ended his days as a penniless monk in the very foundation he had himself endowed.

The scenes from Christ's life are of course drawn from the Gospels, though they are shown with a fullness of detail and an elaboration

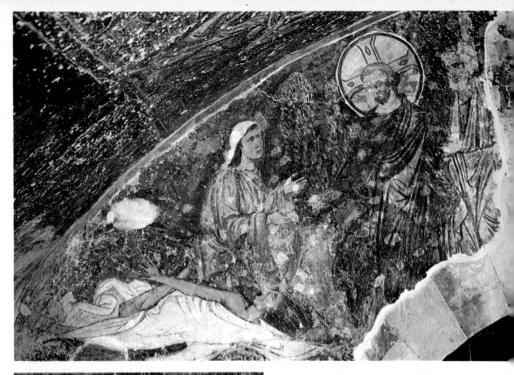

203, 204 Wall-paintings recently uncovered in the Church of Sancta Sophia at Trebizond. They are probably to be dated about 1260

205, 206 (*right*) Mosaics of about 1310 in the Church of the Saviour in Chora (Kariye Camii) at Constantinople. *Ill. 205* (*above right*) shows the donor of the mosaics, Theodore Metochites

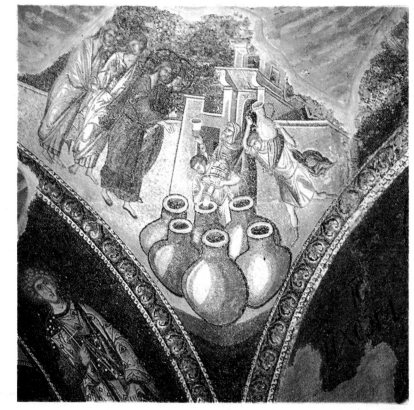

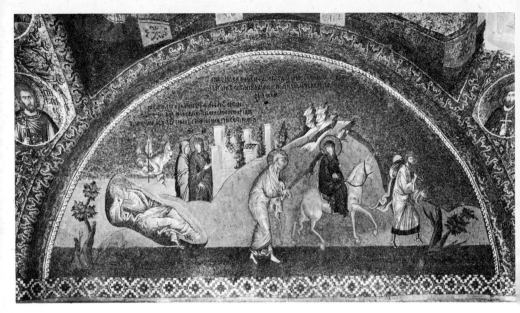

207 Kariye Camii, mosaic depicting Joseph's Dream and the Flight into Egypt. It dates from about 1310

not seen elsewhere till a later date. The Marriage at Cana (*Ill. 206*) may serve as an example; the jars of wine and the boys bringing the materials for the feast are quite charming. Another scene, one which is rather less common in Byzantine art, is Joseph's Dream (*Ill. 207*) and the Flight into Egypt. The artist has been particularly successful in the way the Dream is depicted, for Joseph is essential to the composition, yet at the same time seems to be part of the non-mundane world of the spirit—the dream-world to which he at that moment belonged. The scene forms part of the cycle of the Virgin's life, drawn from the Apocryphal Protevangelium of James. Another scene is the Annunciation to Elizabeth at the Well (*Ill. 208*) redolent at the same time of great spiritual feeling and earthly delight. The Nativity of the Virgin (*Ill. 209*) is full of detail with numerous subsidiary figures, ornate furniture, and a rich composition at the back, but it tells the story vividly and forcefully; the scene of the Washing of the Child in the corner is especially effective. The first steps of the Child Virgin, as she totters forward under the loving

226

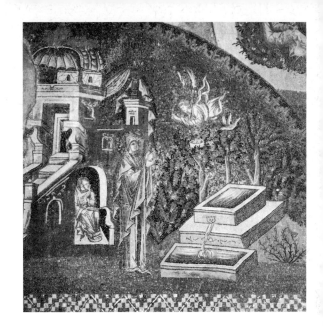

208, 209 Mosaics, Kariye Camii. Elizabeth at the Well and the Nativity of the Virgin. The story of the Virgin forms one of the main themes of the decoration

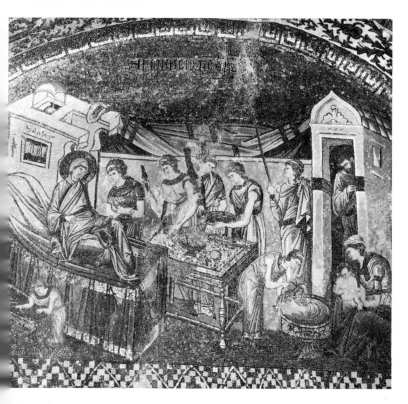

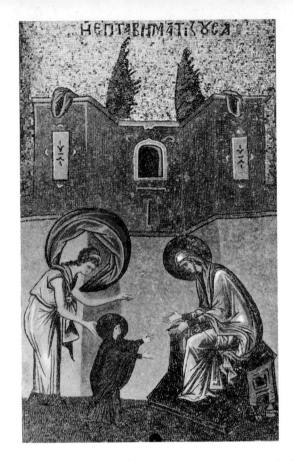

210 Mosaic, Kariye
Camii. The first steps
of the Virgin. The
shawl over the atten-
dant's head derives
from an old classical
motif usually asso-
ciated with personifi-
cations (see *Ill. 66*)

care of her nurse (*Ill. 210*), is perhaps more wholly human; it is both
entrancing and delightful, and the absence of detail not only makes
the scene all the more effective, but also serves to show the skill of the
artist who knew the value of open spaces in his compositions in
spite of his love for decoration. It may be contrasted with a magni-
ficent panel showing the Virgin Interceding with Christ, a sort of
incomplete Deesis (*Ill. 211*). Below are two figures on a smaller
scale, a posthumous portrait of the Prince Isaac Porphyrogenitus, and
one of a nun, Melane by name, who is probably to be identified as
Maria, sister of Andrinocus II Palaeologus, who was married to the
Mongol Khan Abaka, son of Hulagu, and who returned to Con-
stantinople at his death and founded the Church of St Mary of the
Mongols.

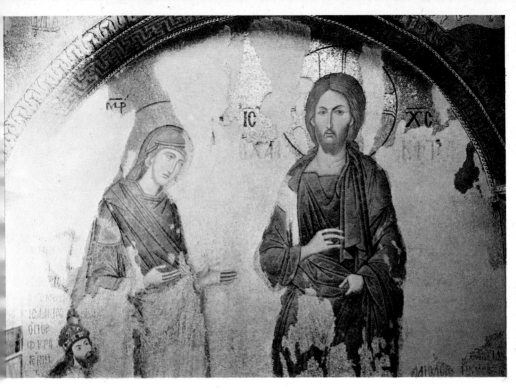

211 Mosaic. The Virgin Interceding with Christ. Below is a posthumous portrait of the Prince Isaac Porphyrogenitus and on the other side the Princess Maria Palaeologina who became a nun under the name of Melane

Beside the church and running the length of the sanctuary and the two narthices combined, is a separate chapel or *parecleseion*, which, as the tomb-niches or *arcosolia* in its walls designate, was built as a funerary chapel. Here the decoration is in paint, not mosaic, but the artistic quality of the work is no less considerable. The paintings date from around 1305, the very years that Giotto was working on the frescoes of the Arena Chapel in Padua. The iconography draws from the same sources, but the style is distinct, for the painter of the Kariye Camii *parecleseion* sought different ends. His work was in its own way no less fine. As is appropriate in a funerary chapel, the scenes are in one way or another concerned either with death or with the after-life. There is a wonderful rendering of the Resurrection in the apse, represented in the way usual in the Byzantine world by the

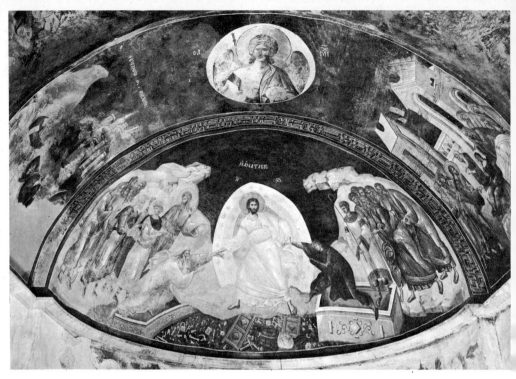

212 Wall-painting in the apse of a side chapel or *pareccleseion* at Kariye. The Anastasis or Descent of Christ into Limbo

Descent of Christ into Limbo (*Ill. 212*). Christ's face is of exceptional delicacy and the figure of Eve at one side is of outstanding beauty, though it is perhaps the spiritual feeling of the scene as a whole that is most striking. Below on the walls the respective fates that await the just and the unjust are shown with great expression—the Entry of the Elect into Paradise, on the one hand, and the Worm that Sleepeth Not and the Unquenchable Fire, on the other. Beside these scenes are the Saints who act as intercessors between the human and the divine. On the roof of the eastern bay is the Second Coming of Christ (*Ill. 213*). It is a very complicated scene, with the assembly of the Apostles at either side and that of the Angels behind; Our Lord is silhouetted before a mandorla or glory in the centre, the Virgin on one side, St John on the other, interceding for the sins of the world. Above is an Angel holding the Scroll of Heaven (*Ill. 214*), a

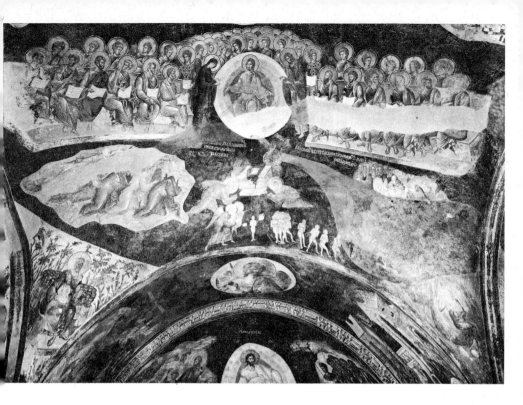

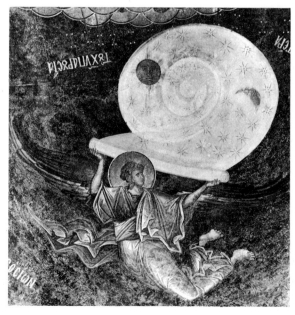

213, 214 Wall-painting in the apse of a side chapel or *pareccleseion* at Kariye Camii. (*Above*) The Second Coming of Christ on the vault, and (*right*) an Angel holding the Scroll of Heaven is an unusually effective and imaginative composition

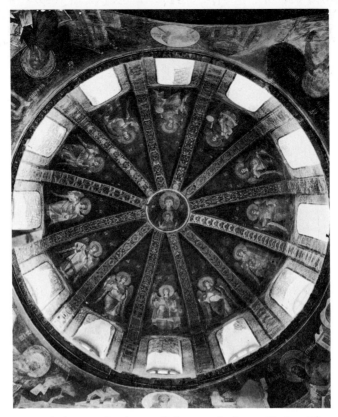

215 Painting on the dome of the *pareccleseion* at Kariye. The Virgin, Angels and decorative bands

composition of great beauty and originality; if ever one seeks for an explanation of El Greco's art in the Byzantine world, as one undoubtedly must, it is in works like this that one can find it.

In the pendentives and on the arches are scenes of the heavenly world, some of them very unusual, like one in which the Ark of the Covenant is being carried to Solomon's Temple on the backs of three men. At the centre of the main dome is a medallion of the Virgin, with decorative bands leading up to it, with full-length figures of Angels between them (*Ill. 215*). The ornamental bands are surprisingly suggestive of Italian work a century or more later. The way in which the dome is divided up into sections or lobes is

232

216 Mosaic in the dome of the Church of St Mary Pammakaristos (Fetiye Camii) at Constantinople

paralleled in Moslem architecture, and the idea may have come to the Byzantine world direct, or by way of Sicily or Southern Italy.

Much has, of course, perished, but Kariye Camii is not the only monument of Constantinopolitan art that survives from these years. There are mosaics of similar date and character in another church, St Mary Pammakaristos, usually known by its Turkish name of Fetiye Camii. The building has undergone a good deal of repair since Byzantine times, but the mosaics that remain are in good condition. Originally they comprised a bust of the Pantocrator in the dome (*Ill. 216*) with the Twelve Apostles around its perimeter and below, on the walls, in the semi-domes of the three apses and

233

217 The western façade of Kilisse Camii, probably identifiable as the Church of St Theodore Tyro, Constantinople. The lower levels of the arcades are filled with marble slabs

under the arches, the principal scenes of Christ's life and the figures of the Virgin and a number of Saints. The mosaics are at present being cleaned under the auspices of the Byzantine Institute of America; they are to be dated to about 1320.

There are more mosaics of the period, of rather coarser type, in another church known as Kilisse Camii; the mosaics, which have not yet been fully cleaned, adorn the domes which form the roof of the exo-narthex. The church is probably to be identified as that of St Theodore Tyro (*Ill. 217*). It is an attractive building, and in spite of the changes that it underwent when it was transformed into a mosque after the Turkish Conquest of 1453, it retains its original plan and something of its quality as a building. Some good sculptured marble slabs still survive between the pillars of its western front. An even more delightful example of the architecture of the age is furnished by the east end of the double church known as St Mary Panachrantos, converted into a mosque under the name Phenari Issa Camisi. The east end (*Ill. 218*) was added to earlier structures (cf. p. 61) in the fourteenth century.

In addition to these large-scale monuments there are a few portable works which are now preserved elsewhere but which, for one reason

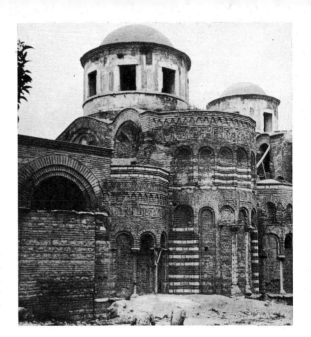

218 The east end of the Church
of St Mary Panachrantos. It is a
double church, with an east end
of later date than the rest of the
building. The domes are addi-
tions of the Turkish period

or another, may be assigned to Constantinople. Most outstanding
among them are several miniature mosaics, where the tiny cubes,
often no bigger than a pin's head, are set in wax on a wooden core.
At one time it was thought that such precious works were more in
keeping with the spirit of an earlier age, for they are costly and
precious, and it was believed that the Court and nobles of Palaeologue
times were too impoverished to sponsor the more sumptuous arts,
but the style of most of these mosaics, now that we know more
about it, attests a fourteenth-century date, and we must conclude
that even if the economic position was serious, no sacrifices were
made in the way of reducing expenditure on works of religious art.
One of the loveliest of all is that bearing the Annunciation in the
Victoria and Albert Museum (*Ill. 219*). It is close in style to the
Kariye Camii wall-mosaics, and the tall, elongated figures, the ela-
borate background, the delicate pose of the Angel, and the love of
detail all intimate a date in the early fourteenth century. To much the
same period is to be assigned a mosaic diptych in the Cathedral
Treasury in Florence (*Ill. 220*) on which the Twelve Feasts of the
Church are depicted, six on each leaf; they are the Annunciation,
Nativity, Presentation in the Temple, Baptism, Transfiguration,

235

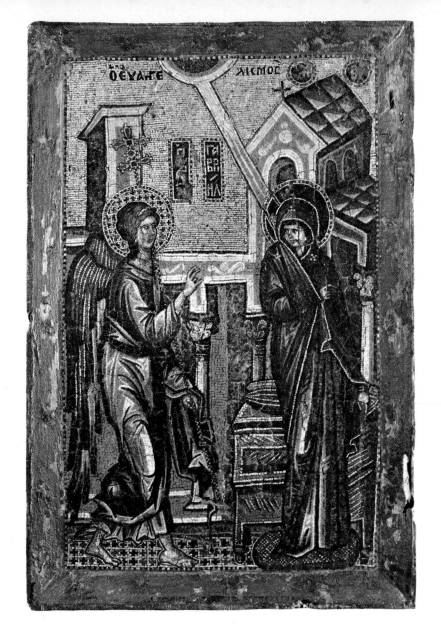

219 Miniature mosaic, the Annunciation. The style is close to that of the large-scale mosaics in Kariye Camii. One of the loveliest of all such miniatures, it is preserved in the Victoria and Albert Museum

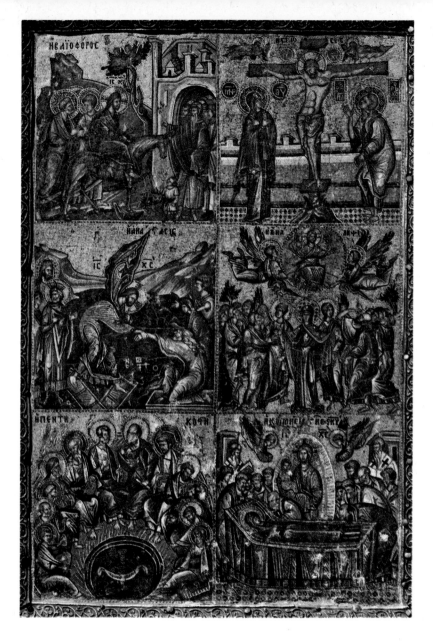

220 Miniature mosaic bearing the Entry, the Crucifixion, the Anastasis, the Ascension, Pentecost and the Dormition of the Virgin. It forms a diptych with a leaf bearing six scenes from Christ's early life

Raising of Lazarus, Entry into Jerusalem, Crucifixion, Resurrection (where Our Lord breaks down the gates of Purgatory), Ascension, and Pentecost, together with the Assumption of the Virgin. Many other lovely examples of miniature mosaics of this period preserved elsewhere, notably in several of the monasteries on Mount Athos, are no doubt to be assigned to Constantinopolitan workshops. They bear witness to the fact that the sumptuous arts were not dead in the Palaeologue Age, and this is borne out by the existence of other sumptuous things, such as the rich textiles which notables of the period are depicted as wearing—the costume worn by Theodore Metochites, the donor of Kariye Camii, in his portrait among the mosaics there is typical—or of actual treasures like a chalice (*Ill. 221*) in the Monastery of Vatopedi on Mount Athos, which is associated in an inscription with the Despot Manuel Cantacuzenus of Mistra (1349–80). Its body is of jasper, its stem of silver-gilt with medallions in relief at the base. It has been suggested that the handle shows Western influence, but there are similar ones on some of the earlier Byzantine chalices in the Treasury of St Mark's.

It is however true to say that painted panels, which were of course cheaper than mosaics or ivories, were becoming more numerous and more important than they were at an earlier age, and from about 1300 onwards they came to constitute one of the most important arts. Happily quite a number survive, though they are scattered in collections over a very wide area. The first that may be noted is in the Pushkin Museum at Moscow and depicts the Assembly of the Twelve Apostles (*Ill. 222*). It is exquisitely painted and the colouring is very attractive. The inclusion of high-lights in white is a typical feature of the paintings of this age, though it is perhaps more obvious on the panels than on the wall-paintings. The way in which they are laid on is sometimes helpful in the business of dating, for at first, around 1300, the high-lights were put on in fairly broad masses, as is the case here, whereas later they took the form of a sort of hatching made up of thin parallel lines.

Progress towards this mannerism, though it has not gone very far, is to be seen on an outstandingly lovely painting of the Annunciation now at Skoplje (*Ill. 223*), but originally in the Church of St Clement

238

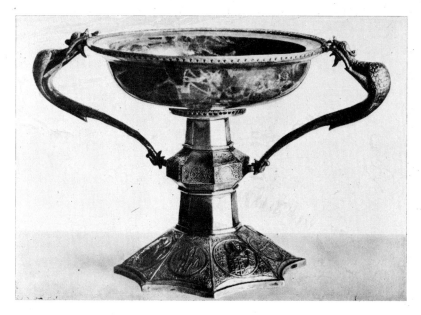

221 The chalice of Manuel Cantacuzenus, in the Monastery of Vatopedi, Mount Athos. The body is of jasper

at Ochrid. It occupies one side of a double processional icon; the place where a pole for bearing it was attached can be seen at the bottom. On the other face is the Virgin, in the pose of the Hodegetria, or Indicator of the Way (*Ill. 224*), but she bears a special designation 'Saviour of Souls', and the figures are surrounded by a mount of silver repoussé work of much the same date as the icon. The Annunciation is a painting of outstanding beauty worthy to rank with the finer products of any of the Italian schools. It may be objected that the painter was troubled as to how to depict the throne; clearly there is a pillar at either side to support the canopy, though one of them is obscured by the Virgin's body in a way that strictly speaking it should not be. But, to paraphrase the eighteenth-century critic Jonathan Richardson when speaking of Raphael's *Miraculous Draught of Fishes*, 'had the painter been more exact, the picture would have been all throne and no figure, and that would in itself have been displeasing. As it is, it is perhaps not perfect; but

239

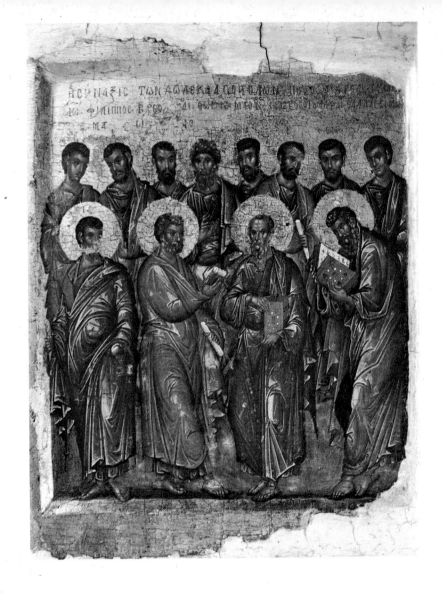

222 Icon, entitled the Assembly of the Apostles. The four figures in the front
represent Peter, James, John and Matthew. The inclusion of high-lights in white is
a typical feature of paintings done around 1300

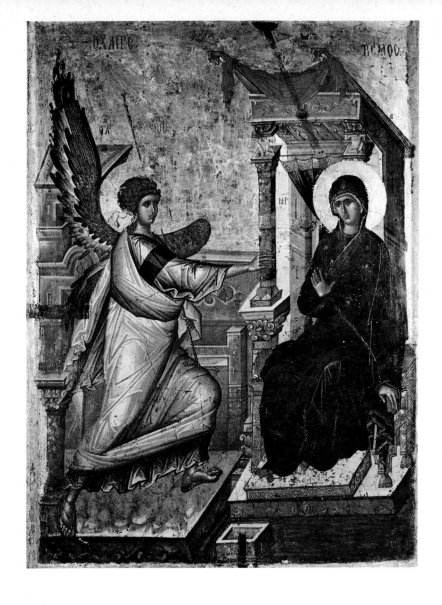

223 Reverse of double-sided icon, the Annunciation. Though from the Church of St Clement at Ochrid, it is to be assigned to a Constantinopolitan master working in the first half of the fourteenth century

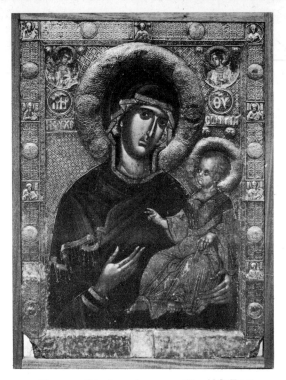

224 Obverse of the icon shown on *Ill. 223*. The Virgin and Child, designated Saviour of Souls. The icon was a processional one, mounted on a pole for carrying

it would have been worse otherwise', and, one may add, its deeply spiritual content surely serves to redeem any short-coming of academic draughtsmanship. Once again, though it comes from a church in Yugoslavia, both its style and records associated with it attest that it is to be attributed to a painter from the capital.

Another outstanding icon is a small one depicting the Archangel Michael, now at Pisa (*Ill. 226*), a jewel-like little treasure, exquisite in its colouring. Once more the style attests a date in the first half of the fourteenth century, though it is perhaps a little later than the Kariye Camii mosaics. A larger icon, showing Christ, which is now in the Hermitage Museum (*Ill. 225*), serves as a guide, for on each margin is the portrait of a donor, and there are two inscriptions which serve to identify them as a certain Alexius, and his brother John, who

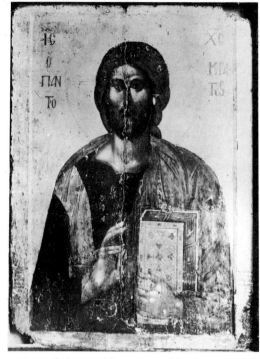

225 Icon of Christ, with portraits of the donors at the bottom of the two margins. It was painted for a monastery on Mount Athos between 1360 and 1370

presented the icon to the Monastery of the Pantocrator on Mount Athos between 1360 and 1370. Other icons accompanied by inscriptions are preserved elsewhere. From the purely artistic point of view, however, the palm must perhaps go to an icon of the Virgin and Child in the Tretyakov Gallery at Moscow, known as *Our Lady of Pimen* (*Ill. 227*). The way in which the high-lights are painted—they appear as thin parallel lines beside the eyes—denotes a date at the very end of the fourteenth century. Though the style is somewhat distinct from that of the other icons we have been examining, this icon was nevertheless probably painted in Constantinople, although it is to be assigned to a distinct school which was later to become important especially in the Adriatic, where it is usually known by the term Graeco-Italian.

243

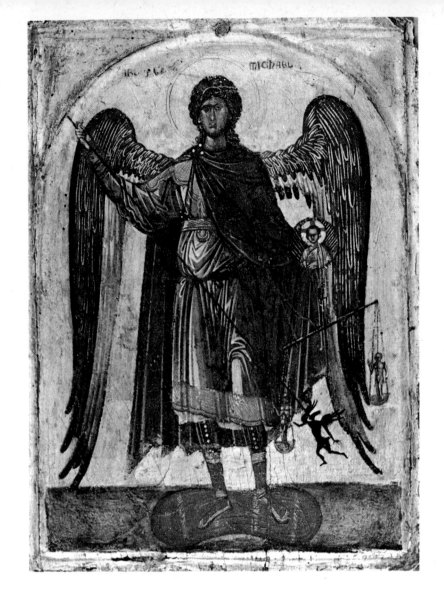

226 Icon of the Archangel Michael in the Museo Civico at Pisa. It is one of the
most exquisite works of the Palaeologue age that have come down to us

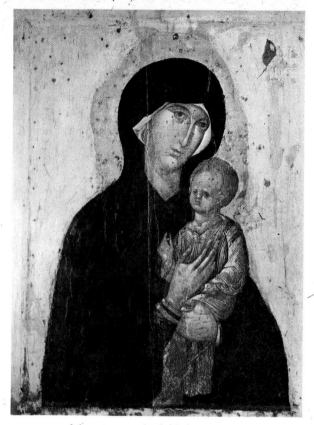

227 Icon of the Virgin and Child, known as *Our Lady of Pimen*. It belongs to a school which was later to become important as the Graeco-Italian

Apart from the miniature mosaics and the icons, examples of painting done in the capital have been preserved for us in another form, namely that of book-illustrations. There are quite a number of illuminated manuscripts of the age and their illustrations are often of very high quality. A copy of the Works of Hippocrates, now in the Bibliothèque Nationale (Gr. 2144) is interesting, for the portrait of Hippocrates himself (*Ill. 228*) shows a new mastery of perspective. In the depiction of the throne the painter has avoided, or almost avoided, the difficulties which were noted with regard to the Ochrid Annunciation. On another page is portrayed the donor of the book, the High Admiral Apocaucos (*Ill. 230*); here the perspective of the

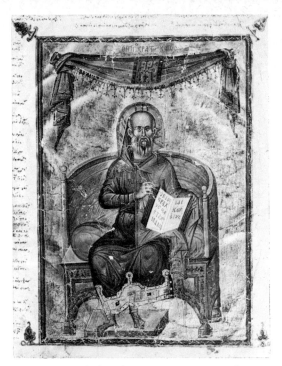

228 Portrait of the physician Hippocrates, from a manuscript of his works in the Bibliothèque Nationale written in Constantinople around 1342

throne has been rather less successfully tackled. But the colour contrasts are effective and the portrait of the page who peers over the back of the throne is particularly delightful. The manuscript dates from about 1342. Another, also in the Bibliothèque Nationale (Gr. 1242) was done about thirty years later. It contains an impressive portrait of the Emperor John VI Cantacuzenus presiding over a council of Bishops and Monks, but the finest of the illuminations represents the Transfiguration (*Ill. 231*). The colouring is unusual, in the great predominance of blue; it is indeed extremely daring, but also wholly effective in conveying the mystic nature of the subject.

Though there are certain variations of style in these works, they are in the main all distinguished by a remarkable feeling for colour, by a fine balance of design, and by a real sense of grace. These were all factors characteristic of the Constantinopolitan school, and attest

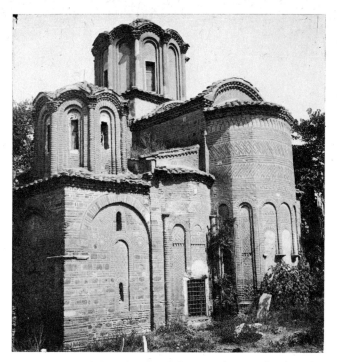

229 East end of the Church of the Apostles at Salonika. The
decorative brickwork is outstanding, the tall drums of the domes
typical of its period, c. 1312

not only the great powers of the artists but also the highly cultured
nature of the patrons. A rather distinct outlook distinguishes the
paintings and mosaics which were done in and around Salonika, the
next largest and in many ways the next most important city of
the Byzantine world. The monuments in the region of the city are,
as one would expect, mostly paintings, for the provinces were poorer
than the capital, but vestiges of a mosaic decoration which must once
have been both extensive and fine survive in the Church of the Holy
Apostles in the city itself, and other mosaics once existed in the
neighbourhood, though little now survives.

The Church of the Holy Apostles is a delightful building; it is,
indeed, one of the best examples of later Byzantine architecture
that we have, and nowhere else was brickwork used to produce
so effective a decoration (*Ill. 229*). The vestiges of the mosaics,

247

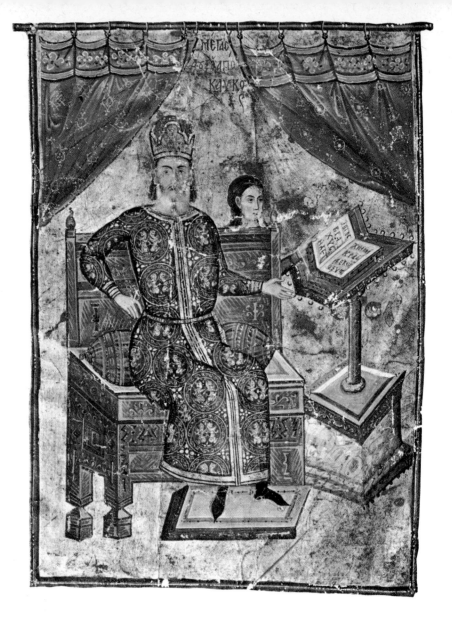

230 Portrait of the High Admiral Apocaucos seated on a large wooden throne

231 (*right*) The Transfiguration from a manuscript done for John Cantacuzenus between 1370 and 1375

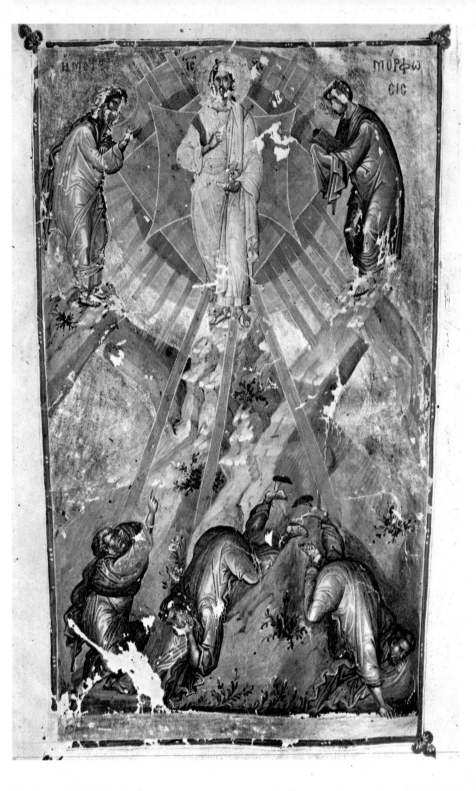

232 Mosaic, The Transfiguration, in the Church of the Holy Apostles, Salonika. It was done about 1312 and is therefore contemporary with the mosaics of Kariye Camii at Constantinople

which are to be dated to about 1312, are in the main dome, in the pendentives that support it, and on the adjacent vaults. They are unfortunately very battered, but enough survives to show that the work was both very accomplished technically and very lovely from the artistic point of view. The colouring is however perhaps a little deeper and more sombre than that at Kariye Camii: the scene of the Transfiguration (*Ill. 232*) may serve as an example and may be compared with that in the Cantacuzenus Manuscript (cf. *Ill. 231*).

Dr Paul Underwood, who was responsible for directing the conservation of the mosaics at Kariye Camii, thinks that the same workshop could have also been responsible for the Salonika mosaics;

Greek authorities, Professor Xyngopoulos foremost among them, on the other hand, insist that a distinct school was at work at Salonika which first developed in the city itself and then affected the whole of Macedonia. Work that is to be assigned to it was less brilliant, less elegant, than that at Constantinople, but at the same time showed a greater interest in realism and vivid expression. This is especially noticeable in the scene of the Nativity; the Shepherds (*Ill. 233*) are figures of peculiar vividness and liveliness. If compared with those at Kariye Camii however the differences can hardly be said to be greater than those one would attribute to a distinction of hand. Other secular figures at Kariye Camii, like the Soldiers before Pilate, or the individuals in scenes like the Apostles in the Dormition, are treated in no less realist a manner, and any great distinction of school with regard to the Salonika mosaics can hardly be accepted.

But mosaics were a luxury art, and it was really in the paintings that the local style developed most freely. Indeed, the growth of a

233 Mosaic. Detail of Shepherds from the scene of the Nativity. This may be compared with the rendering in paint at Sopoćani, done some forty years earlier (*Ill. 186*)

new and independent school, which is usually termed the Macedonian, had, as we have seen above, already begun before 1200 at Kurbinovo and it continued on both sides of the frontier which today separates Greece from Yugoslavia. It would seem that the painters were at first generally Greek, and Greeks were employed by the Slav patrons until 1300 or even later. Only then do inscriptions in Slav become general, and only from after 1300 can a style that is truly Slav be distinguished.

An interesting characteristic of the Macedonian school is that not a few of the painters signed their works. The names of Astrapas, Michael, and Eutychios, who worked in the Slav area have already been noted (cf. p. 205). Professor Xyngopoulos, in a recent study, has listed quite a number of names of men who worked in the Greek area. The most important of them was called Panselinos; his name

234 Wall-painting, the Washing of the Feet, in the Church of the Protaton, Karyes, Mount Athos. It is to be dated to around 1300 and is perhaps to be associated with the painter Panselinos

has long been known in association with paintings on Mount Athos, though there has been a good deal of dispute as to when he lived. It was thus at one time held that he was working as late as the sixteenth century, but Professor Xyngopoulos has recently made out a very good case for identifying him as the master responsible for the original decoration of the Church of the Protaton at Karyes; this, thanks to indisputable archaeological evidence, is to be dated to between 1282 and 1328. Whether or not Panselinos was the painter, the paintings show the realism and vividness typical of the Macedonian school, and the differences between this work and that of the Constantinopolitan school as we see it at Kariye Camii are obvious. The angular, forceful gestures of Peter in the scene of the Washing of the Feet (*Ill. 234*) may be compared with the more delicate, more restrained approach of the Kariye Camii painter. Professor Xyngopoulos has also assigned to Panselinos wall-paintings of the fourteenth century in a side chapel of the Church of St Demetrius at Salonika.

If the paintings on Mount Athos, in Salonika, and elsewhere in Macedonia represent the work of a separate Macedonian school, the manner of Constantinople was to the fore in other places, notably in a number of churches in the little mountain town of Mistra in the Peloponnese. The city enjoyed considerable prosperity during the last centuries of Byzantine rule: indeed it was there that the story of later Byzantine painting saw its fullest development outside Constantinople and it is there that it can be most satisfactorily studied.

The town of Mistra (*Ill. 235*) is today a ruin, uninhabited but for a few nuns who live in monastic buildings attached to one of the churches. In the fourteenth century it was a prosperous township owing allegiance to Constantinople, though it was separated from the capital not only by a considerable distance but also by a number of independent Latin territories. It was usually ruled by one of the Emperor's younger sons under the title of Despot, and it formed through the Palaeologue period the most important and towards the end, the only, province of the once mighty Empire. It fell to the Turks in 1460, thus retaining its independence for seven years longer than Constantinople and one year less than the Empire of Trebizond.

235 View of the hill town of Mistra in the Peloponnese; its churches contain wall-paintings of outstanding quality

It was renowned as a seat of culture and learning. The philosopher George Gemistos Plethon resided there in the fifteenth century; there the famous Cardinal Bessarion, whose lovely reliquary (*Ill. 236*) is preserved in the Accademia in Venice, sat at Plethon's feet, and there men who were to revive the study of the classics in the West did much of their writing. The Despots in many cases married Italian wives, and the city's culture drew something from Italy, though in the main it remained basically Byzantine. The arcades of the Church of the Pantanassa are thus rather Florentine in style, and the fashion that we see there and in other churches at Mistra of decorating the exteriors of the buildings with glazed pottery bowls built into the masonry with their insides turned outwards was also probably adopted from Italy where it was in great favour in towers of the Romanesque period. But the churches are nevertheless Byzantine buildings and their paintings belong to Byzantine, not to Western art.

The town of Mistra was actually founded about 1246 by a Frank, William de Villehardouin, brother of the more famous Geoffrey,

236 Icon of the Crucifixion, mounted in a silver frame and known as the 'reliquary of Cardinal Bessarion'

but it was ceded to Michael Palaeologus in 1259. The earliest of the churches is that of St Demetrius which was later to serve as Cathedral. It was founded in 1312, but restored in the fourteenth century by a Bishop Matthew, whose monogram appears on the sculptured iconostasis. Its wall-paintings are of various dates. Some are in the lovely style of the Palaeologue Revival, but the most impressive of them, the Virgin in the apse, with the Divine Liturgy below (*Ill. 237*), is distinguished by the calm and grandeur normally typical of eleventh- or early twelfth-century work; it serves as proof that the newer manner was not universally adopted and that in those days as now, old, conservative styles survived alongside the more progressive ones.

More typical of the fourteenth century are the paintings in the Church of the Virgin Hodegetria, also known as the Aphentiko, which was founded at much the same date. It forms part of a larger monastic complex, the Brontocheion, which also comprises a second church, dedicated to St Theodore. The paintings in the former are in

237 Wall-painting in the apse of the church of St Demetrius at Mistra. Above, the Virgin and Child; below, the Divine Liturgy

a poor state of preservation, but must once have been among the finest at Mistra, full of picturesque detail and done with great delicacy. They are to be dated to the second quarter of the fourteenth century on the basis of an inscription on the walls of a chapel on the south side reproducing *chrysobulls* or royal warrants in the names of Michael VIII (1258–82) and Adronicus II (1282–1328). Lovely Angels support a glory on the roof of this chapel; in the gallery is a fine series of scenes from Our Lord's life; all are vivid and brilliant; the Healing of the Paralytic (*Ill. 238*) may be noted for the loveliness of its colour. The other church, that of St Theodore, was founded about 1296 by one Pachomios who had distinguished himself in the wars against the Franks. The paintings on the walls show scenes from the life of the Virgin, those on the vaults the life of Christ;

238 Church of the Aphentiko, Mistra. Wall-painting showing the Healing of the Paralytic. c. 1290

239 Church of the Peribleptos, Mistra. Wall-paintings in the dome and the vaults below the dome. c. 1350

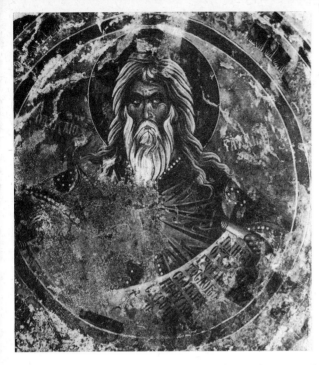

240 Wall-painting in the Brontocheion, Mistra. The Prophet Zacharias. 1296

on the roof are busts of Prophets. Zacharias is both striking and typical (*Ill. 240*). In one of the eastern chapels is a portrait of Manuel Palaeologus on his knees before the Virgin.

Next in date among the painted decorations at Mistra is that in the Peribleptos. There is no inscription to date it, but the style of the architecture suggests that the church was built between 1310 and 1350 and the paintings must have been added soon after the completion of the church. They are, happily, better preserved than those in the Brontocheion. Christ Pantocrator occupies the central dome, with the Ascension on the vault to the east, the Nativity and the Baptism to the south, the Transfiguration and the Last Supper to the north, and Doubting Thomas and the Giving of Tongues to the west (*Ill. 239*). The colours are brilliant and of outstanding beauty and tell well at a distance; the drawing and fine detail can only be properly appreciated when seen close to or with the aid of glasses. Thus there is a great deal of fine draughtsmanship in the Nativity (*Ill. 243*) which is executed with the delicacy of a miniature though the figure of the Virgin, silhouetted against her bed in the

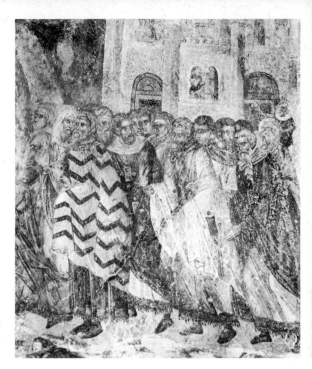

241 Wall-painting. The Entry into Jerusalem. Church of the Peribleptos, Mistra. c. 1350

middle, stands out with great strength and gives the effect almost of some modern abstract composition. The same is true of other scenes in the church, for in spite of their very battered condition, surprising beauties lie hidden. The Entry into Jerusalem (*Ill. 241*) is thus intensely alive, and the strange costumes of the crowd waiting at the Gates of the City to welcome Our Lord strike a brilliant and unexpected note which serves to compel the attention; full of detail though it is, there is a grandeur and sweep about the composition which is intensely impressive.

The exquisite, almost miniature-like style of the paintings in the Peribleptos had a heritage on Mount Athos, in Crete, and elsewhere in Greece. But work of the school does not appear again at Mistra, for the paintings in the one remaining church that is reasonably well preserved, that of the Pantanassa, are in a rather different style. The church itself was built by the Despot Manuel Cantacuzenus about 1350 and restored by John Frangopoulos in the year 1428. The paintings belong to the latter date. The best of them are on the vaults and in the galleries; those in the side aisles and the narthex are

259

242 Wall-painting. The Annunciation. Church of the Pantanassa, Mistra. 1428

later again, and are less important. At the east end of the main vault is the Ascension, Christ in the centre, a group of spectators on each side. To the west of it, also on the vault, are scenes from Christ's life: the Annunciation, the Nativity (*Ill. 244*), the Presentation in the Temple, the Entry into Jerusalem, and the Raising of Lazarus. All show mastery of composition and a gaiety of conception and colouring which is wholly delightful. In the Annunciation (*Ill. 242*) for example there is a riot of fanciful architecture in the background and a great deal of enchanting detail in the foreground including a partridge drinking at a little fountain, but the real beauty of the picture lies in the figure of the alighting Angel, so delicately suspended in space. Most glorious of all, however, is the Raising of Lazarus (*Ill. 243*). There the artist uses colour to express the significance of the scene, with a subtlety worthy of El Greco. Indeed, the green and purple costumes of the workmen and the strange pinkish-red of the sarcophagus produce an astonishingly dramatic effect against the yellow background. Only El Greco in the West, and later Gauguin, would have used their colours in just this way.

From the beginning of the fifteenth century onwards the pursuit of examples of Byzantine painting may be carried on over the whole

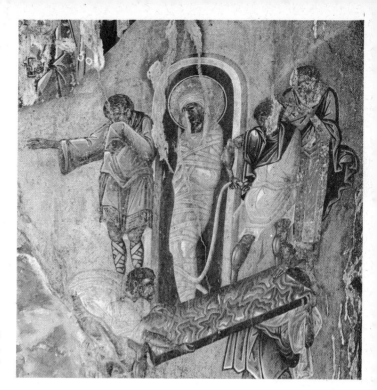

243 Wall-painting. The Raising of Lazarus. Church of the Pantanassa, Mistra. 1428

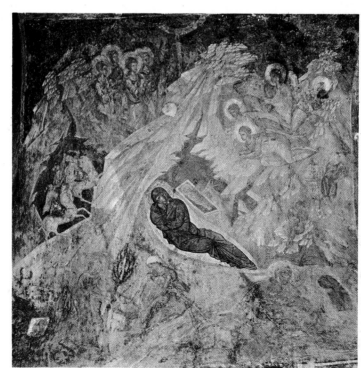

244 Wall-painting. The Nativity. The Church of the Peribleptos, Mistra. c. 1350

of Greece, for numerous churches were set up and still more were decorated at that time; work went on even during the years of Turkish domination. Most of it, though it follows a grand tradition, is not of great distinction, though here and there a decoration stands out, and it is on Mount Athos that the story of the last phase of Byzantine painting can best be followed, for the monks there always enjoyed greater freedom after the Turkish Conquest than did the civil population of Greece, and whereas churches in Greece were invariably small and in most cases poor, the Athos monasteries were mostly prosperous, the churches were quite large and many of them of real architectural distinction. The main church of the Monastery of St Paul, seen from above (*Ill. 245*), gives an idea of the considerable size and the degree of elaboration of the architecture. Most of the wall-paintings that decorate these buildings however belong to the sixteenth century, and so fall outside the scope of this survey. Nor can we be concerned here with the other later works that were produced on Mount Athos after the Turkish Conquest, such as carved iconostases, pieces of church furniture, or reliquaries. A word may however be said of the embroideries, which showed an uninterrupted development from the fourteenth century onwards till the seventeenth. Examples are preserved in many monastic treasuries in the East, and there are others in collections in the West. One of the finest is in the Vatican and is usually known as the Dalmatic of Charlemagne (*Ill. 246*), though it dates from the fifteenth century and can have no connexion with the Emperor who was crowned at Rome as Ruler of the West in 800.

Of all the later products, however, the most important were the painted panels, or icons, and though one tends to think of Russia when the word icon is mentioned, the Greek schools were little less important and certainly no less productive. The classification and study of these panels is still in its infancy, but several schools can be distinguished and the work of a number of masters of real ability can be separated from a mass of material which, however valuable to the faithful, must, from the artistic point of view, be regarded as hackwork. Among the finer works a fifteenth-century icon of the Raising of Lazarus (*Ill. 247*) may be noted. It has been attributed to a

245 Church of the Monastery of St Paul, Mount Athos, seen from above. It is fifteenth century but reproduces an earlier style

246 Embroidery, the so-called Dalmatic of Charlemagne, in the Vatican. It is a work of the fifteenth century

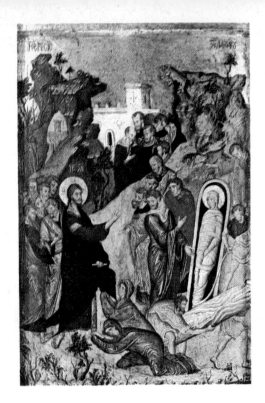

247 Icon. The Raising of Lazarus. It is a late work done probably in the fifteenth century, but serves to show that Byzantine art did not die with the Turkish conquests

Greek master called Byzagios, who was working in the first quarter of the century. It is not perhaps as great a work as are the superb wall-paintings in the Pantanassa at Mistra, or as such an icon as the Ochrid Annunciation (cf. *Ill. 223*), but it is nonetheless a painting of quality, an object of delight in itself, and takes a worthy place in the room in which it hangs in the Ashmolean Museum at Oxford beside the works of masters of the Sienese and Florentine schools. Panels such as these bring the story to an end. They should not be neglected, even if they do not fall into the same category as the great wall-mosaics, or the delicate ivories of an earlier age, or lack the pioneering significance of the earlier churches or the 'humanist' paintings of the twelfth century. Above all they disprove the theory of extended yet progressive decay which has in the past so often been associated with the word 'Byzantine'.

Bibliography

List of Illustrations

Chronology

Index

Bibliography

The bibliography has been restricted to fundamental works only, in English, French, German and a few in Italian. Books in other languages and articles in periodicals have not been included, for the latter are primarily of a specialized character and are often difficult to obtain, while languages like Russian, Serbo-Croat, Modern Greek or Turkish are known only to a few; it is however in these languages that much of the most important first-hand material has been published. The serious student will find references to such articles in the books cited and will need to turn not only to such international periodicals as the *Byzantinische Zeitschrift* (Munich), *Byzantion* (Brussels), *Byzantinoslavica* (Prague) or the *Cahiers Archéologiques* (Paris), but also to the various journals issued in the U.S.S.R., Bulgaria, Yugoslavia, Greece and Turkey, in the languages of those countries.

General Works

BRÉHIER, L. *L'Art Byzantin*, Paris, 1924

DALTON, O. M. *Byzantine Art and Archaeology*, Oxford, 1911

DALTON, O. M. *East Christian Art*, Oxford, 1925

DIEHL, C. *Manuel d'Art Byzantin*, Paris, 1925

GLÜCK, H. *Die Christliche Kunst des Ostens*, Berlin, 1923

HAMILTON, J. A. *Byzantine Architecture and Decoration*, London, 1956

RICE, D. TALBOT *The Beginnings of Christian Art*, London, 1957

RICE, D. TALBOT *Byzantine Art*, Harmondsworth, 3rd ed. 1962

WULFF, O. *Altchristliche und Byzantinische Kunst*, Berlin, 1914

Egypt and Syria

DUTHUIT, G. *La Sculpture Copte*, Paris, 1931

FRANCOVICH, G. DE 'L'Arte siriaca e il suo influsso sulla pittura medioevale nell' Oriente e nell'Occidente', in *Commentari*, Anno II, nos. 1–4, Florence, 1951

GAYET, A. *L'Art Copte*, Paris, 1902

GRÜNEISEN, W. DE *Les Caractéristiques de l'Art Copte*, Florence, 1922

KITZINGER, E. 'Notes on Early Coptic Sculpture', in *Archaeologia*, LXXXVII, 1937

LEVI, D. *Antioch Mosaic Pavements*, Princeton, 1947

MOREY, C. R. *Early Christian Art*, Princeton, 1942

VOLBACH, W. F. *Elfenbeinskulpturen der Spätantike und des frühen Mittelalters*, Mainz, 1952

Central Area

BECKWITH, J. *The Art of Constantinople*, London, 1961

BREHIER, L. *La Sculpture et les Arts Mineurs—Histoire de l'Art Byzantin*, Paris, 1936

DEMUS, O. *Byzantine Mosaic Decoration*, London, 1947

DEMUS, O. and DIEZ, E. *Byzantine Mosaics in Greece*, Harvard, 1931

DIEHL, C., LE TOURNEAU, M. and SALADIN, H. *Les Monuments Chrétiens de Salonique*, Paris, 1918

EBERSOLT, J. *Les Arts Somptuaires de Byzance*, Paris, 1923

EBERSOLT, J. *La Miniature Byzantine*, Paris, 1926

GRABAR, A. *Byzantine Painting*, Geneva, 1953

GRABAR, A. and CHATZIDAKIS, M. *Greece—Byzantine Mosaics*, UNESCO, 1959

MILLET, G. *L'Ecole Grecque dans l'Architecture Byzantine*, Paris, 1916

RICE, D. TALBOT *The Art of Byzantium*, London, 1959

WEITZMANN, K. *Die Byzantinische Buchmalerei des IX und X Jahrhunderts*, Berlin, 1935

WHITTEMORE, T. *The Mosaics of Hagia Sophia at Istanbul*, Oxford, no. 1, 1935; no. 2, 1936; no. 3, 1942; no. 4, 1952

Eastern Areas

DOURNOVO, L. A. *Armenian Miniatures*, London, 1961

JERPHANION, G. DE *Les Eglises Rupestres de Cappadoce*, 2 vols text and 3 albums, Paris, 1925–32

MOURIER, J. *L'Art au Caucase*, Brussels, 1907

NERESSIAN, S. DER *Armenia and the Byzantine Empire*, Harvard, 1945

NERESSIAN, S. DER *The Chester Beatty Library: A Catalogue of the Armenian Manuscripts*, 2 vols, Dublin, 1958

STRZYGOWSKI, J. *Die Baukunst der Armenier und Europa*, Vienna, 1918

STRZYGOWSKI, J. *Origin of Christian Church Art*, Oxford, 1923

Italy

DEMUS, O. *The Mosaics of Norman Sicily*, London, 1949

DEMUS, O. *The Church of San Marco in Venice*, vol. I 'Architecture', Dumbarton Oaks, 1960; vol. II 'Mosaics' (not yet published)

KITZINGER, E. *The Mosaics of Monreale*, Palermo, 1960

LAZAREV, V. N. 'The Mosaics of Cefalù', in *Art Bulletin*, XVII, 1935

Balkans

FILOW, B. D. *L'Ancien Art Bulgare*, Berne, 1919

GRABAR, A. *La Peinture Religieuse en Bulgarie*, Paris, 1928

GRABAR, A. and MIATEV, K. *Bulgaria—Mediaeval Wall-paintings*, UNESCO, 1962

MILLET, G. *L'Art Byzantin chez les Slaves*, 2 vols, Paris, 1930

MILLET, G. and FROLOW, A. *La Peinture du Moyen Age en Yougoslavie*, 2 vols, Paris, 1954 and 1957

OKUNEV, N. *Monumenta Artis Serbicae*, 4 parts, Zagreb-Prague, 1928, 1930, 1931 and 1932

PETKOVIĆ, V. R. *La Peinture Serbe du Moyen Age*, Belgrade, vol. I, 1930; vol. II, 1934

PETKOVIĆ, V. R. and BOSKOVIĆ, G. *Dečani*, Belgrade, 1941

RADOJČIĆ, S. *Icônes de Serbie et de Macédoine*, Belgrade, 1961

RICE, D. TALBOT and RADOJCIC, S. *Yugoslavia—Mediaeval Frescoes*, UNESCO, 1955

Palaeologue Age

BYRON, R. and RICE, D. TALBOT *The Birth of Western Painting*, London, 1930

MILLET, G. *Monuments Byzantins de Mistra*, Paris, 1910

MILLET, G. *L'Iconographie de l'Evangile*, Paris, 1916

MILLET, G. *Monuments de l'Athos*, Paris, 1927

UNDERWOOD, P. A. 'The Frescoes in Kariye Camii', in *Dumbarton Oaks Papers*, nos 9–15, Harvard, 1956–61

XYNGOPOULOS, A. *Thessalonique et la Peinture Macédonienne*, Athens, 1955

List of Illustrations

The author and publishers are grateful to the many official bodies, institutions, and individuals mentioned below for their assistance in supplying original illustration material.

23 Border of mosaic pavement from Antioch. Early sixth century. Louvre, Paris. After D. Levi (ed.), *Antioch Mosaic Pavements*, Princeton University Press.

24 Part of a mosaic pavement from Antioch. Fifth century. After D. Levi (ed.), *Antioch Mosaic Pavements*, Princeton University Press.

25 Manuscript; The Rabbula Gospels. The Ascension. $13 \times 9\frac{7}{8}$ ($33 \times 25 \cdot 2$). Written at Zagba, Eastern Syria in 586. Laurentian Library, Florence. Photo: Thames and Hudson Archive.

26 The Rabbula Gospels; The Crucifixion. 13×10 ($33 \times 25 \cdot 5$). Photo: Thames and Hudson Archive.

27 Ivory diptych; The Adoration and the Nativity. $8\frac{1}{4} \times 3\frac{1}{8}$ ($21 \cdot 5 \times 8 \cdot 5$). Sixth century. British Museum, London. Photo: Max Hirmer.

28 Ivory pyxis; Christ, the Twelve Apostles and the Sacrifice of Isaac. $4\frac{3}{4} \times 5\frac{1}{2}$ ($12 \times 14 \cdot 6$). Fifth century. Ehem. Staatliche Museen, Berlin-Dahlem. Museum photo.

29 Painted cover of wooden reliquary; Scenes from the Life of Christ. Sixth century. From the treasury of the Sancta Sanctorum of the Lateran, now in the Vatican. Photo: Vatican Library.

30 Icon; The Ascension. $18\frac{1}{8} \times 11\frac{3}{4}$ (46×30). Late sixth or early seventh century. Monastery of St Catherine, Mount Sinai. Photo: Allen.

31 Silver dish. Palestinian or Syrian work with stylized renderings of the Ascension, the Resurrection and the Crucifixion. Seventh century. Found at Perm, now in the Hermitage, Leningrad. After Smirnov.

32 Metal pilgrim flask. Obverse: the Ascension. $7\frac{1}{2} \times 5\frac{7}{8}$ (19×15). Early seventh century. Treasury of the Cathedral of Monza. Photo: Max Hirmer.

33 Manuscript with Syriac text; The Nativity. Dated between 1216 and 1220. British Museum (Add. 7170, f. 21). Photo: Courtesy of the Trustees of the British Museum.

34 Manuscript with Syriac text; The Marriage at Cana. 17×13 ($43 \cdot 5 \times 33 \cdot 5$). Dated 1219 or 1220. Vatican, Rome. (Syr. 559, f. 57 v.). Photo: Vatican Library.

35 Sancta Sophia, Constantinople. 532–37. Interior. After Fossati, *Aya Sophia, Constantinople, as recently restored by order of H.M. the Sultan Abdul Medjiel*, London, 1852.

36 Sancta Sophia, Constantinople. 532–37. Exterior. Photo: Josephine Powell.

37 Ivory; The Archangel Michael. $16\frac{7}{8} \times 5\frac{1}{2}$ ($42 \cdot 8 \times 14 \cdot 3$). Sixth century. British Museum, London. Photo: Courtesy of the Trustees of the British Museum.

38 Mosaic; Procession of female saints. Set up c. 561. Church of St Apollinare Nuovo, Ravenna. Photo: Alinari.

39 Silver plate; Personification of India. Diam. $17\frac{3}{4}$ (45). Sixth century. Archaeological Museum, Istanbul. Photo: Max Hirmer.

40 Mosaic; Floor of the Great Palace, Constantinople. Sixth century. Photo: Walker Trust.

41 Mosaic; Floor of the Great Palace, Constantinople. Sixth century. Photo: Walker Trust.

42 Detail of the cornice and capitals. Church of SS Sergius and Bacchus, Constantinople. 526–37. Photo: Josephine Powell.

43 The Church of the Assumption of the Virgin, Nicaea. Exterior. Seventh or eighth century. Photo: Klougé.

44 Plan; Sancta Sophia, Constantinople. 532–37. After Salzenberg, *Altchristliche Baudenkmäler von Constantinopel vom V bis XII Jahrhundert*, Berlin, 1854.

45 Manuscript; The Entry into Jerusalem. Rossano Codex. $12 \times 10\frac{1}{4}$ ($30 \cdot 7 \times 26$). Sixth century. The Cathedral, Rossano. Photo: Max Hirmer.

46 Plan; elevation and interior view; Church of St Eirene, Constantinople. 532. Plans after Salzenberg. Photo: Klougé.

47 Plan; The Church of St John, Ephesus. Sixth century. After Wiegand.

48 Marble relief; The Archangel Gabriel. Sixth century. Archaeological Museum, Adalia. Photo: Michael Ballance.

49 Marble arch sculptured with busts of the Apostles. Probably sixth century. From the Church of St Mary Panachrantos, Constantinople. Archaeological Museum, Istanbul. Museum photograph.

50 Silver cross. Presented to the Pope by the Emperor Justin II (565–78). $15\frac{3}{4} \times 12\frac{1}{4}$ (40 × 31). The Vatican, Rome. Photo: Alinari.

51 Silver paten; The Communion of the Apostles. Diam. $14\frac{5}{8}$ (37). It bears a stamp in the name of Justin II (565–78). Archaeological Museum, Istanbul. Photo: Max Hirmer.

52 Mosaic; St Demetrius and two children. c. 640. Church of St Demetrius, Salonika. Photo: Max Hirmer.

53 Mosaic; St Demetrius and donors. c. 640. Church of St Demetrius, Salonika. Photo: Max Hirmer.

54 Silver dish. The Marriage of David. Diam. $10\frac{5}{8}$ (27). Stamp of Heraclius (613–29). The Nicosia Museum, Cyprus. Photo: Max Hirmer.

55 Silver dish; Meleager and Atalanta. Diam. 11 (27·8). Stamp of Heraclius (613–29). The Hermitage, Leningrad. Museum photograph.

56 Mosaic; St Demetrius with supplicants. Late seventh century. Church of St Demetrius, Salonika. Photo: Josephine Powell.

57 Mosaic; Landscape. 715. The Great Mosque, Damascus. Photo: de Lorey.

58 Silk textile; Lion hunt. $16\frac{1}{2} \times 13\frac{1}{2}$ (42·2 × 34·7). Eighth century. Vatican, Rome. Museum photograph.

59 Silk textile; Two riders confronted. $28\frac{3}{4} \times 27\frac{1}{4}$ (73 × 69). Eighth century. Formerly at Mozac, now in the Textile Museum, Lyons. Museum photograph.

60 Silk textile; The Annunciation, in medallions. $27 \times 13\frac{1}{8}$ (68·7 × 33·6). Seventh century. Vatican, Rome. Photo: Max Hirmer.

61 Silk textile; Quadriga. Height, $29\frac{1}{2}$ (75). Eighth century. Musée de Cluny, Paris. Photo: Max Hirmer.

62 Silk textile; Lion strangler. Height, $12\frac{1}{4}$ (31). Eighth century. Victoria and Albert Museum, London. Photo: Max Hirmer.

63 Mosaic; The Archangels Arche and Dynamis. Church of the Assumption, Nicaea. c. 850. (Now destroyed.) Photo: Klougé.

64 Ivory; The Harbaville Triptych. Centre panel, $9\frac{1}{2} \times 5\frac{1}{2}$ (24·2 × 14·2). Late tenth century. Louvre, Paris. Photo: Max Hirmer.

65 Manuscript; The Paris Psalter. $14\frac{1}{8} \times 10\frac{1}{4}$ (36 × 26). Tenth century. David composing the Psalms. Bibliothèque Nationale (Gr. 139), Paris. Photo: Max Hirmer.

66 Manuscript; The Paris Psalter. The Prayer of Isaiah. $14\frac{1}{8} \times 10\frac{1}{4}$ (36 × 26). Tenth century. Bibliothèque Nationale (Gr. 139), Paris. Photo: Max Hirmer.

67 Ivory triptych; The Crucifixion. Centre panel, $10\frac{3}{4} \times 6\frac{1}{4}$ (27·5 × 16·3). Late tenth century. British Museum, London. Photo: Max Hirmer.

68 Ivory; The Coronation of Romanos and Eudoxia. $9\frac{1}{2} \times 5\frac{7}{8}$ (24·5 × 15·5). c. 950. Cabinet des Médailles, Paris. Photo: Max Hirmer.

69 Manuscript; The Homilies of St Gregory Nazianzus. The Vision of Ezekiel. $16\frac{1}{8} \times 11\frac{3}{4}$ (41 × 30·5). 867–86. Bibliothèque Nationale, Paris. Photo: Max Hirmer.

70 Manuscript; The Homilies of St Gregory Nazianzus. The Raising of Lazarus and Entry into Jerusalem. $16\frac{1}{8} \times 11\frac{3}{4}$ (41 × 30·5). 867–86. Bibliothèque Nationale, Paris. Photo: Max Hirmer.

71 Ivory statuette; The Virgin and Child. Height $12\frac{3}{4}$ (32·5). Victoria and Albert Museum, London. Museum photograph.

72 Ivory reliquary framing a fragment of the True Cross. 12¼×6¾ (31×17·4). 963–69. Church of St Francis, Cortona. Photo: Max Hirmer.

73 Ivory casket; The Veroli Casket. 4½× 15¾×6 (11·5×40·5×15·5). Late tenth century. Victoria and Albert Museum, London. Museum photograph.

74 Manuscript; The Joshua Roll. The Stoning of Achan. Vatican, Rome (Gr. 431). Photo: Vatican Library.

75 Manuscript; Conception of the World. Cosmas Indicopleustes, f. 43. Ninth-century copy of a sixth-century original. Vatican, Rome (Gr. 699). Photo: Vatican Library.

76 Mosaic; Virgin and Child. c. 1100. Eastern vault and apse of the Monastery Church of Hosios Lukas, Greece. Photo: R. Clogg.

77 Mosaic; Christ the Almighty. c. 1100. The dome, Daphni, Greece. Photo: David Talbot Rice.

78 Mosaic; The Virgin. Ninth century. Apse of the Church of the Assumption, Nicaea. (Now destroyed.) Photo: Klougé.

79 Mosaic; The Nativity. c. 1000. Monastery Church of Hosios Lukas, Greece. Photo: Josephine Powell.

80 Mosaic; The Transfiguration. c. 1100. Daphni, Greece. Photo: Josephine Powell.

81 Mosaic; The Anastasis. c. 1050. The Nea Moni, Chios. Photo: R. Clogg.

82 Mosaic; The Crucifixion. c. 1000. Narthex of the Monastery Church of Hosios Lukas, Greece. Photo: Josephine Powell.

83 The Church of the Nea Moni, Chios, Greece. Exterior. Photo: Rosemarie Pierer, Hamburg.

84 Wall-painting; The Ascension. c. 1040. Eastern vault, Church of Sancta Sophia, Ochrid. Photo: Department of Ancient Monuments, Macedonia.

85 Wall-painting; The Dormition of the Virgin. Detail of Christ. c. 1040. Western wall, Church of Sancta Sophia, Ochrid. After Raška.

86 Psalter of Basil II (976–1025). Six scenes from the Life of David. 15½×11¾ (39·5×30·5). The Marcian Library, Venice. Photo: Max Hirmer.

87 Mosaic; Leo VI before Christ. 886–912. Above narthex door, Sancta Sophia, Constantinople. 185×90½ (470×230). Photo: Courtesy of the Byzantine Institute, Inc.

88 Mosaic; Constantine and Justinian offer homage to the Virgin. c. 1000. Above south door of Sancta Sophia, Constantinople. 194½×118⅞ (494×302). Photo: Max Hirmer.

89 Plaques in cloisonné enamel from the crown of Constantine Monomachos (1042–55). Height of biggest dancing girl, 3⅞ (10). National Museum, Budapest. Museum photograph.

90 Mosaic; Christ blessing the Empress Zoe and Constantine Monomachos (1042–55). Original height, 96⅛×94½ (244×240). South Gallery, Sancta Sophia, Constantinople. Photo: Max Hirmer.

91 Psalter of Basil II (976–1025). Portrait of Basil II. Height, 15½ (39·5). The Marcian Library, Venice. Photo: Max Hirmer.

92 Silk textile with elephants in medallions. 63¾×53½ (162×136). c. 1000. From the Tomb of Charlemagne, Aachen. Photo: Schlossmuseum, Berlin.

93 Silk textile with eagles. The Shroud of St Germain l'Auxerrois. 66⅞×45¼ (170×115). Eleventh century. Church of Eusebius, Auxerre. Photo: Giraudon.

94 Silk textile with a bull and diaper pattern. 12¾×7⅞ (32·7×20). Tenth century. Treasury of St Servatus, Maastricht. Photo: Byzantine Exhibition, Edinburgh.

95, 96 Ivory casket, side and end, with Chinese bird and hunting scene. 5½×10¼×5⅛ (14×26×13). Eleventh century. Troyes Cathedral. Photo: Max Hirmer.

97 Chalice bearing the name of the Emperor Romanos. *c.* 1070. Treasury of St Mark's, Venice. Photo: Osvaldo Böhm.

98 Silver-gilt and enamel cover for the Gospels, bearing the name of the Emperor Nicephorus Phocas. *c.* 970. Monastery of Lavra, Mount Athos. After N. P. Kondakov, *Athos.*

99 Gold and enamel cover for the Gospels. Tenth century. Public Library, Siena. Photo: Alinari.

100 Gold and enamel reliquary cover for a fragment of the True Cross. $9\frac{1}{8} \times 6\frac{3}{8}$ (23·5 × 16·6). Eleventh century. Treasury of St Mark's, Venice. Photo: Byzantine Exhibition, Edinburgh.

101 Silver-gilt and enamel reliquary for a fragment of the True Cross. $18\frac{7}{8} \times 13\frac{3}{4}$ (48 × 35). Late tenth century. Limburg an der Lahn. Photo: Max Hirmer.

102 Paten of onyx with enamel of Last Supper. Diam. $4\frac{6}{8}$ (12·3). Eleventh century. Stoclet Collection, Brussels. Photo: Giraudon.

103 Pottery plaque; St George. Polychrome ware. Tenth century. Private possession. Photo: David Talbot Rice.

104 Pottery plaque; St Theodore. Polychrome ware. Tenth century. From Patleina. Now in the National Museum, Sofia. Photo: Talbot Rice.

105 Pottery bowl with design of two doves. Sgraffito ware. Diam. 8 (20·5). Thirteenth or fourteenth century. Collection David Talbot Rice. Photo: Eileen Tweedy.

106 Mosaic; The Doubting Thomas. *c.* 1100. Daphni, Greece. Photo: Josephine Powell.

107 Mosaic; Joachim and the angel. *c.* 1100. Daphni, Greece. Photo: Josephine Powell.

108 Mosaic; The Virgin between the Emperor John Comnenus and the Empress Eirene. $97\frac{1}{4} \times 175\frac{1}{4}$ (247 × 445). *c.* 1118. South gallery, Sancta Sophia, Constantinople. Photo: Max Hirmer.

109 Mosaic; The Emperor Alexius Comnenus. Height, $97\frac{1}{4}$ (247). *c.* 1122. South gallery, Sancta Sophia, Constantinople. Photo: Courtesy of the Byzantine Institute Inc.

110 Double-sided reliquary of gold and enamel. Obverse, the Virgin. $3\frac{1}{4} \times 2\frac{3}{4}$ (8·7 × 7·2). Twelfth century. Basilica of the Virgin, Maastricht. Photo: F. Lahaye, Maastricht.

111 Miniature mosaic; Christ. $21\frac{1}{4} \times 16\frac{1}{8}$ (54 × 41). *c.* 1150. Museo Nazionale, Florence. Photo: Byzantine Exhibition, Edinburgh.

112 Manuscript; The Homilies of St John Chrysostom. The Emperor Nicephorus Botiniates (1078–81) between St John Chrysostom and the Archangel Michael. $16\frac{1}{2} \times 12\frac{1}{4}$ (41·5 × 31·5). Bibliothèque Nationale (Coislin 79), Paris. Photo: Max Hirmer.

113 Ivory panel; St John the Baptist and the Apostles Philip, Stephen, Andrew and Thomas. $9\frac{1}{8} \times 5\frac{1}{4}$ (23·5 × 13·5). Late eleventh century. Victoria and Albert Museum, London. Museum photograph.

114 Ivory plaque; The Forty Martyrs (Detail). Width, $4\frac{7}{8}$ (12·8). Twelfth century. Staatliche Museen, Berlin-Dahlem. Photo: Byzantine Exhibition, Edinburgh.

115 Icon; 'Our Lady of Vladimir'. Height of panel, *c.* 31 (78). *c.* 1125. The Tretyakov Gallery, Moscow. After Anisimov, *Our Lady of Vladimir.*

116 Wall-painting; A saint. 1164. Nerezi, Macedonia. Photo: Department of Ancient Monuments, Macedonia.

117 Wall-painting; The Deposition. 1164. Nerezi, Macedonia. Photo: Josephine Powell.

118 Steatite relief, partly gilt; The Archangel Michael. $5\frac{7}{8} \times 4$ (15·2 × 10·9). Twelfth century. The Bandini Museum, Fiesole. Photo: Byzantine Exhibition, Edinburgh.

119 Icon; SS Prokopios, Demetrius and Nestor. $11 \times 7\frac{1}{8}$ (28 × 18). Eleventh century. Monastery of St Catherine, Mount Sinai. Photo: Allen.

273

120 The church of Changli Kilisse, near Akseray, Asia Minor. Photo: Michael Ballance.

121 Wall-painting, showing earlier and later layers. Toqale Kilisse, Cappadocia. Photo: Josephine Powell.

122 Wall-painting; The Proof of the Virgin. Tenth or eleventh century. The church of Kiliclar, Cappadocia. After Jerphanion, *Les Eglises Rupestres de Cappadoce.*

123 Wall-painting; Moses. Eleventh century. The Church of Elmale Kilisse, Cappadocia. Photo: Josephine Powell.

124 Plan; The church of Mastara, Armenia. 684. After Stryzgowski. *Die Baukunst der Armenier und Europa.*

125 Plan; The church of Achthamar. 915–21. After Stryzgowski, *op. cit.*

126 The church on the Island of Achthamar, Lake Van. 915–21. South side. Photo: Josephine Powell.

127 The church on the Island of Achthamar, Lake Van. 915–21. West end. Photo: Josephine Powell.

128 Plan; The Cathedral at Bagaran, Armenia. 624. After Stryzgowski, *op. cit.*

129 The city church, Ani. 622. After Stryzgowski, *op. cit.*

130 Elevation. The circular church of Zwarthnotz, Armenia. 641–61. After Stryzgowski. *op. cit.*

131 The Church of the Redeemer, Ani. Photo: V. Gordon.

132 Plan; The Cathedral of Thalin, Armenia. Seventh century. After Stryzgowski, *op. cit.*

133 The Cathedral of Ani. 989–1001. East end. Photo: V. Gordon.

134 The Church of St Gregory of Tigrane Honentz, Ani. 1215. Photo: V. Gordon.

135 The Cathedral of Mschet, Georgia. Tenth century. Photo: David Talbot Rice.

136 Plan; The church of Djvarî near Mschet. 619–39. After Stryzgowski, *op. cit.*

137 Sculpture. 619–39. Over the west door, the church of Djvarî. Photo: David Talbot Rice.

138 Miniature; Architectural composition. The Etchmiadzin Gospels. $13\frac{3}{8} \times 10\frac{5}{8}$ (34×27). 989. Matenadaran 2374. Erevan, Armenia. Photo: Editions Cercle d'Art.

139 Miniature; The Sacrifice of Abraham. $13\frac{1}{4} \times 10\frac{5}{8}$ (33.5×27). Sixth century. Bound up with the Etchmiadzin Gospels. Matenadaran 2374. Erevan, Armenia. Photo: Editions Cercle d'Art.

140 Miniature; The Presentation in the Temple. $14\frac{3}{8} \times 9\frac{3}{4}$ (36.3×23). The Gospels of Mugni. Mid-eleventh century. Matenadaran 7736. Erevan, Armenia. Photo: Editions Cercle d'Art.

141 Miniature; The Holy Women at the Sepulchre. $10\frac{5}{8} \times 14\frac{1}{2}$ (27×36.5). Gospels of 1038. Matenadaran 6201. Erevan, Armenia. Photo: Editions Cercle d'Art.

142 Miniatures; Scenes from the Gospels. Gospels of the Six Painters. Thirteenth century. Matenadaran 7651. Erevan, Armenia. Photo: Editions Cercle d'Art.

143 Mosaic; The Archangel Michael. 1125–30. Ghelat, Georgia. After Amiranashvili.

144 Wall-painting; The Archangel Michael. Tenth century. David–Garedja, Georgia. After Amiranashvili.

145 Embossed bronze with enamels and precious stones. Detail of the Khakhuli Icon. Twelfth century. Tbilisi Museum. After Tchubinashvili.

146 The Cathedral, Cefalù, Sicily. c. 1131. East end. Photo: Anderson.

147 Mosaic; Christ. c. 1155. Apse, the Cathedral of Cefalù. Photo: Josephine Powell.

148 Mosaic; Three of the Church Fathers. c. 1143. Palatine Chapel, Palermo. Photo: Anderson.

149 Mosaics in the area beneath the dome. c. 1143. Palatine Chapel, Palermo. Photo: Anderson.

150 Mosaic; Christ with Adam, and the Creation of Woman. *c.* 1158. Nave, Palatine Chapel, Palermo. Photo: Anderson.

151 Mosaic; The Nativity. 1143–51. The Martorana, Palermo. Photo: Anderson.

152 Mosaic; The Crowning of Roger II by Christ. 1143–51. Narthex, Martorana, Palermo. Photo: Anderson.

153 Mosaic; The Healing of the Paralytic, the Lame and the Blind. Detail. 1180–90. Cathedral of Monreale. Photo: Thames and Hudson Archive.

154 Mosaic; The Healing of the Paralytic, the Lame and the Blind.' 1180–90. Cathedral of Monreale. Photo: Alinari.

155 Mosaic; The Crowning of William II by Christ. 1180–90. Cathedral of Monreale. Photo: Anderson.

156 Mosaic; Hunting scene. 1160–70. The Norman *stanze*, Palace of Palermo. Photo: Anderson.

157 Mosaic; Isaac and Esau (Detail of Fig. 159). 1180–90. Cathedral of Monreale. Photo: Thames and Hudson Archive.

158 Miniature mosaic; The Crucifixion. $14\frac{1}{8} \times 11\frac{3}{4}$ (36.5×30). Late twelfth century. Staatliche Museen, Berlin (Ost). Photo: Max Hirmer.

159 Mosaic; Scenes from the Old Testament. 1180–90. Cathedral of Monreale. Photo: Alinari.

160 Silk textile; Confronted eagles. Twelfth century. Staatliche Museen, Berlin (Ost). Photo: Giraudon.

161 Icon; Enthroned Virgin and Child. $32\frac{1}{8} \times 19\frac{3}{8}$ (81.5×49). Late twelfth century. National Gallery, Washington. Museum photograph.

162 Mosaic; The Last Supper. Last quarter of twelfth century. St Mark's, Venice. Photo: Alinari.

163 Mosaic; The Virgin, *c.* 1190, and Apostles, early eleventh century. Apse, Cathedral of Torcello. Photo: Anderson.

164 Mosaic; The Last Judgment. Twelfth century. Cathedral of Torcello. Photo: Alinari.

165 Mosiac; The Virgin. *c.* 1310. Apse, Murano. Photo: Alinari.

166 Ivory; Scenes from the New Testament. $9\frac{7}{8} \times 4\frac{3}{4}$ (25×12). Twelfth century. Victoria and Albert Museum, London. Museum photograph.

167 Marble relief; Confronted peacocks. Twelfth century. St Mark's, Venice. Photo: Anderson.

168 Stone sculpture; St Agathonikos. Twelfth century. Caorle, near Venice. Photo: Osvaldo Böhm.

169 Silver-gilt and enamel Gospel-cover. $10\frac{1}{4} \times 6\frac{1}{4}$ (26×16). Eleventh and thirteenth century. Treasury of St Mark's, Venice. Photo: Max Hirmer.

170 Wall-painting; The Sebastocrator Kaloian and his consort, Dessislava. 1259. Boiana. After Filow.

171 Wall-painting; Christ in the Temple. Detail of Christ's head. 1259. Boiana. Photo: Musée Nationale d'Archéologie, Sofia.

172 Wall-painting; Christ blessing. 1259. Boiana. Photo: Musée Nationale d'Archéologie, Sofia.

173 Wall-painting; Angel. 1191. Kurbinovo, Macedonia. Photo: R. Hoddinott.

174 Wall-painting; St Theodore Tyro. 1259. Boiana. Photo: Musée Nationale d'Archéologie, Sofia.

175 Wall-painting; The Archangel Michael. Late twelfth century. Kastoria, Macedonia. After Pelekannides.

176 Wall-painting; The Crucifixion. Thirteenth century. Church of the Mother of God, Studenica. Photo: R. Hoddinott.

177 Wall-painting; The Crucifixion. Detail of Christ's head. Thirteenth century. Church of the Mother of God, Studenica. Photo: Collection de l'Ecole des Hautes Etudes.

178 Wall-painting; Portrait of King
Vladislav (1230–37). Monastery Church
of Mileševo. After Okunev.

179 Wall-painting; The Resurrection. Detail
of the angel. 1230–37. Monastery Church
of Mileševo. Photo: Department of
Ancient Monuments, Serbia.

180 Wall-painting; The Maries at the Empty
Tomb. 1230–37. Monastery Church of
Mileševo. After Okunev.

181 Wall-painting; The Annunciation.
Detail of the Virgin's head. 1230–37.
Monastery Church of Mileševo. Photo:
Collection de l'Ecole des Hautes
Etudes.

182 The three churches, Peć. Thirteenth
century. Photo: David Talbot Rice.

183 Wall-painting; Portrait of King Uroš.
c. 1265. Sopoćani. Photo: Department
of Ancient Monuments, Serbia.

184 Wall-painting; The Dormition of the
Virgin. Detail. c. 1265. Sopoćani.
Photo: Department of Ancient Monu-
ments, Serbia.

185 Wall-painting; The Anastasis. c. 1265.
Sopoćani. Photo: Department of Ancient
Monuments, Serbia.

186 Wall-painting; The Nativity. Detail
of shepherds. c. 1265. Sopoćani. Photo:
Department of Ancient Monuments,
Serbia.

187 Wall-painting; The Mocking of Christ.
c. 1317. Staro Nagoričino. Photo:
Department of Ancient Monuments,
Serbia.

188 Wall painting; St Jacob of Persia. c. 1317.
Staro Nagoričino. After Okunev.

189 The Church of St Clement, Ochrid.
Founded 1295. Photo: R. Hoddinott.

190 Wall-painting; The Agony in the Gar-
den. c. 1295. Church of St Clement,
Ochrid. Photo: Department of Ancient
Monuments, Macedonia.

191 Wall-painting; The Crucifixion, by
Astrapas. 1307–09. Exo-narthex of the
Church of the Mother of God Ljeviška,
Prizren. Photo: Eileen Tweedy.

192 Wall-painting; The Communion of the
Apostles. c. 1310. Church of the Mother
of God Ljeviška, Prizren. Photo:
Department of Ancient Monuments,
Macedonia.

193 Wall-painting; Hand maiden. Detail
from the Nativity of the Virgin. Four-
teenth century. Church of St Demetrius,
Peć. Photo: Department of Ancient
Monuments, Macedonia.

194 The Church of St John the Baptist,
Gračanica. c. 1321. Photo: Josephine
Powell.

195 Wall-painting; St John the Baptist. c.
1321. Conch of the northern apse,
Church of St John the Baptist, Gračanica.
Photo: Josephine Powell.

196 Wall-painting; St Blaise. Mid-fourteenth
century. Markov Manastir. Photo:
Department of Ancient Monuments,
Serbia.

197 Wall-painting; Rachel lamenting. Mid-
fourteenth century. Markov Manastir.
After Okunev.

198 Wall-painting; The Archangel Michael.
1407–18. Monastery Church of Mana-
sija. Photo: Department of Ancient
Monuments, Serbia.

199 Icon; St Nicholas. $43\frac{1}{4} \times 35\frac{3}{8}$ (110×90).
Fourteenth century. Monastery of
Chilandari, Mount Athos. After
Radojčić.

200 Icon; Christ (detail). $47\frac{1}{4} \times 35\frac{3}{8}$ ($120 \times$
90). c. 1260. Monastery of Chilandari,
Mount Athos. After Radojčić, Icônes
de Serbie, 1961.

201 Icon; The Archangel Gabriel. $64\frac{5}{8} \times 22$
(164×56). Monastery of Dečani. Photo:
Department of Ancient Monuments,
Serbia.

202 Mosaic; The Deesis. Detail of Christ.
Mid-twelfth century. Sancta Sophia,
Constantinople. Photo: Max Hirmer.

203 Wall-painting; The Feeding of the Five
Thousand. Detail. Average height, $234\frac{1}{4}$
(595). Thirteenth century. Church of
Sancta Sophia, Trebizond. Photo: Russell
Trust.

204 Wall-painting; Expulsion of a devil from the Daughter of the Woman of Canaan. Thirteenth century. Church of Sancta Sophia, Trebizond. Photo: Russell Trust.

205 Mosaic; Portrait of Theodore Metochites. *c.* 1310. Church of the Saviour, Kariye Camii, Constantinople. Photo: Max Hirmer.

206 Mosaic; The Marriage at Cana. *c.* 1310. Church of the Saviour, Kariye Camii, Constantinople. Photo: Max Hirmer.

207 Mosaic; Joseph's Dream. *c.* 1310. Church of the Saviour, Kariye Camii, Constantinople. Photo: Max Hirmer.

208 Mosaic; Elizabeth at the well. *c.* 1310. Church of the Saviour, Kariye Camii, Constantinople. Photo: Josephine Powell.

209 Mosaic; The Nativity of the Virgin. *c.* 1310. Church of the Saviour, Kariye Camii. Photo: Josephine Powell.

210 Mosaic; The first steps of the Virgin. *c.* 1310. Church of the Saviour, Kariye Camii, Constantinople. Photo: Josephine Powell.

211 The Virgin Interceding with Christ. *c.* 1310. Church of the Saviour, Kariye Camii, Constantinople. Photo: Max Hirmer.

212 Wall-painting; The Anastasis. *c.* 1310. Apse of the pareccleseion, Church of the Saviour, Kariye Camii, Constantinople. Photo: Courtesy of the Byzantine Institute, Inc.

213 Wall-painting; The Second Coming of Christ. *c.* 1310. Vault of the pareccleseion, Church of the Saviour, Kariye Camii, Constantinople. Photo: Courtesy of the Byzantine Institute, Inc.

214 Wall-painting; Angel holding the Scroll of Heaven. *c.* 1310. Vault of the pareccleseion, Church of the Saviour, Kariye Camii, Constantinople. Photo: Courtesy of the Byzantine Institute, Inc.

215 Wall-painting; The Virgin, angels and decorative bands. *c.* 1310. Dome of the pareccleseion, Church of the Saviour, Kariye Camii, Constantinople. Photo: Courtesy of the Byzantine Institute, Inc.

216 Mosaic; Christ. *c.* 1320. Dome of St Mary Pammakaristos (Fetiye Camii), Constantinople. Photo: Max Hirmer.

217 The Church of St Theodore (Kilisse Camii), Constantinople. Fourteenth century. Photo: Max Hirmer.

218 Church of St Mary Panachrantos (Phenari Issa Camii), Constantinople. East end. Fourteenth century. Photo: Courtauld Institute, London.

219 Miniature mosaic; The Annunciation. $5\frac{1}{8} \times 3\frac{1}{8}$ (13·3 × 8·4). *c.* 1310. Victoria and Albert Museum, London. Photo: Max Hirmer.

220 Miniature mosaic; Six of the twelve feasts of the Church. Height, $10\frac{5}{8}$ (27). Early fourteenth century. Opera del Duomo, Florence. Photo: Max Hirmer.

221 The Chalice of Manuel Cantacuzenus (1349–80). Height *c.* 10 (*c.* 25). Monastery of Vatopedi, Mount Athos. After Dölger.

222 Icon; The Assembly of the Apostles. $15 \times 13\frac{3}{8}$ (38 × 34). Early fourteenth century. Museum of Fine Art, Moscow. Photo: Max Hirmer.

223 Reverse of double-sided icon; The Annunciation. $36\frac{1}{4} \times 26\frac{3}{4}$ (92 × 68). Early fourteenth century. Skopolije Museum. Photo: Byzantine Exhibition, Edinburgh.

224 Obverse of double-sided icon (Fig. 223); The Virgin and Child. $36\frac{1}{4} \times 26\frac{3}{4}$ (92 × 68). Early fourteenth century. Skopolije Museum. Photo: Byzantine Exhibition, Edinburgh.

225 Icon; Christ, with portraits of donors in the margins. Height $41\frac{3}{4}$ (106). 1360–70. Hermitage, Leningrad. Museum photograph.

226 Icon; The Archangel Michael. $12\frac{3}{4} \times 9\frac{1}{2}$ (32·8 × 24·5). First half of fourteenth century. Pisa Gallery. Photo: Byzantine Exhibition, Edinburgh.

227 Icon; 'Our Lady of Pimen'. 29⅞ × 24½ (76·05 × 62·5). Late fourteenth century. Tretyakov Gallery, Moscow. Photo: Max Hirmer.

228 Manuscript of Hippocrates, f. 10; Portrait of Hippocrates. 16¼ × 13¾ (41·5 × 35). c. 1342. Bibliothèque Nationale, Paris (Gr. 2144). Photo: Max Hirmer.

229 Church of the Holy Apostles, Salonika. c. 1312. East end. Photo: Collection de l'Ecole des Hautes Etudes.

230 Manuscript of Hippocrates, f. 11; Portrait of the High Admiral Apocaucos. 16¼ × 13¾ (41·5 × 35). c. 1342. Bibliothèque Nationale, Paris (Gr. 2144). Photo: Max Hirmer.

231 Manuscript of John VI Cantacuzenus, f. 92 v; The Transfiguration. 13 × 9⅞ (33·5 × 25). 1370–75. Bibliothèque Nationale, Paris (Gr. 1242). Photo: Max Hirmer.

232 Mosaic; The Transfiguration. c. 1312. Church of the Holy Apostles, Salonika. After Xyngopoulos.

233 Mosaic; Two shepherds, detail from the Nativity c. 1312. Church of the Holy Apostles, Salonika. After Xyngopoulos.

234 Wall-painting; The Washing of Feet. 1282–1328. Church of the Protaton, Karyes, Mount Athos. Photo: Archives Photographiques, Paris.

235 The town of Mistra. Fourteenth century. Photo: Josephine Powell.

236 The Reliquary of Cardinal Bessarion. Width 31⅛ (79). Early fifteenth century. Accademia, Venice. Photo: Osvaldo Böhm.

237 Wall-painting; Above, the Virgin and Child, below, the Divine Liturgy. Fourteenth century. Apse, Church of St Demetrius, Mistra. Photo: Josephine Powell.

238 Wall-painting; The Healing of the Paralytic. c. 1290. Church of the Aphentiko, Mistra. Photo: Josephine Powell.

239 Wall-painting; The central dome and adjacent areas. c. 1350. Church of the Peribleptos, Mistra. Photo: Josephine Powell.

240 Wall-painting; The Prophet Zacharias. 1296. Church of the Brontocheion, Mistra. After Millet.

241 Wall-painting; The Entry into Jerusalem. Detail. c. 1350. Church of the Peribleptos, Mistra. Photo: Josephine Powell.

242 Wall-painting; The Annunciation. 1428. Church of the Pantanassa, Mistra. Photo: Josephine Powell.

243 Wall-painting; The Raising of Lazarus. Detail. 1428. Church of the Pantanassa, Mistra. Photo: Josephine Powell.

244 Wall-painting; The Nativity. c. 1350. Church of the Peribleptos, Mistra. Photo: Josephine Powell.

245 Church of the Monastery of St Paul, Mount Athos. Fifteenth century and later. Photo: Robert Byron.

246 Embroidery; The 'Dalmatic of Charlemagne'. Width at shoulders, 63¾ × 56¾ (162 × 144). Fifteenth century. Vatican, Rome. Photo: Alinari.

247 Icon; The Raising of Lazarus. 17¾ × 12⅜ (45 × 32). Fifteenth century. Attributed to the painter, Byzagios. Ashmolean Museum, Oxford. Photo: Byzantine Exhibition, Edinburgh.

Chronological chart

	Central Area	Near East	Balkans	Sicily
330	Foundation of Constantinople, the ancient Byzantium, as capital of the Roman world	222		
		Sasanian Dynasty in Persia		
527–565	Reign of Justinian I—so-called 'First Golden Age' of Byzantine Culture			
		632 / 638 / 642 / 650 Islamic conquest of Syria and Egypt	679	
591		Byzantine governors in Armenia — Omayyad Caliphate at Damascus		
726	Iconoclast Age at Constantinople	705		
		750 Establishment of the Abbasid Caliphate at Baghdad		
843			First Bulgarian Empire	
867		885		878–909 Period of Byzantine domination
	Macedonian Dynasty at Constantinople—so-called 'Second Golden Age' of Byzantine Culture	Bagratid kingdom in Armenia with its capital at Ani		
	Final split between the Catholic and Orthodox Churches	1045 Armenia annexed by Byzantium	1018 Byzantine control of Bulgaria	
1054 / 1057 / 1071	Battle of Manzikert—defeat of the Byzantines by the Seljuk armies	1080 / 1089	1060 Cyril and Methodius bring Christianity to the Slavs	1071 Norman Conquest
	Ducas, Comnene and Angelus Dynasties at Constantinople	Period of Georgian Ascendancy	Beginnings of Serbian independence under Stephen Nemanja — 1169 / 1186	
		c. 1200		
1204 / 1261	Latin Dynasty rules at Constantinople—growth in power of Byzantine rulers at Nicaea	1204 / 1220 Arrival of the Mongols in Western Asia	Ascendancy of Cilician Armenia	
	Palaeologue Age	Comnene Dynasty at Trebizond	Second Bulgarian Empire	
		1375	1393	
1453	Fall of Constantinople to the Ottoman Turks	1461		

Index

Hosios Lukas, 92, *79*, *82*; Sancta Sophia, Constantinople, 221, 222, *87*, *88*, *90*, *202*; Cefalù, *147*; Palmero, *147*, *148*, *149*, *150*, *151*, *152*; Monreale, *159*, *153*, *154*, *155*; Venice, *162*; Torcello, *163*, *164*; Murano, *165*; Sopoćani, *233*

Hunting scenes, on textiles, *59*; on ivory casket, 109, *96*; at Achthamar, 140

Iconoclasm, 54, 62, 74, 75, 76 ff., 90

Icons, Coptic, 25, *14*, *15*, *16*; Christ and St Maenas, *19*; at Antioch, 40, *30*; *Our Lady of Vladimir*, 127, 128, *115*, *119*; Khakhuli icon, 157, *145*; Serbian, 216, 218, *199*, *200*, *201*; of Constantinople, 238 ff., *222*, *223*, *225*, *226*, *227*, *247*; *Our Lady of Pimen*, 243, *227*; Sicilian, *161*; Mount Athos, *199*, *200*

India, personification of, 51, *39*

Indian art, 15, 67

Inscribed-cross type of church, 60

Isadore of Miletus, 132

Ivories, of Alexandria, 14, *3*; of Lower Egypt, 15, 16, *5*, *6*; diptychs, 17, *7*, *9*, *27*; Throne of Maximian, 21, *10*, *11*, *12*; at Antioch, 24; caskets, 85 ff., 109, *95*, *96*; Veroli casket, 85, *73*; Pyxis, 16, *5*, *6*, *28*; triptychs, 86, 87, *67*; Harbaville triptych, 77, 86, *64*; Virgin and Child, *71*; reliquary, *72*; plaques, *8*, *68*, 113, 114, *166*; Sicilian, *175*; Venetian, 183, *166*

Ivories, with Christian themes, 36, *27*, *28*

Jacob, St, of Persia, portrait, 205, *188*

Jerphanion, Père de, 134 ff.

Jerusalem, 8; mosaics, Dome of the Rock, 69

John the Baptist, St, representations of, 22, *12*, *113*, *195*

John Chrysostom, St, portrait, *112*

Jonah and the Whale, 18, *8*

Joseph, 21, *11*

Justin II (565–78), 62; silver cross of, *50*

Justinian (527–65), 9, 11, 30; patron of art, 47, 48, 52 ff.; in Asia Minor, 100, 132; portrait, *88*

Kaloian, Sebastocrator, portrait, 190, *170*

Kariye Camii, Constantinople, 223, 226, 228; pareccleseion, 229 ff.; *205*, *206*, *207*, *208*, *209*, *210*, *211*, *213*, *214*, *215*, *221*

Kastoria, Macedonia, 194, *175*

Khakhuli Icon, 157, *145*

Kiev, mosaics at, 97

Kurbinovo, Macedonia, 194, 195, *174*

Latmos, 134

Leo III, 74

Leo VI (886–912), 100, *87*

Lesnovo, church at, 212

Limestone carving, Coptic, 15, *4*

'Linear' style, 118 ff., *109*, *110*, *111*

Ljeviška, Church of the Mother of God, *191*, *192*

Maastricht, Church of St Servatus, textiles at, 109, *94*

'Macedonian' Age, in Constantinople (843–1056), 77, 114, 116, *64*

Macedonian School, 258 ff.

Maenas, St, *19*

Manuscripts, Cotton Bible, 24; Paris Psalter, 24, 178, *65*, *66*; Rabbula Gospels, 37, 39, 40, 41, 135, *25*, *26*; Armenian, 42; Syriac, 42 ff., *33*, *34*; Purple Codex (Rossano Codex), 54, *45*; Homilies of St Gregory Nazianzus, 75, 79, 80, *69*, *70*; works of Nicander (Supp. Gr. 247), *85*; Joshua Roll, 86, *74*; Cosmography of Cosmas Indicopleustes, 88, *75*; Homilies of St John Chrysostom, 122, *112*; Etchmiadzin Gospels, 149, *139*, *138*; Gospels of 1038, 150, *141*; Gospels of Mugni, 150, *140*; Vienna Genesis, 152; Gospels of the Six Painters, 152, *142*; Curzon Manuscript, 194